Encyclopedia of Comparative Letterforms

FOR ARTISTS & DESIGNERS

Dedicated to
Trudy, Lauren, Jared
and the memory
of my mother Lillian

Encyclopedia of Comparative Letterforms

FOR ARTISTS & DESIGNERS

by

Norman S. Weinberger

ART DIRECTION BOOK CO., NEW YORK, N.Y.

FOREWORD

During the past thirty years as designer and art director, I have often desperately longed for a comprehensive volume of comparative letterforms that was easy to use. I felt the need not for another type-book, but for a volume that would suggest the masculine, feminine or neuter qualities of any letter, whether the style I sought was serif or sans-serif, italic or roman, simple or decorative.

Several years ago, it occurred to me that the best way to get the book I wanted was to compile it myself. I hope you find that this book saves you valuable research time and is a constant source of inspiration.

VORWORT

In meiner dreissigjährigen Tätigkeit als Zeichner und Kunstdirektor habe ich mich oft entschieden nach einem umfassenden und leicht zu verwendenden Werk über vergleichbare Buchstabenformen gesehnt. Ich fühlte das Bedürfnis, nicht nach einem weiteren Schrifttypenbuch, sondern nach einem Werk das die männlichen, weiblichen und sächlichen Eigenschaften jeder einzelnen Letter andeuten würde, ob es sich im von mir gesuchten Stile um einen Serifen oder endstrichlosen, einen kursiven oder aufrechten, einen einfachen oder verzierten Stil handelte.

Vor einigen Jahren kam mir der Gedanke, dass der einzig praktische Weg um ein derartiges Buch zu finden wohl der sei, es selbst zu kompilieren. Ich hoffe, dass dieses Buch Ihnen kostbare Nachschlagearbeit ersparen und eine Quelle ständiger Inspiration sein wird.

PREFACE

Pendant trente ans, comme dessinateur et directeur artistique, j'ai souvent et désespérément souhaité avoir un volume compréhensif de formes de lettres comparatives, qui serait facile à consulter. J'éprouvais le besoin non d'un autre livre de caractères quelconque, mais d'un volume qui suggérerait les qualités masculines, féminines ou neutres de n'importe quelle lettre, que le style que je cherchais fût à empattements (serif) ou à caractères antiques (sans serif), italiques ou romaines, simples ou ornées.

Il y a quelques années, l'idée m'est venue que la meilleure manière d'obtenir le livre que je désirais, serait de le compiler moi-même. J'espère que ce livre vous économisera un temps précieux de recherches et sera une source constante d'inspiration.

FORMAT

This Encyclopaedia includes a vast variety of letterforms chosen to best aid the artist. All major categories of letterforms are displayed and the various styles for *each individual letter* are grouped together. For example: The letter "A" is shown in 280 different styles on eight pages in numbered grid boxes. Immediately thereafter is a double spread of all the "A's" for easy review. This format is followed for each successive letter (and numeral) of the alphabet. Please note that for reasons of aesthetics and copyright, the height of some characters has been varied slightly.

An index, also grid, in the back locates names and styles. Metal types cite their foundry and are available from your typographer. For photo styles, contact Photo-Lettering, Inc., 216 East 45th Street, New York, N.Y.

Corresponding lower case one line alphabets are shown separately.

FORMAT

Diese Enzyklopädie enthält eine grosse Verschiedenheit an Buchstabenformen, die so gewählt wurdendamit dem Künstler am besten geholfen werde. Alle besondere Kategorien von Buchstabenformen werden gezeigt und die unterschiedlichen Typen *jeder einzelnen Letter* sind zusammengruppiert. Zum Beispiel: Der Buchstabe "A" wird in 280 verschiedenen Stilen auf acht Seiten in numerierten Quadraten dargestellt. Unmittelbar dahinter kommt eine Verbreitung von allen "A's" zur bequemen Uebersicht. Dieses Format wird für jeden nächsten Buchstaben bezw.Jede nächste Zahl des Alphabets angewendet. Bitte notieren Sie, dass aus ästhetischen und Copyright Gründen die Höhe einiger Typen leicht geändert worden ist.

Ein Index, auch in Gitterform, hinten im Buch, verzeichnet die Namen und Stile. Metalltypen geben ihre Giessereien an und können von Ihrem Typographen bezogen werden. Für Photostile wollen Sie sich bitte an Photo-Lettering, Inc., 216 East 45th Street, New York, N.Y. wenden.

Entsprechende Minuskeln-Alphabete in einer Linie werden in einem getrennten Teil aufgeführt.

FORMAT

La présente encyclopédie comporte une grande variété de formes de lettres choisies dans le but de mieux aider l'artiste. Toutes les principales catégories de formes de lettres y sont exposées et les différents styles de *chaque lettre individuelle* sont groupés ensemble. Par exemple: La lettre "A" est montrée dans 280 styles différents sur 8 pages dans des cases de grille numérotées. Immédiatement après vient une composition double de tous les "A" permettant de les passer facilement en revue. Ce format est suivi pour chaque lettre (et nombre) successif de l'alphabet. Notez que pour des raisons d'esthétique et de copyright, la hauteur de quelques caractères a été légèrement modifiée.

Un index, également en grille, à la fin du livre, continent les noms et les styles. Les caractères métalliques mentionnent leur fonderie et peuvent être obtenus de votre typographe. Pour les styles photographiques adressez-vous à Photo-Lettering, Inc., 216 East 45th Street, New York, N.Y.

Les alphabets minuscules correspondants, sur une ligne, sont représentés dans une section séparée.

The author deeply thanks the following without whom this book could never have been compiled:

AMERICAN TYPE FOUNDERS, INC. • BALTIMORE TYPE AND COMPOSITION CO.

BAUER ALPHABETS, INC. • DEBERNY ET PEIGNOT, FOUNDERIES • DETROIT TYPE FOUNDRY • LOS ANGELES TYPE FOUNDERS, INC.

LUDLOW TYPOGRAPH CO. • LUDWIG AND MAYER • MACKELLAR, SMITH AND JORDAN

MONOTYPE CORP., LTD. • MOULDTYPE FOUNDRIES, LTD.

PHOTO-LETTERING, INC. • STEMPEL, D. AG. • STEPHENSON, BLAKE AND CO., LTD. • WEBER, C. E.

CAPITALS

NOPQRSTUVWXYZABCDEFGHIJKLMNOPQRSTUVWXYZABCDEFGHIJKLMNOPQRSTUVWXYZABCDEFGHIJKLMNOPQRSTUVWXYZ

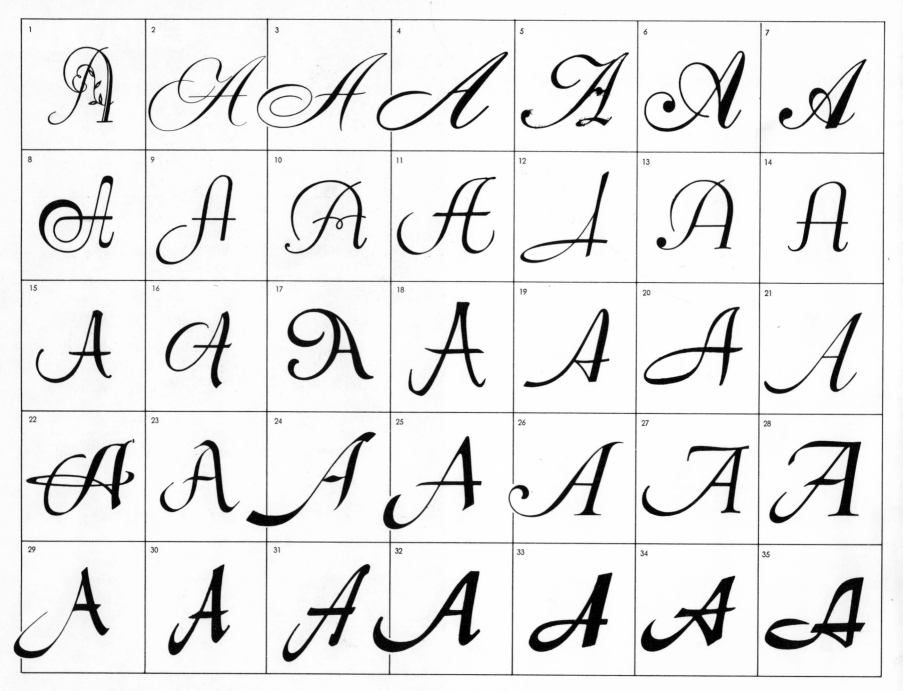

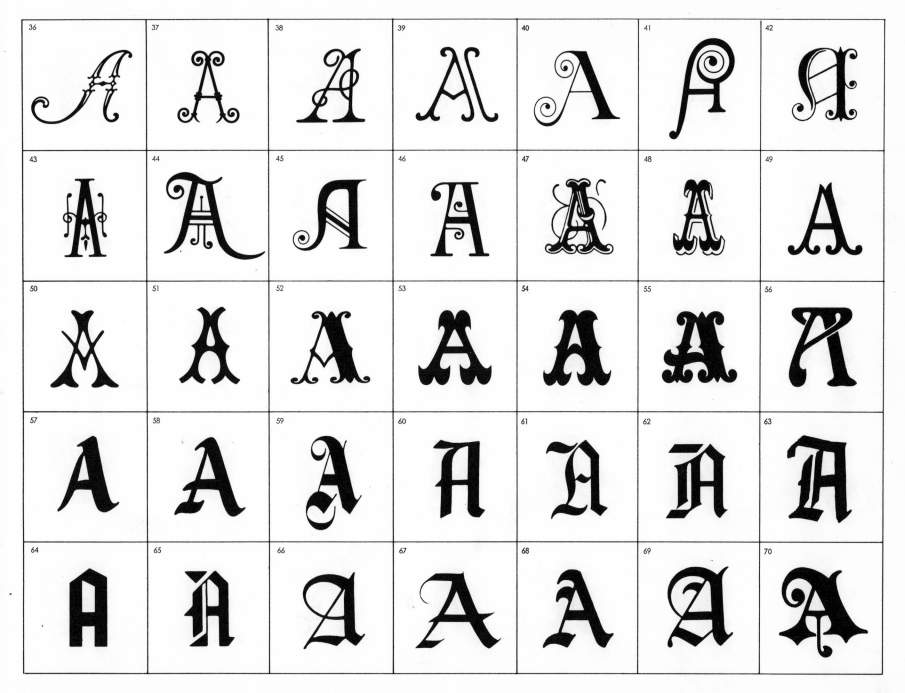

3

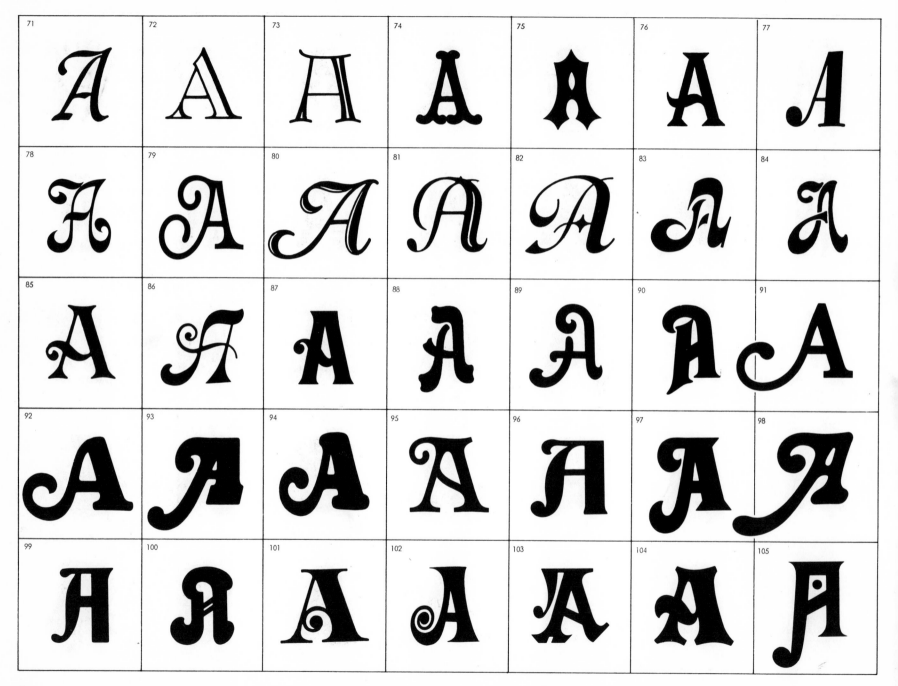

106 107 108 109 110 111 112
113 114 115 116 117 118 119
120 121 122 123 124 125 126
127 128 129 130 131 132 133
134 135 136 137 138 139 140

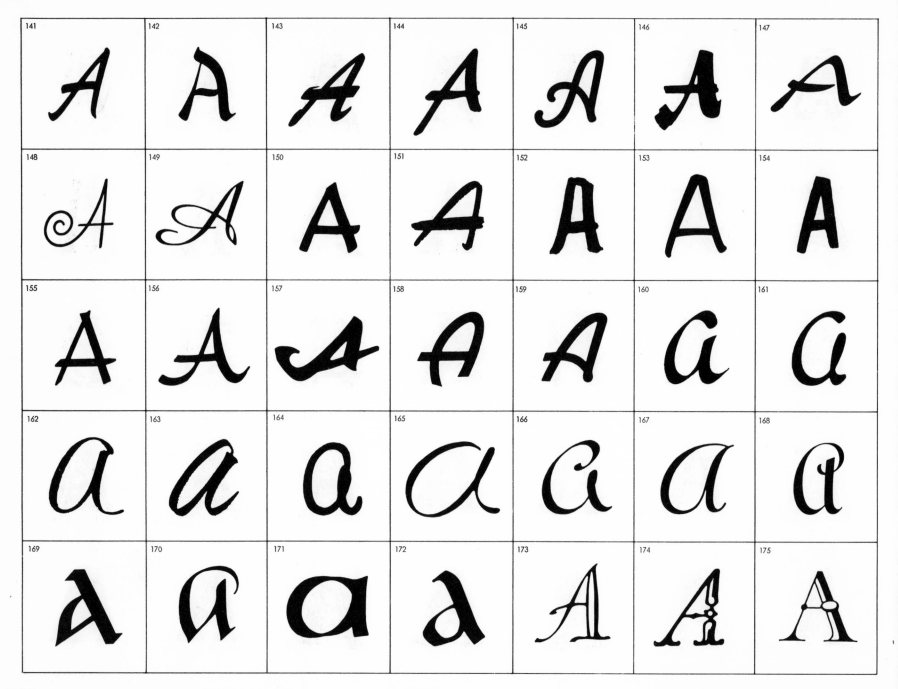

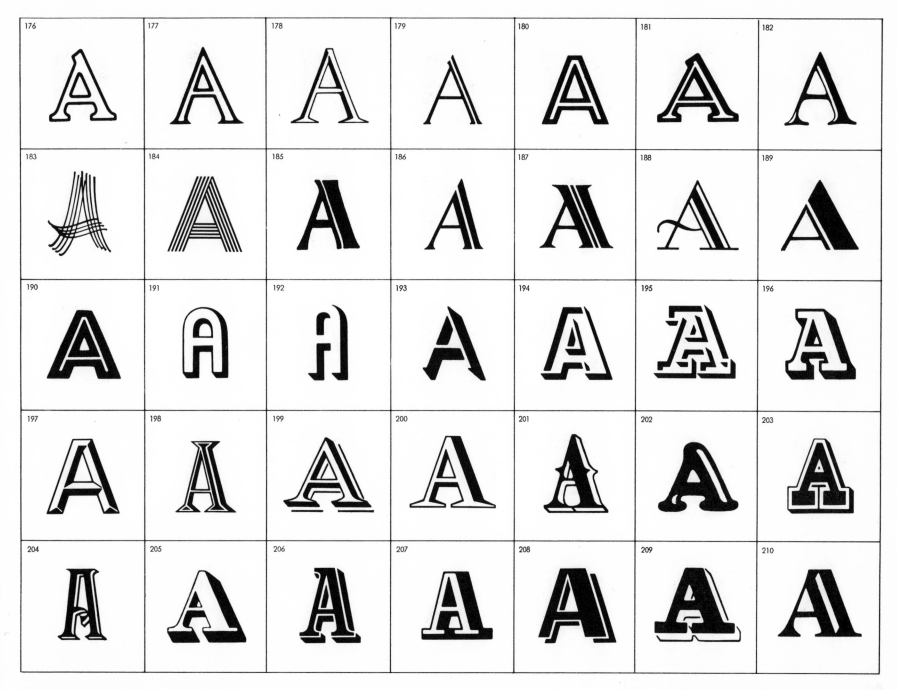

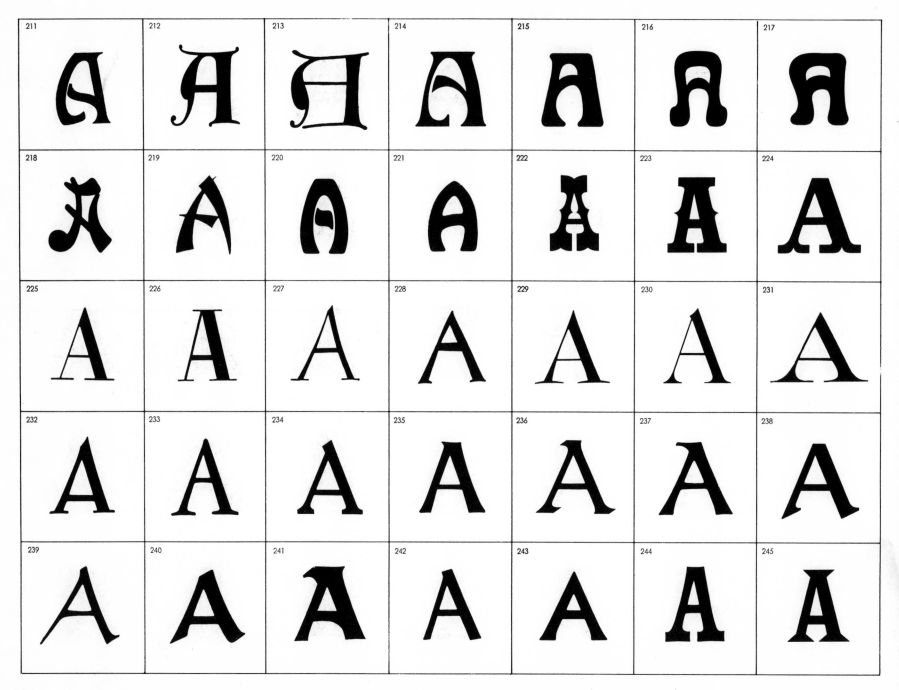

246 247 248 249 250 251 252
253 254 255 256 257 258 259
260 261 262 263 264 265 266
267 268 269 270 271 272 273
274 275 276 277 278 279 280

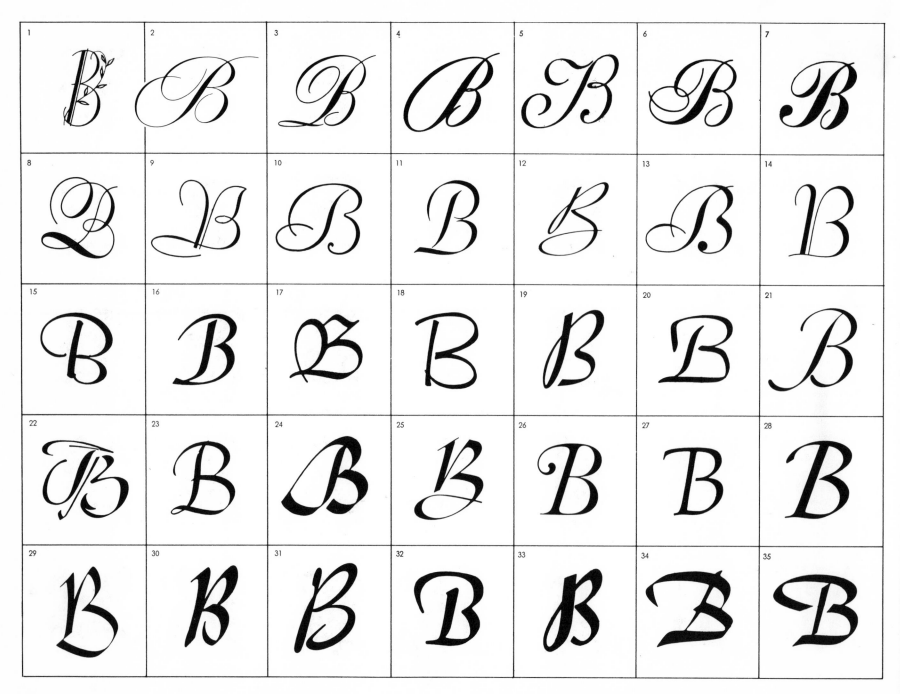

36 37 38 39 40 41 42
43 44 45 46 47 48 49
50 51 52 53 54 55 56
57 58 59 60 61 62 63
64 65 66 67 68 69 70

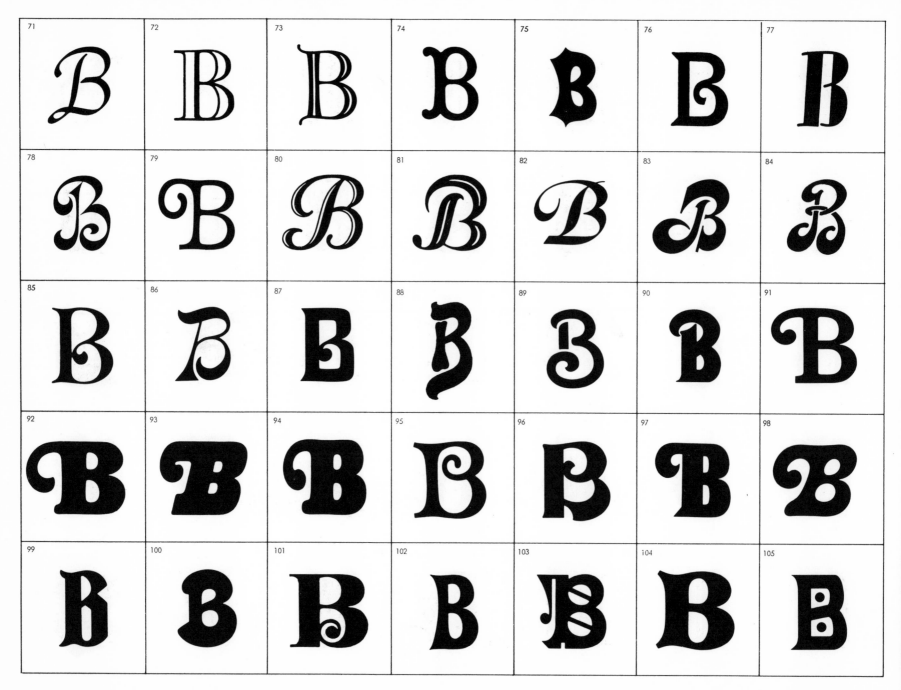

106	107	108	109	110	111	112
113	114	115	116	117	118	119
120	121	122	123	124	125	126
127	128	129	130	131	132	133
134	135	136	137	138	139	140

141	142	143	144	145	146	147
148	149	150	151	152	153	154
155	156	157	158	159	160	161
162	163	164	165	166	167	168
169	170	171	172	173	174	175

176 177 178 179 180 181 182
183 184 185 186 187 188 189
190 191 192 193 194 195 196
197 198 199 200 201 202 203
204 205 206 207 208 209 210

211	212	213	214	215	216	217
218	219	220	221	222	223	224
225	226	227	228	229	230	231
232	233	234	235	236	237	238
239	240	241	242	243	244	245

246 247 248 249 250 251 252
253 254 255 256 257 258 259
260 261 262 263 264 265 266
267 268 269 270 271 272 273
274 275 276 277 278 279 280

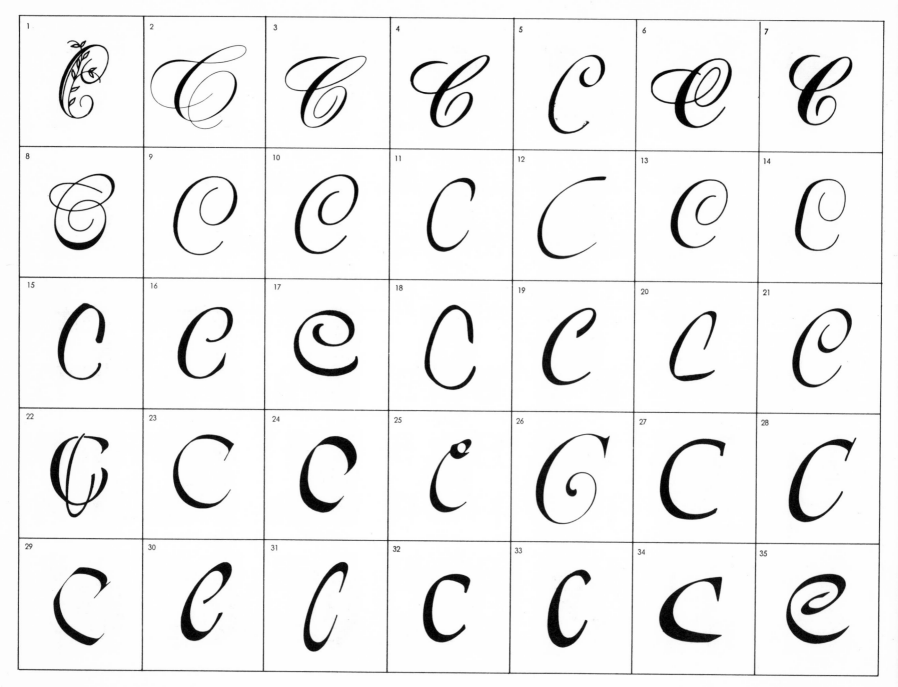

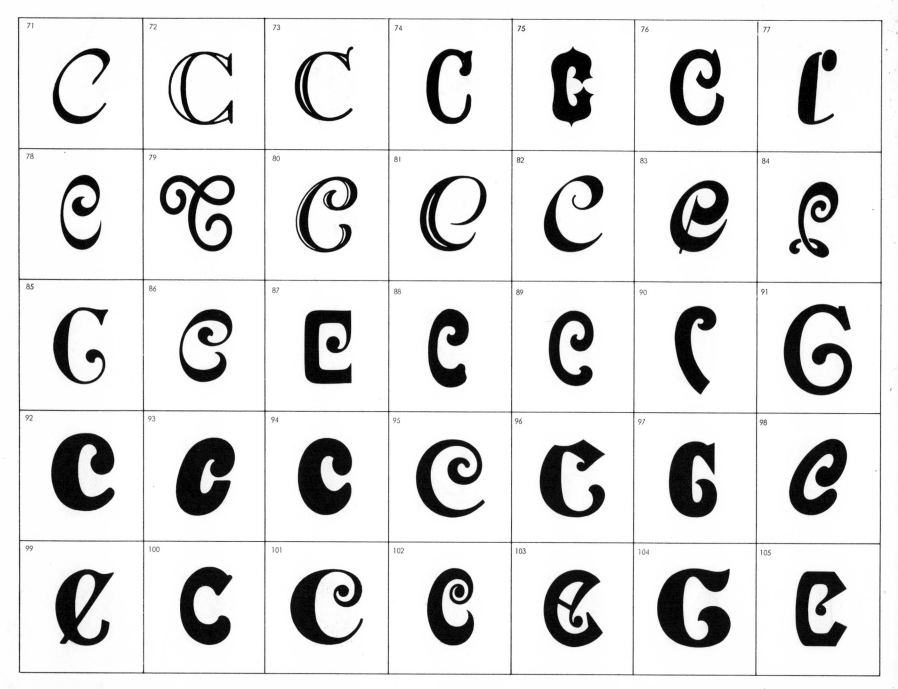

106	107	108	109	110	111	112
113	114	115	116	117	118	119
120	121	122	123	124	125	126
127	128	129	130	131	132	133
134	135	136	137	138	139	140

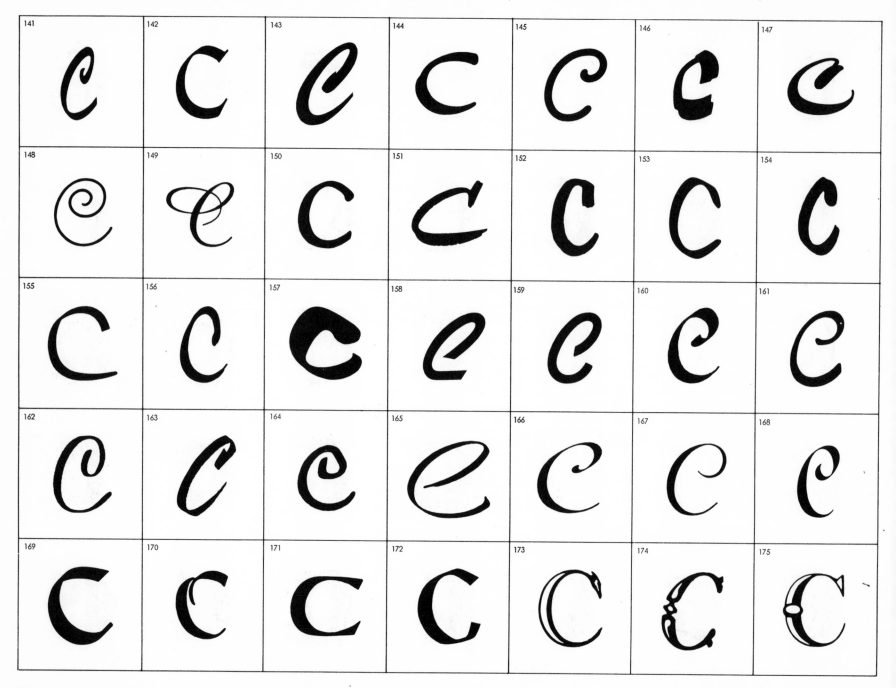

176 177 178 179 180 181 182
183 184 185 186 187 188 189
190 191 192 193 194 195 196
197 198 199 200 201 202 203
204 205 206 207 208 209 210

27

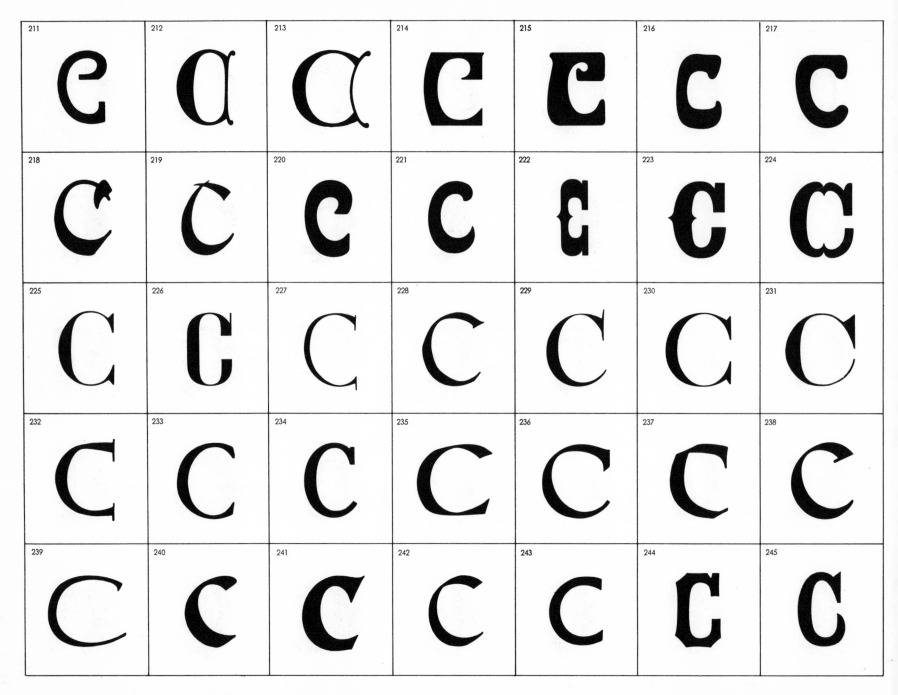

246	247	248	249	250	251	252
253	254	255	256	257	258	259
260	261	262	263	264	265	266
267	268	269	270	271	272	273
274	275	276	277	278	279	280

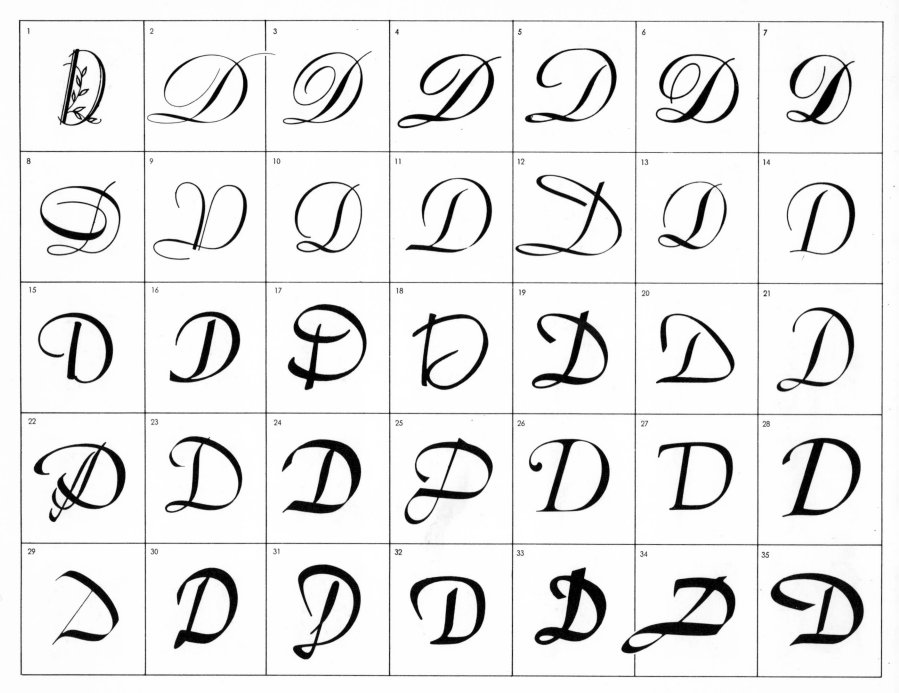

36	37	38	39	40	41	42
43	44	45	46	47	48	49
50	51	52	53	54	55	56
57	58	59	60	61	62	63
64	65	66	67	68	69	70

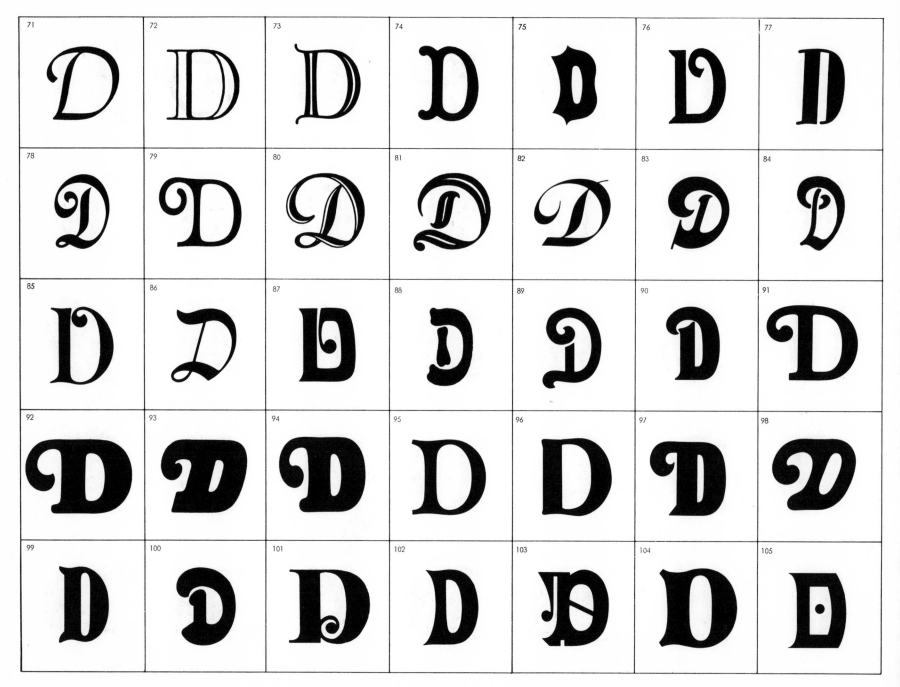

106 107 108 109 110 111 112
113 114 115 116 117 118 119
120 121 122 123 124 125 126
127 128 129 130 131 132 133
134 135 136 137 138 139 140

141	142	143	144	145	146	147
148	149	150	151	152	153	154
155	156	157	158	159	160	161
162	163	164	165	166	167	168
169	170	171	172	173	174	175

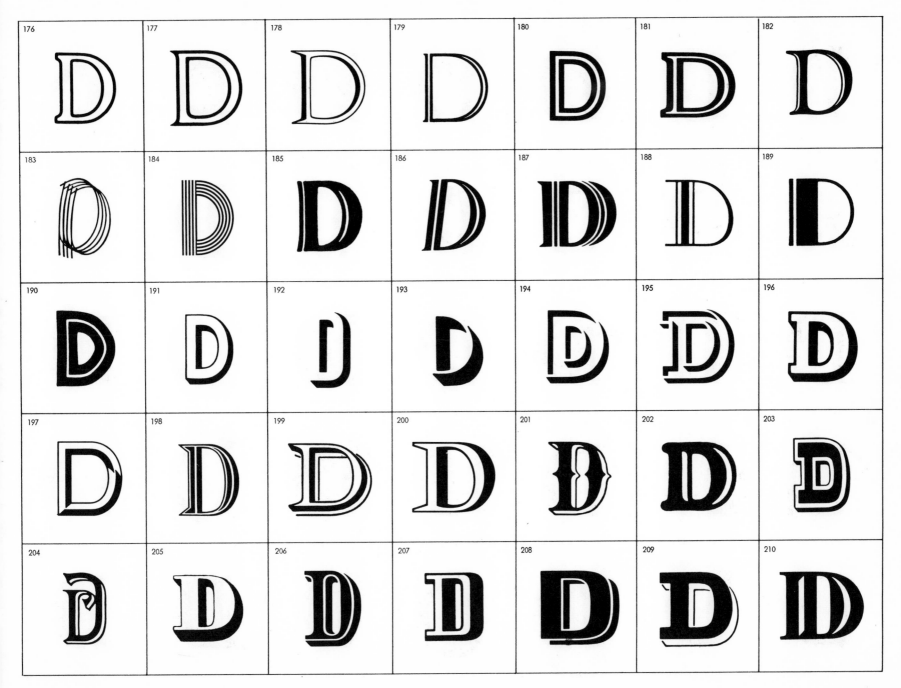

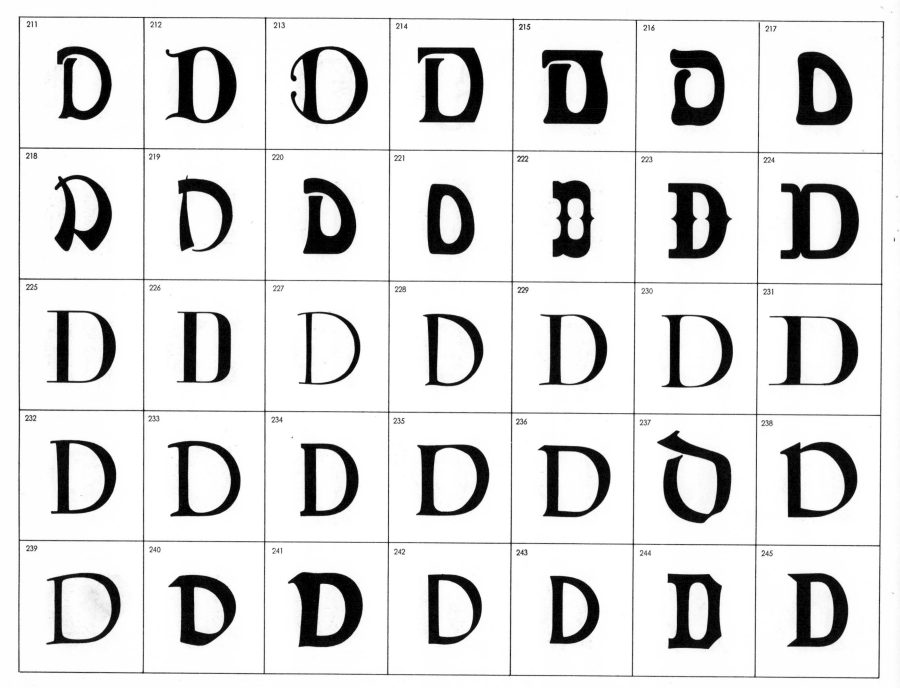

246	247	248	249	250	251	252
253	254	255	256	257	258	259
260	261	262	263	264	265	266
267	268	269	270	271	272	273
274	275	276	277	278	279	280

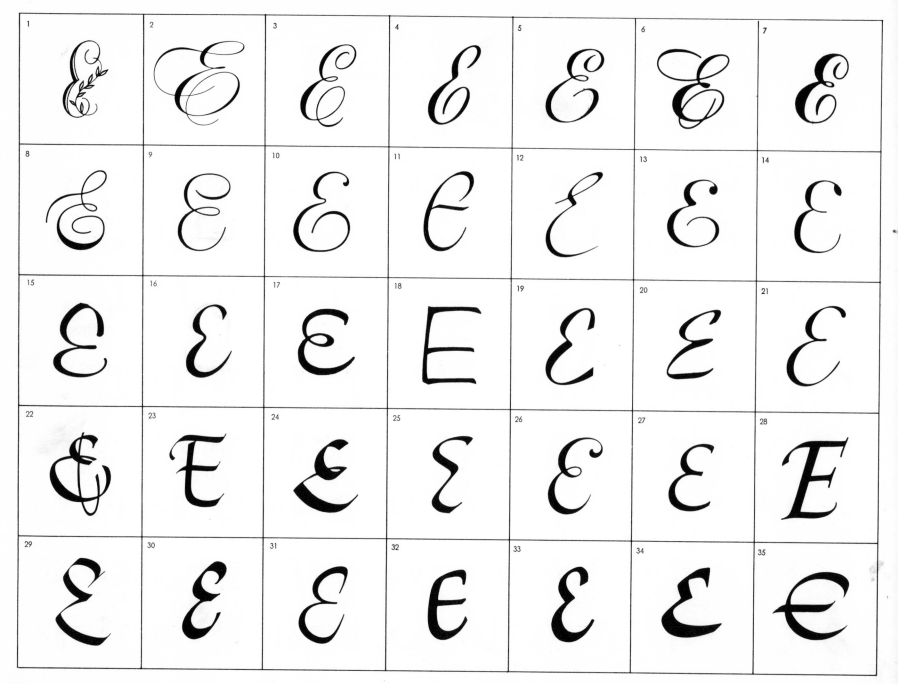

42

36	37	38	39	40	41	42
43	44	45	46	47	48	49
50	51	52	53	54	55	56
57	58	59	60	61	62	63
64	65	66	67	68	69	70

43

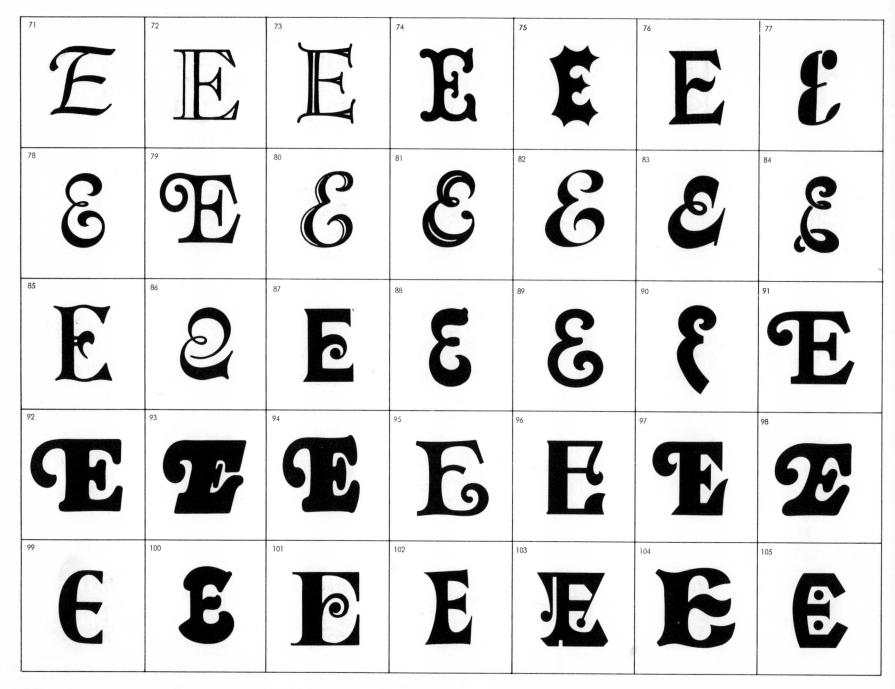

44

106 107 108 109 110 111 112
113 114 115 116 117 118 119
120 121 122 123 124 125 126
127 128 129 130 131 132 133
134 135 136 137 138 139 140

45

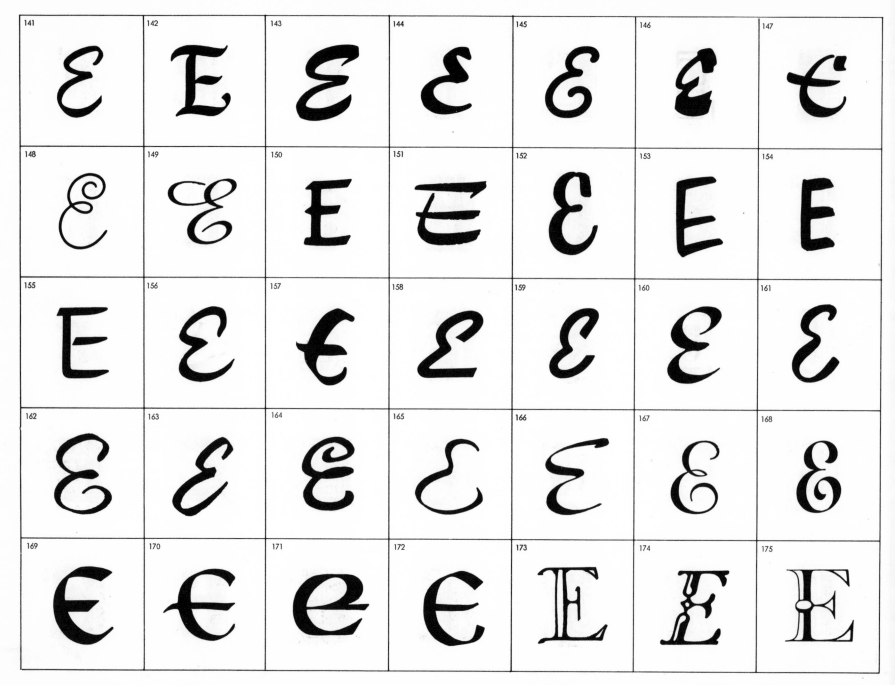

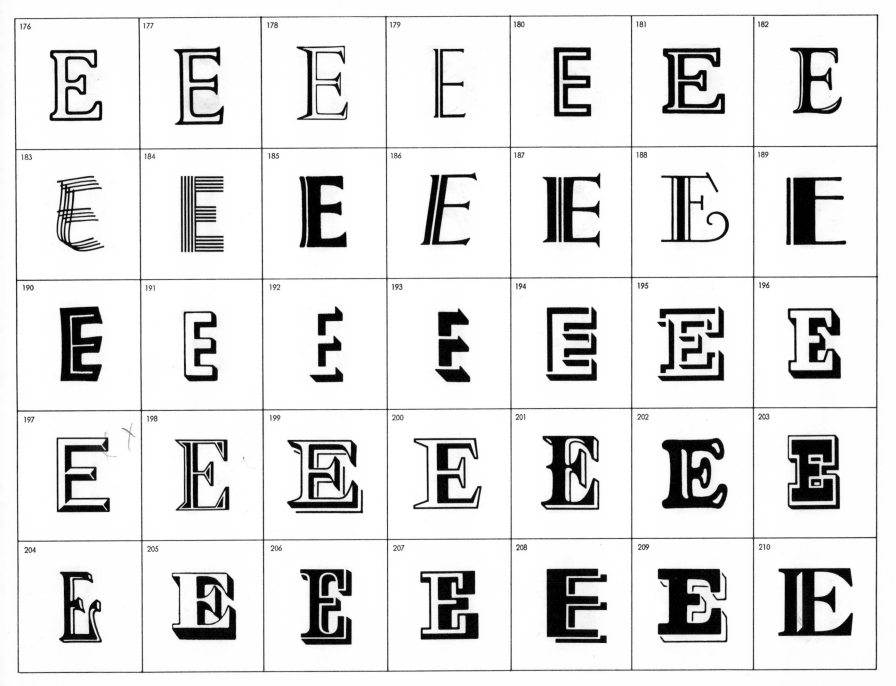

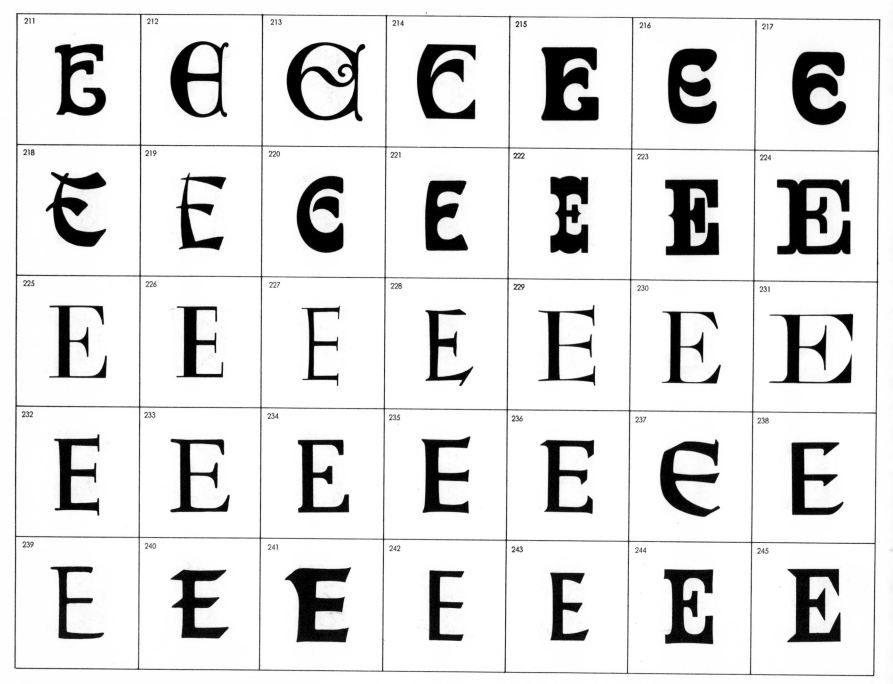

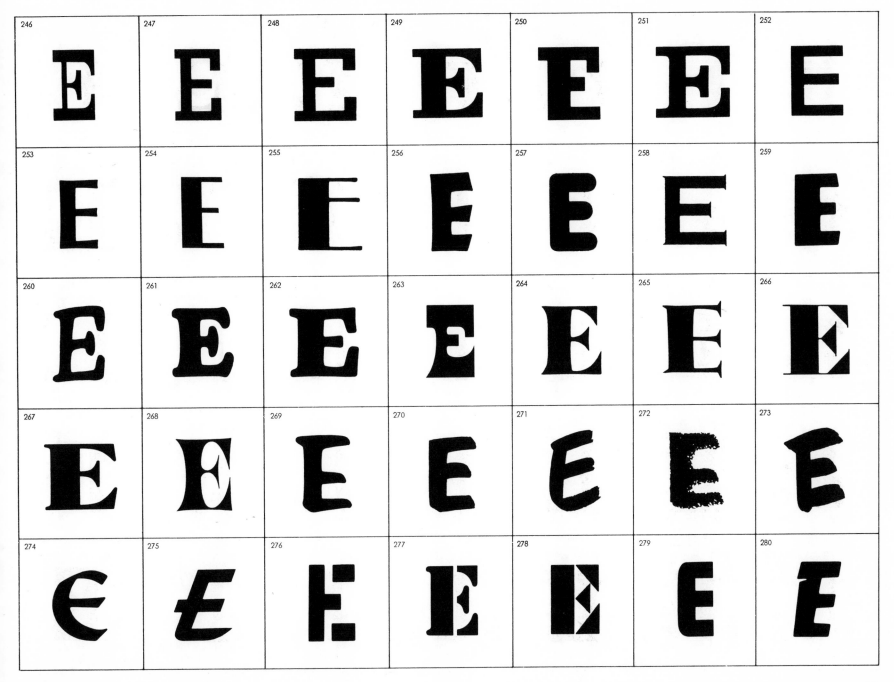

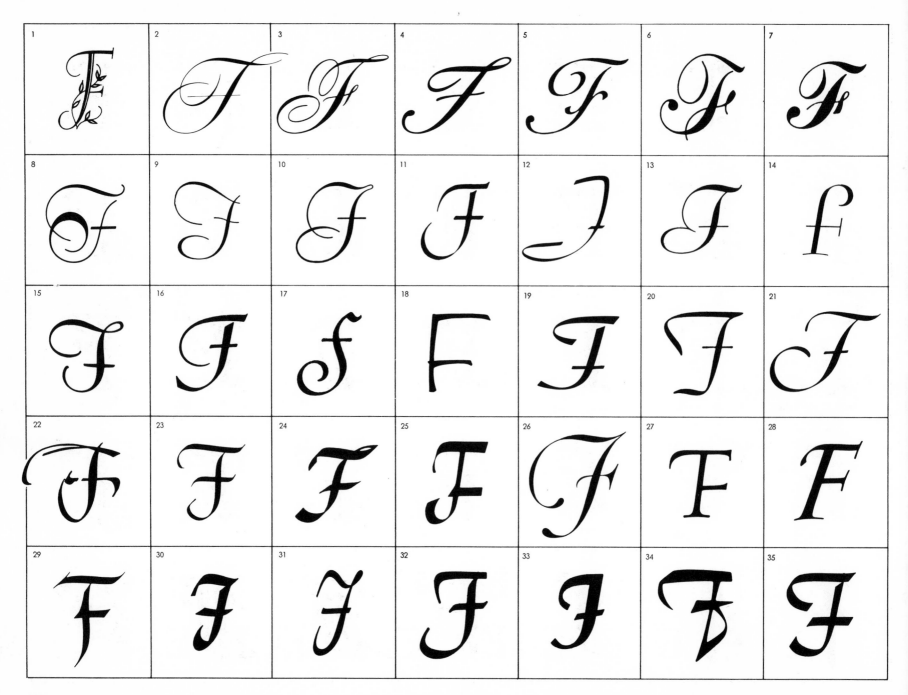

36	37	38	39	40	41	42
43	44	45	46	47	48	49
50	51	52	53	54	55	56
57	58	59	60	61	62	63
64	65	66	67	68	69	70

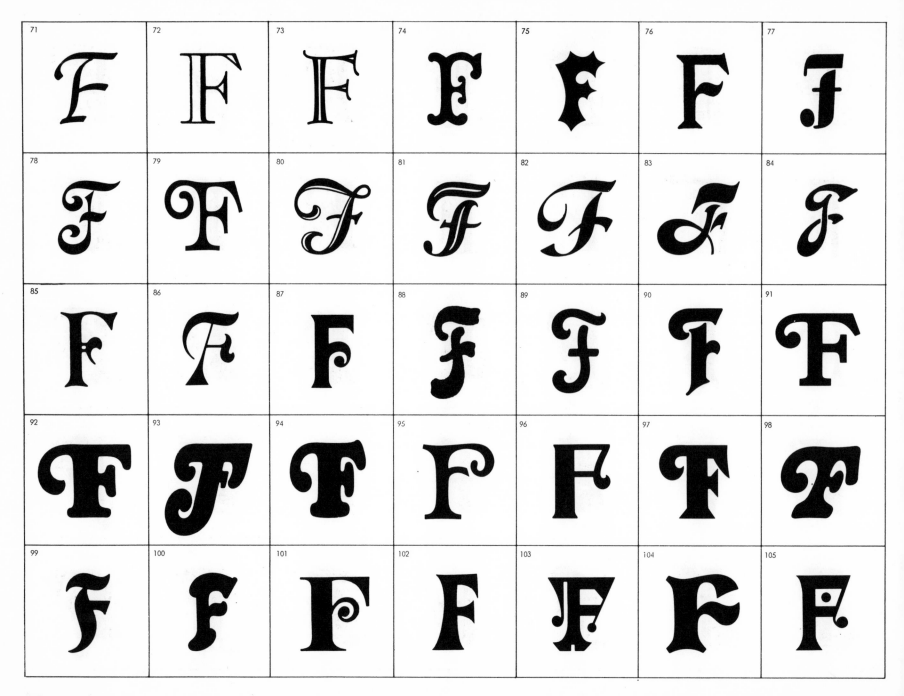

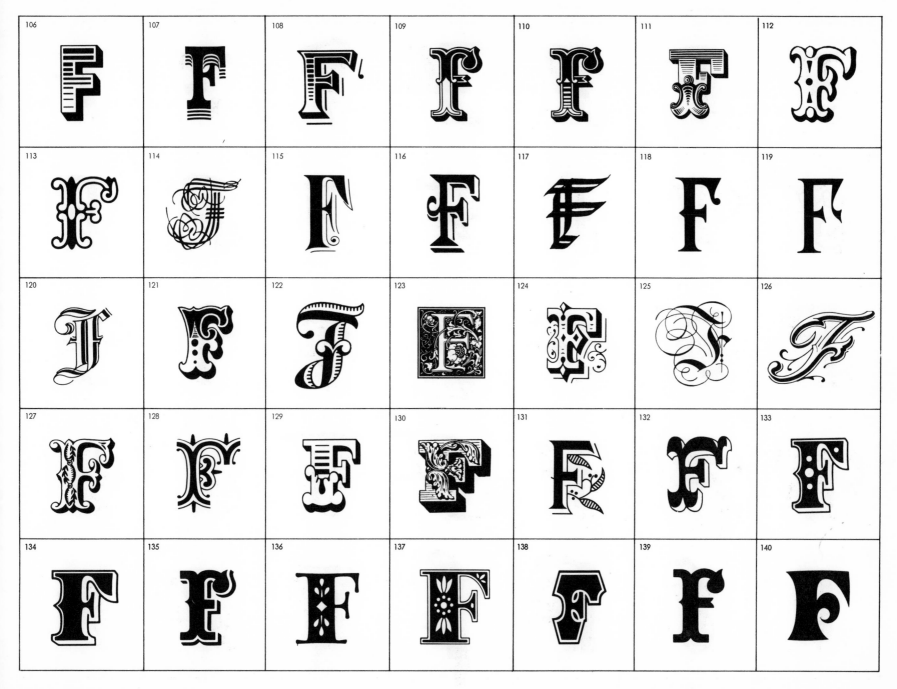

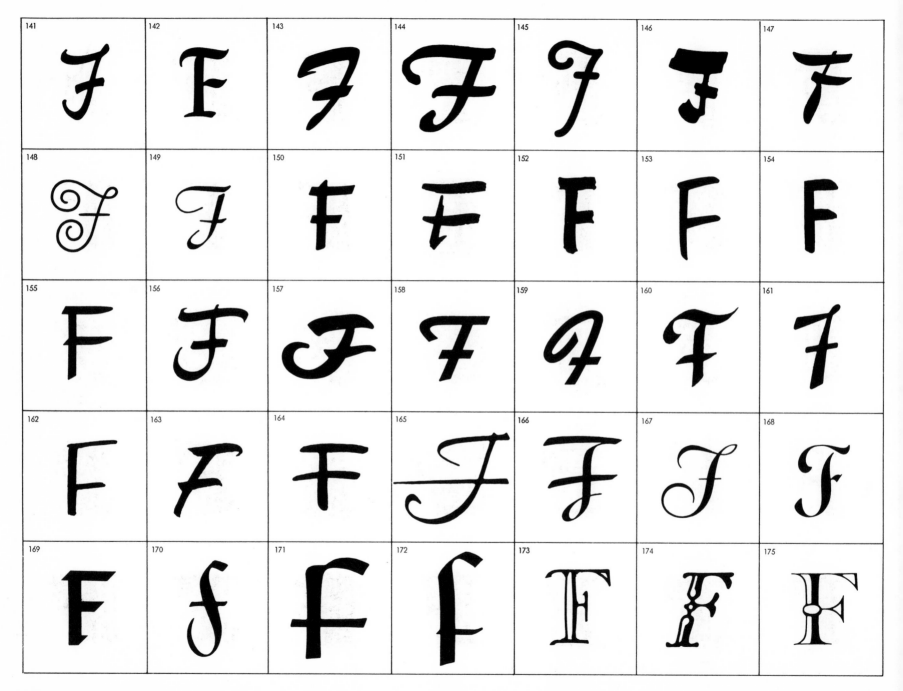

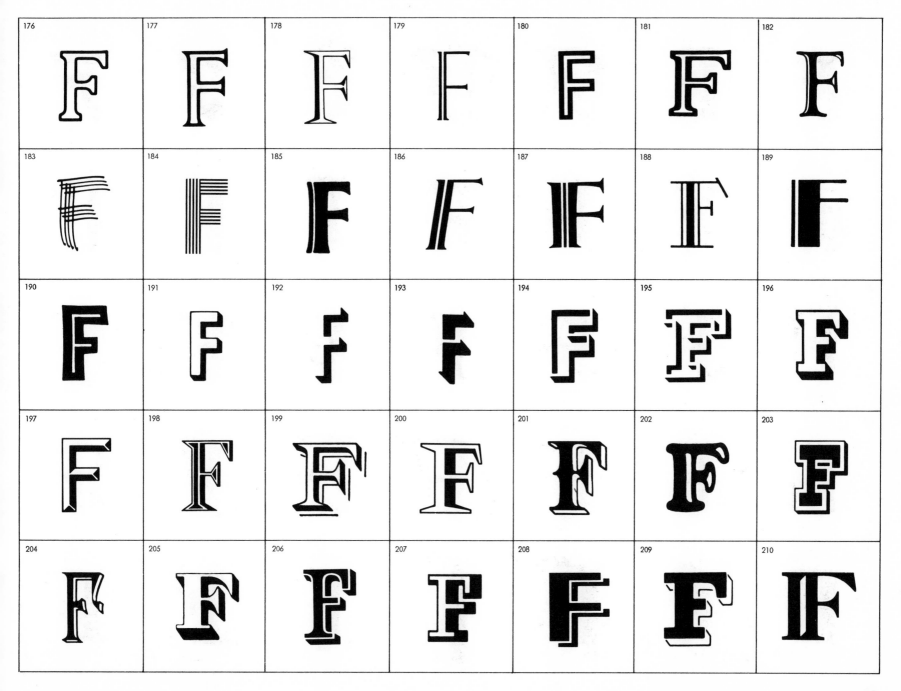

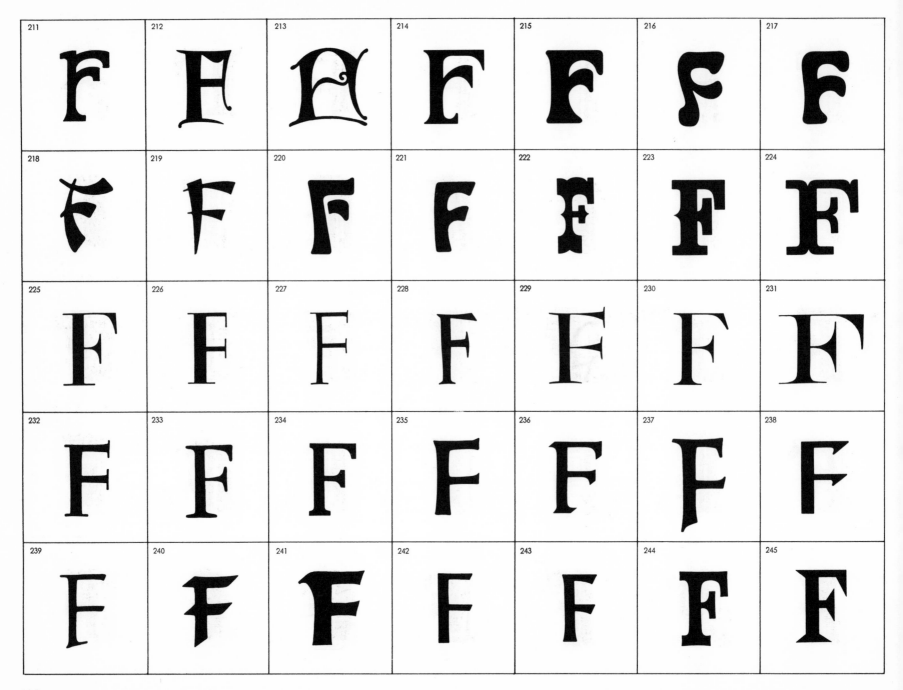

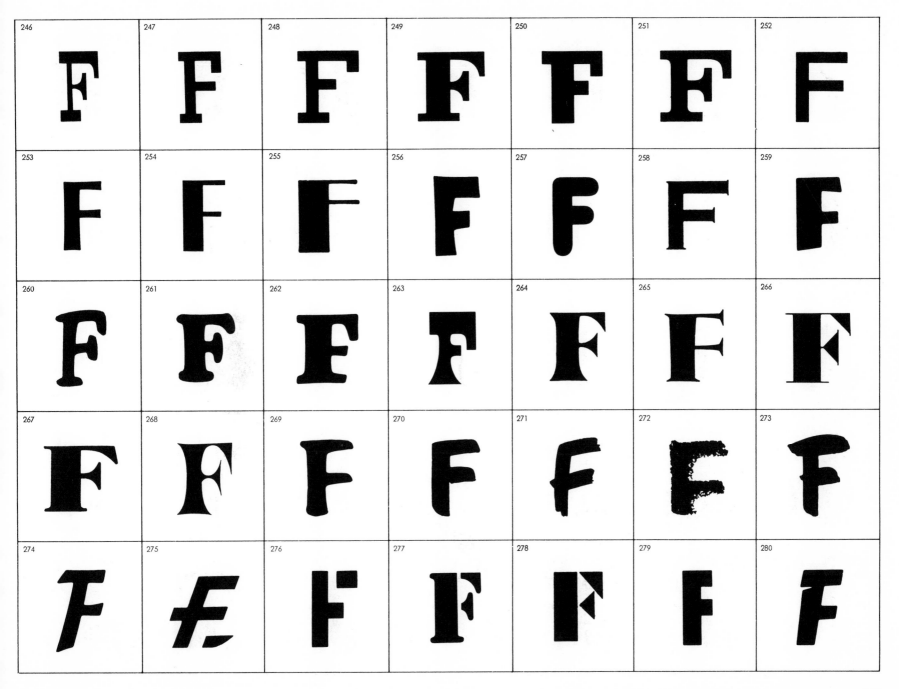

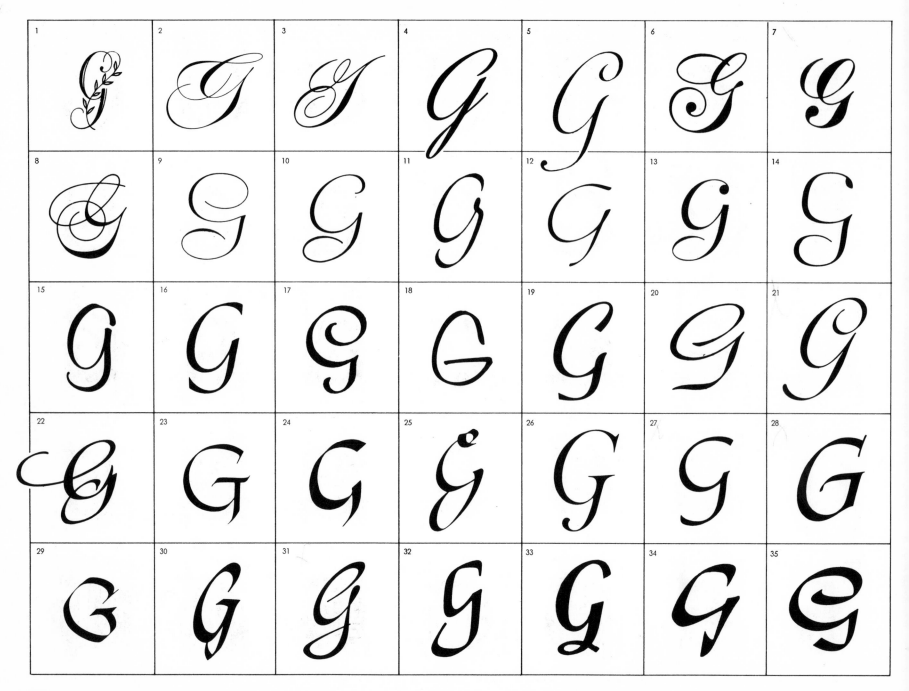

36	37	38	39	40	41	42
43	44	45	46	47	48	49
50	51	52	53	54	55	56
57	58	59	60	61	62	63
64	65	66	67	68	69	70

71 72 73 74 75 76 77
78 79 80 81 82 83 84
85 86 87 88 89 90 91
92 93 94 95 96 97 98
99 100 101 102 103 104 105

64

106	107	108	109	110	111	112
113	114	115	116	117	118	119
120	121	122	123	124	125	126
127	128	129	130	131	132	133
134	135	136	137	138	139	140

141 142 143 144 145 146 147
148 149 150 151 152 153 154
155 156 157 158 159 160 161
162 163 164 165 166 167 168
169 170 171 172 173 174 175

59233

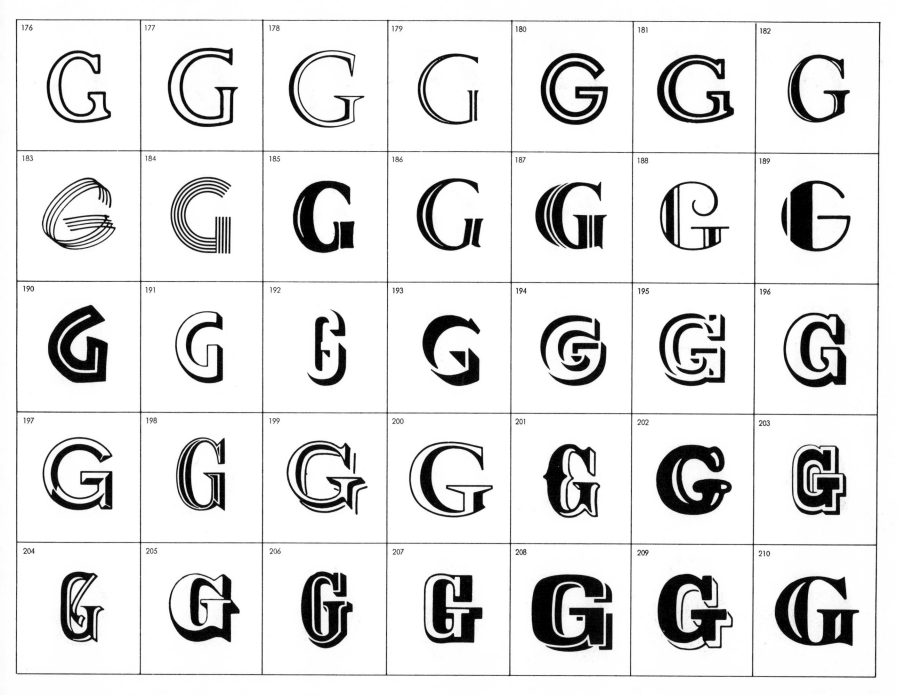

211 212 213 214 215 216 217
218 219 220 221 222 223 224
225 226 227 228 229 230 231
232 233 234 235 236 237 238
239 240 241 242 243 244 245

246	247	248	249	250	251	252
G	G	G	G	G	G	G

253	254	255	256	257	258	259
G	G	G	G	G	G	G

260	261	262	263	264	265	266
G	G	G	G	G	G	G

267	268	269	270	271	272	273
G	G	G	G	G	G	G

274	275	276	277	278	279	280
G	G	G	G	G	G	G

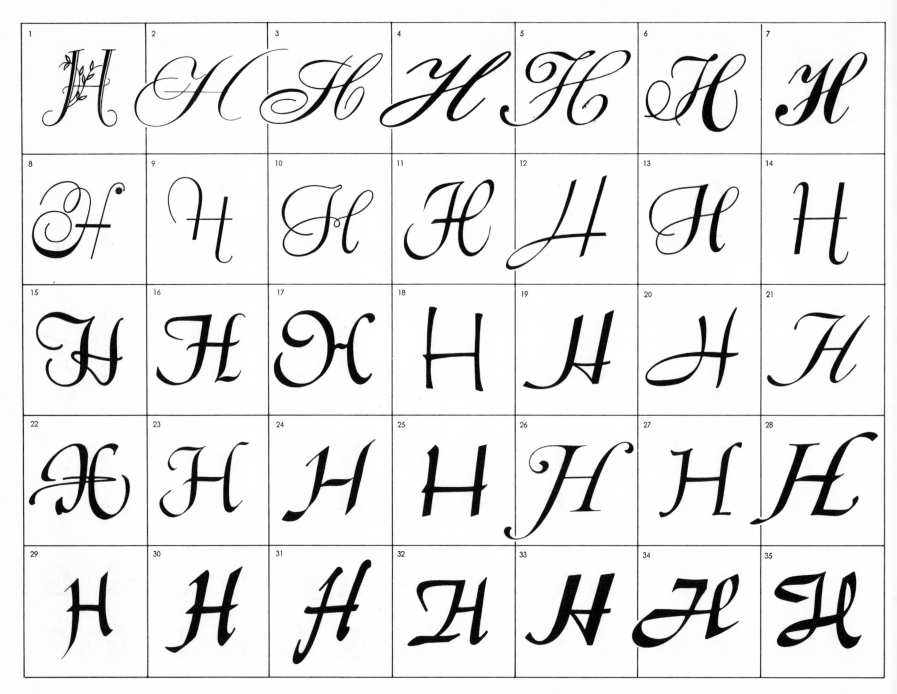

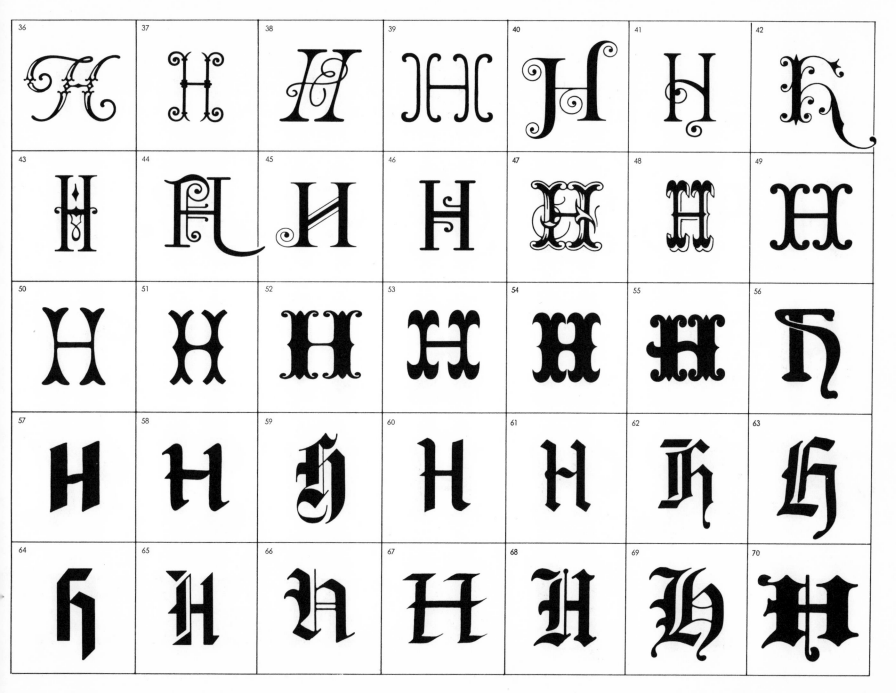

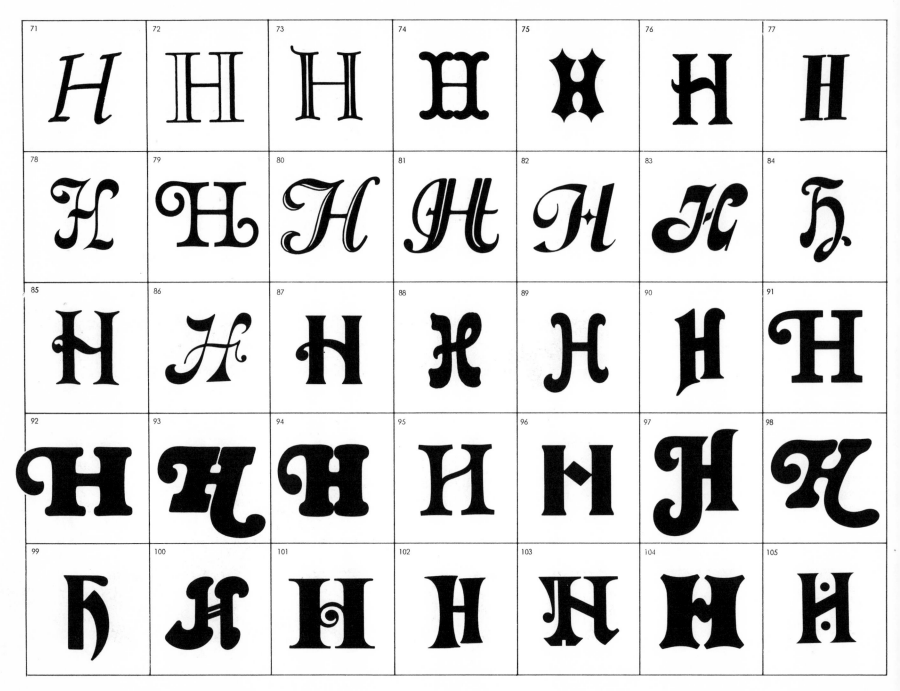

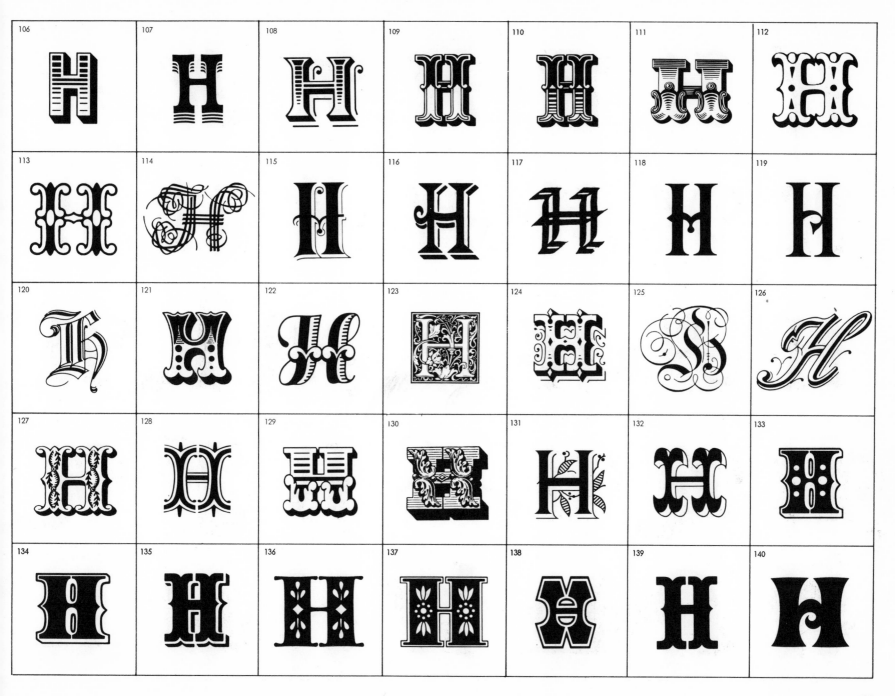

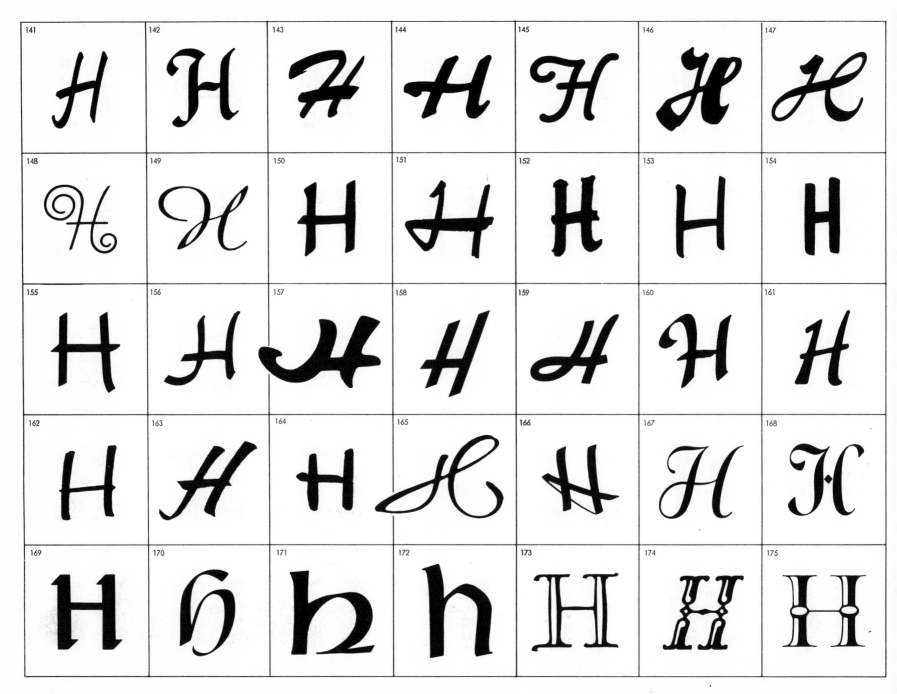

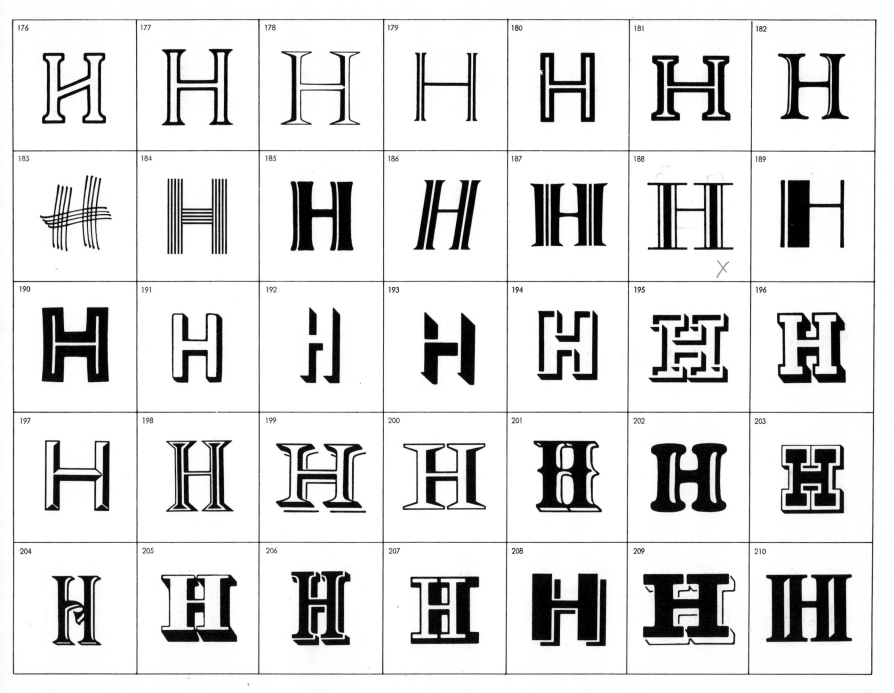

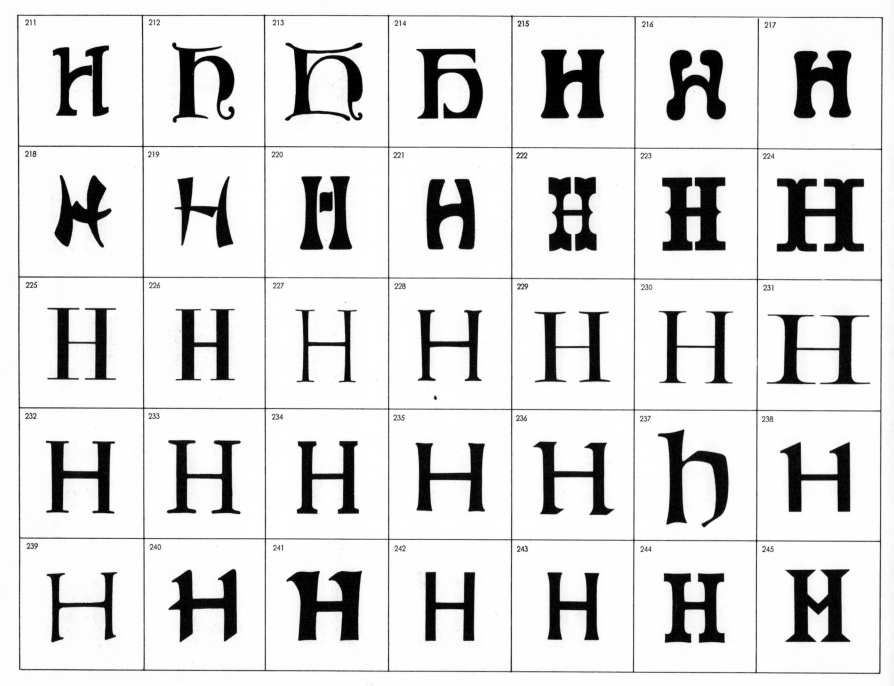

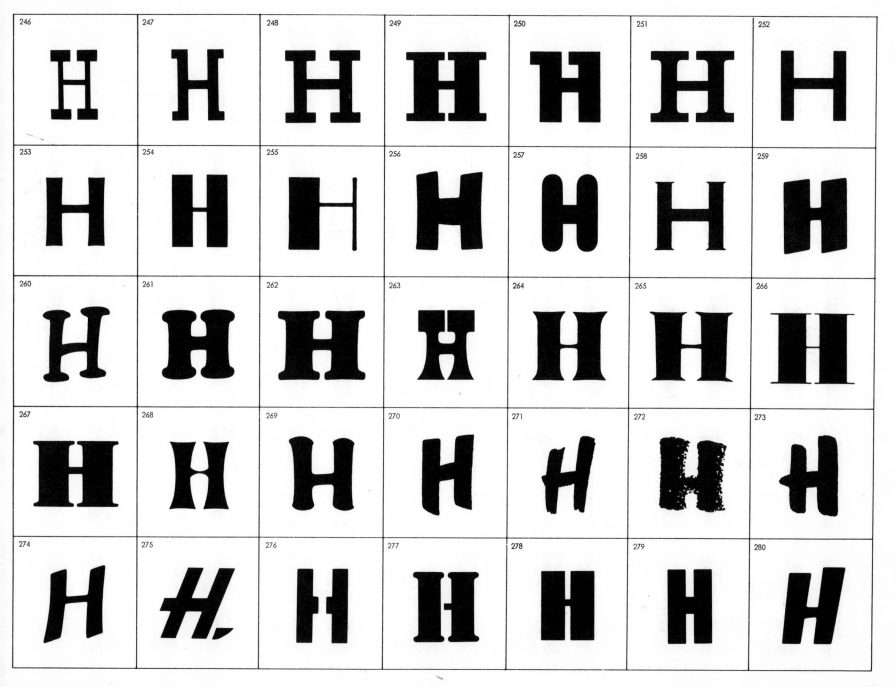

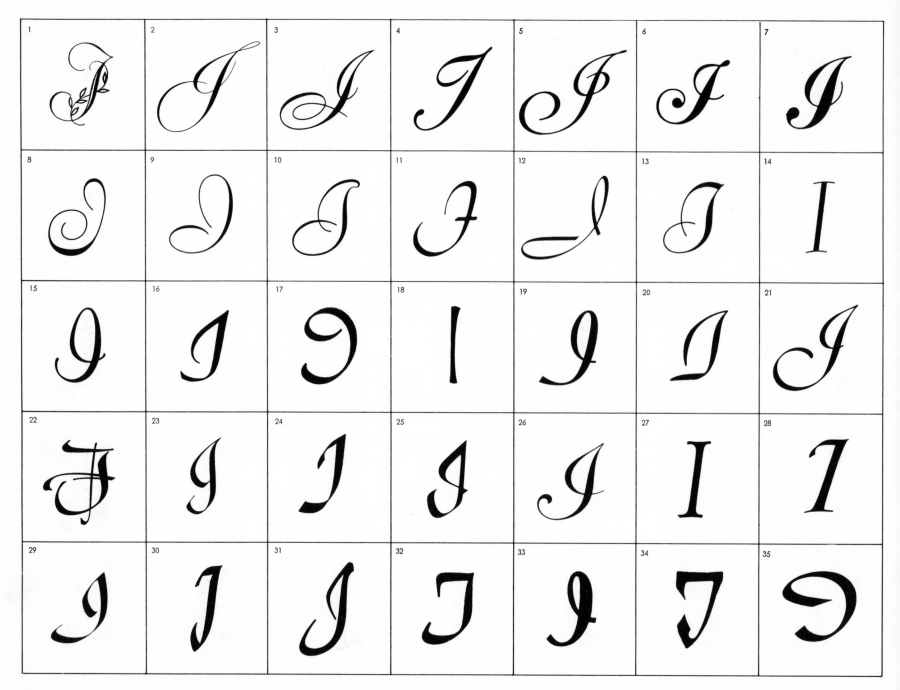

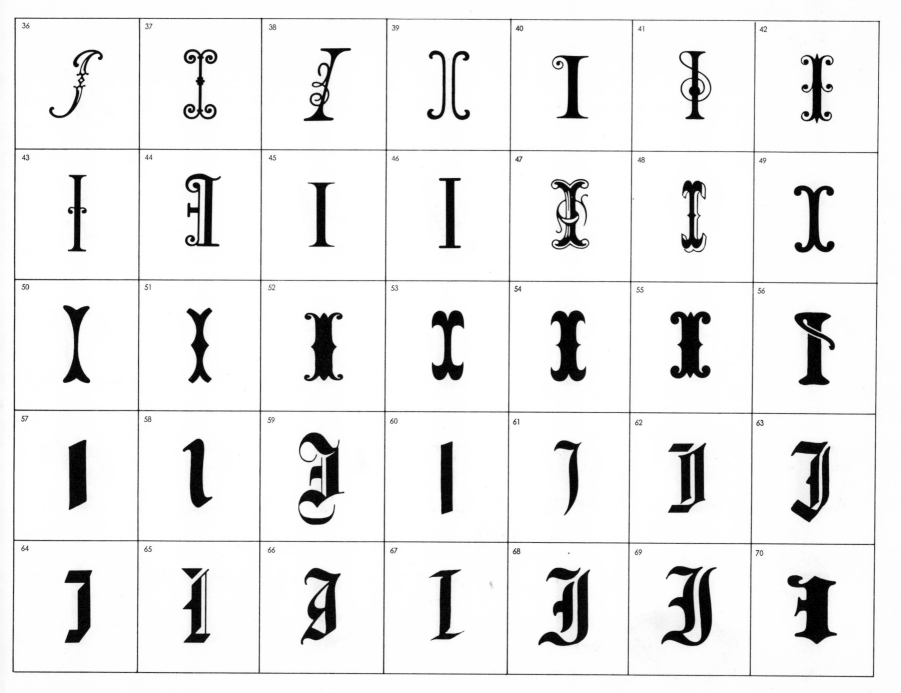

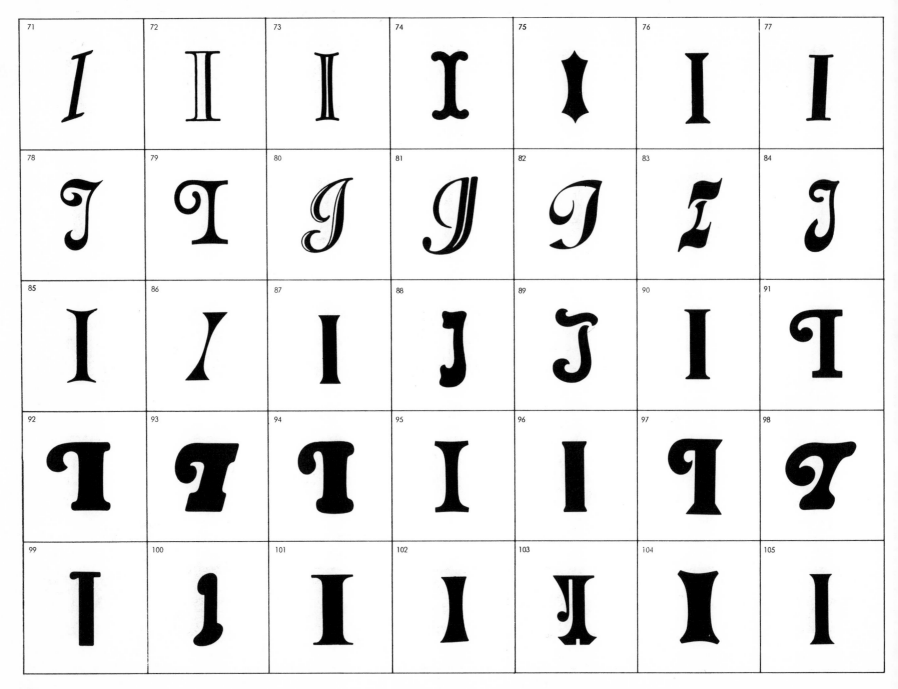

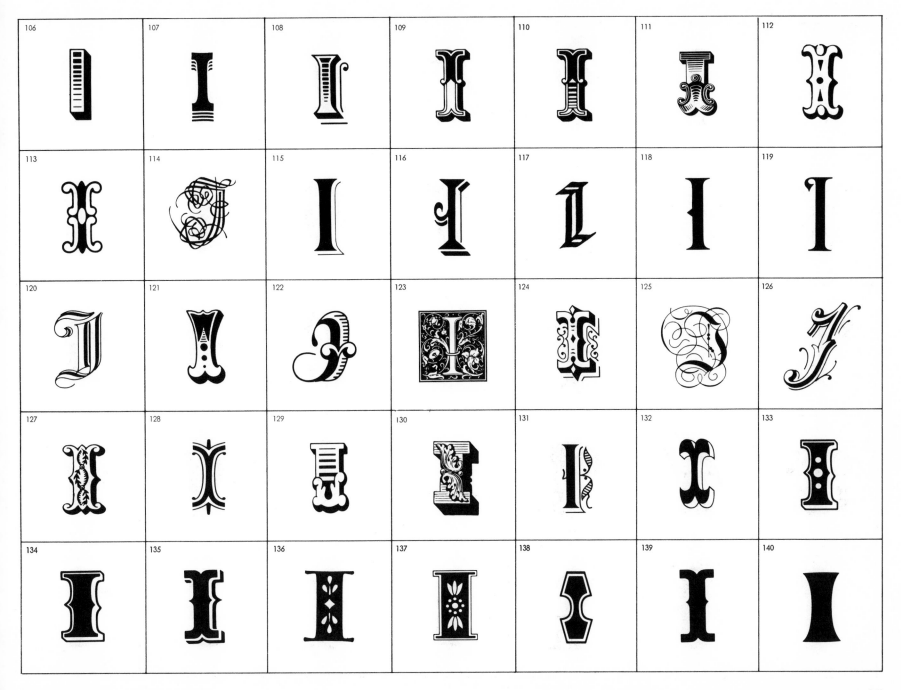

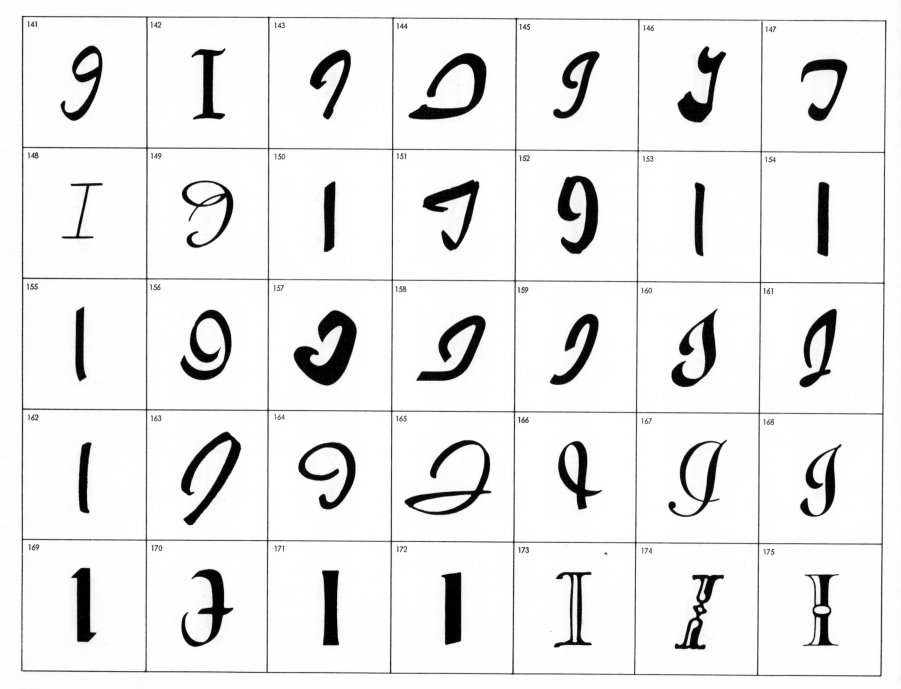

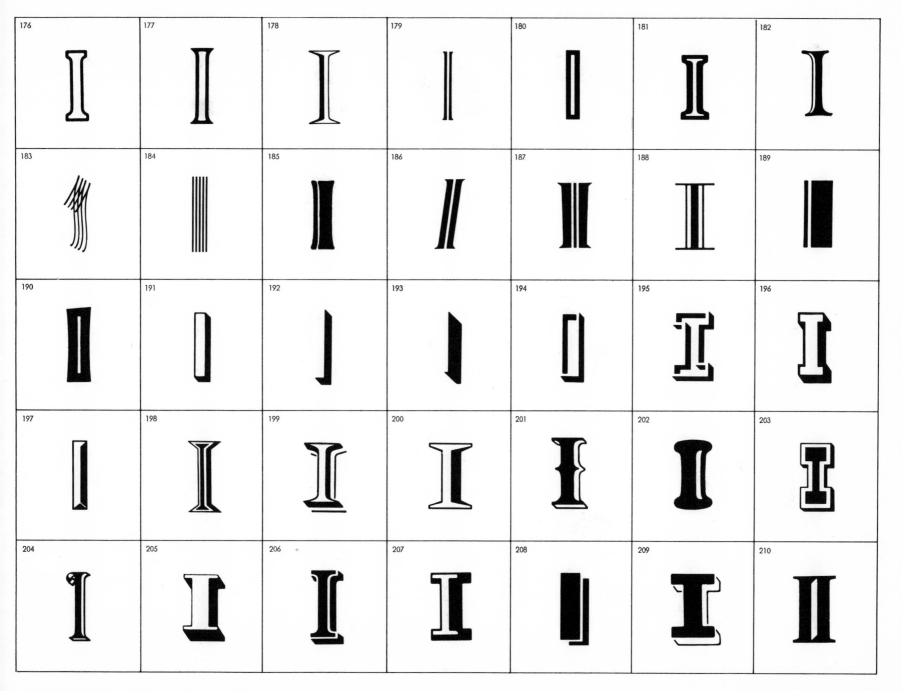

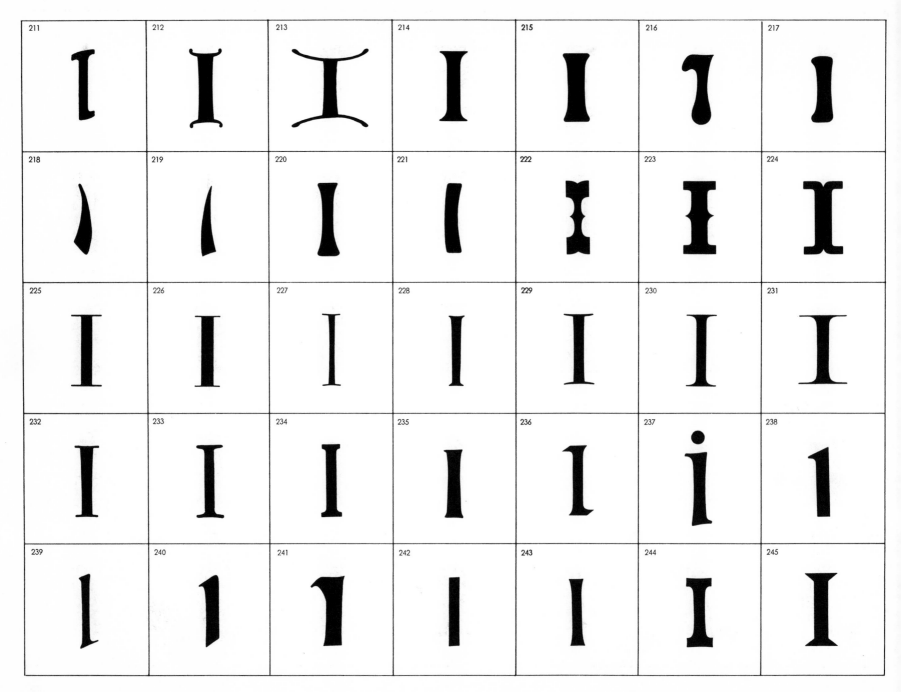

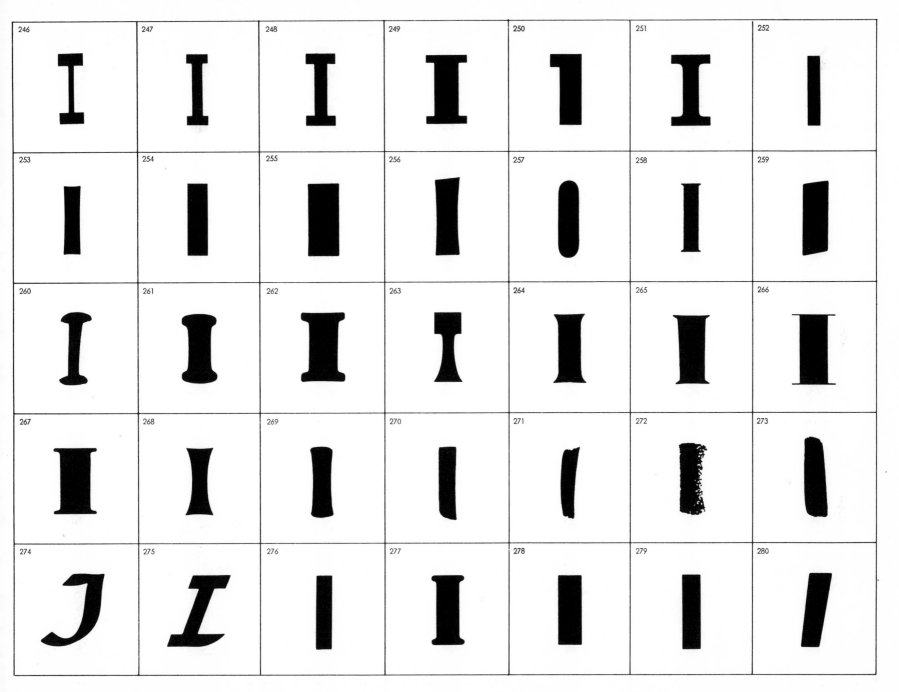

89

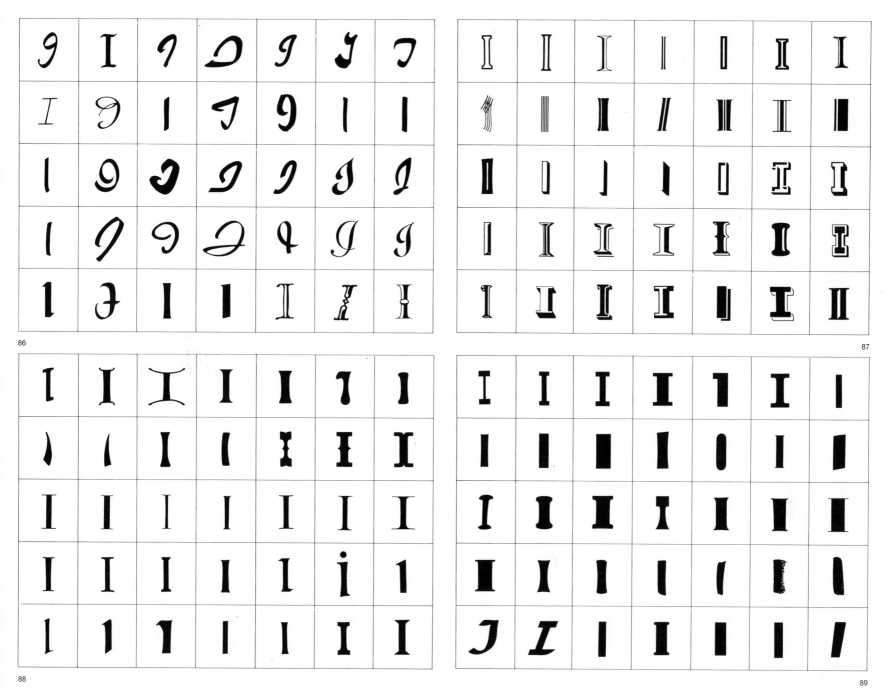

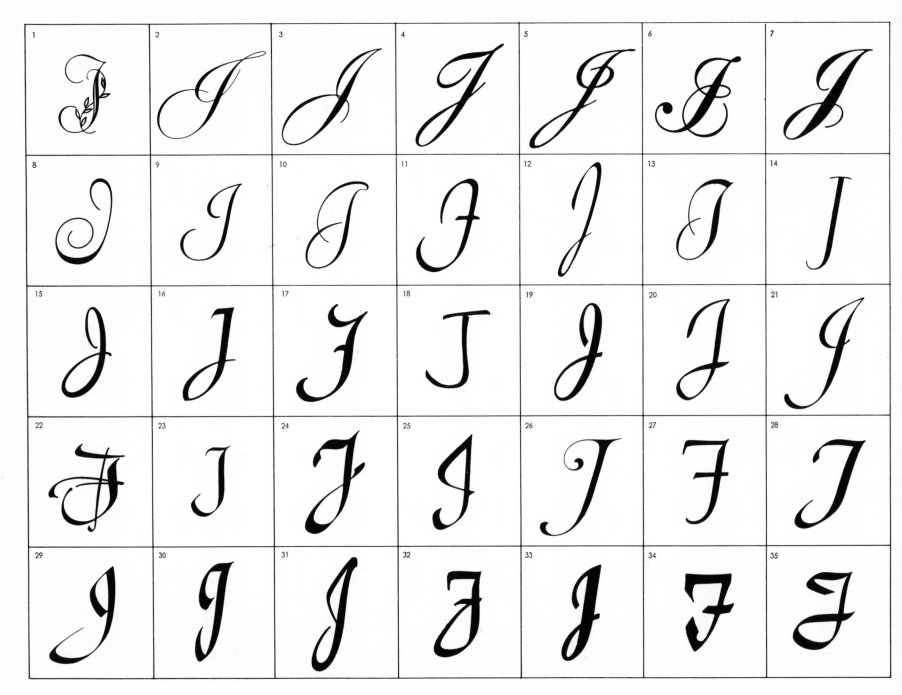

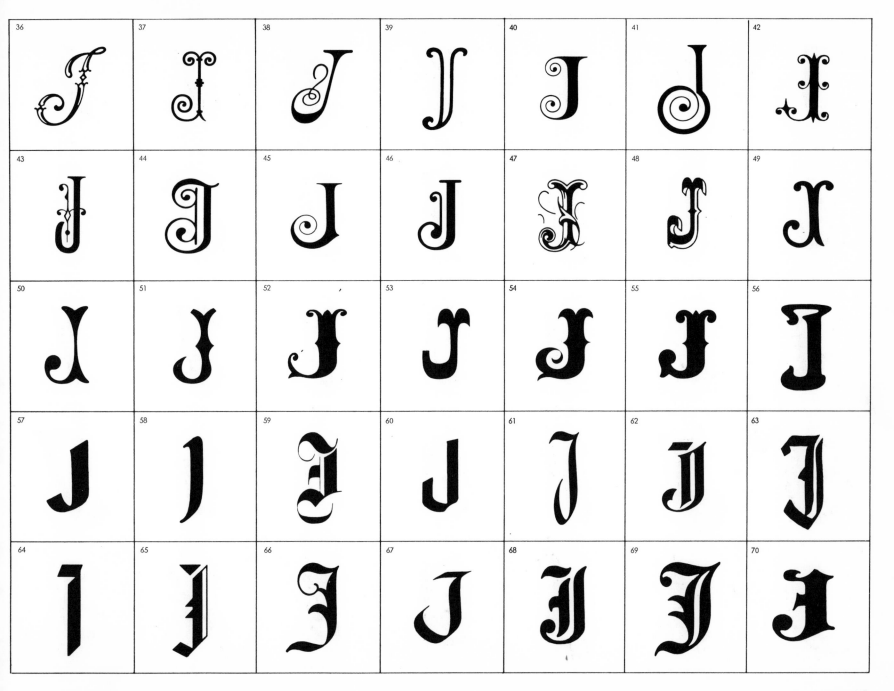

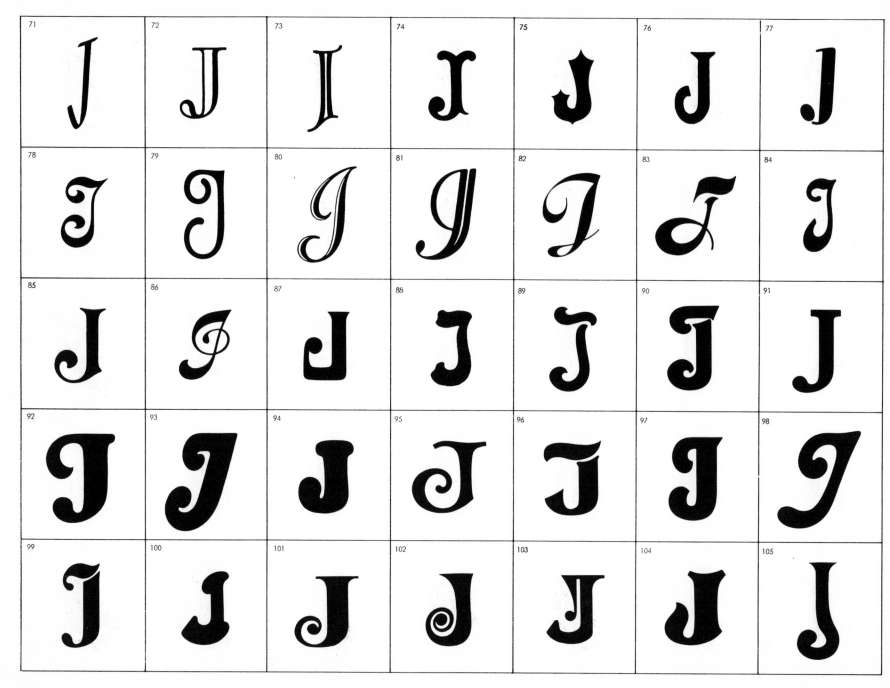

106	107	108	109	110	111	112
113	114	115	116	117	118	119
120	121	122	123	124	125	126
127	128	129	130	131	132	133
134	135	136	137	138	139	140

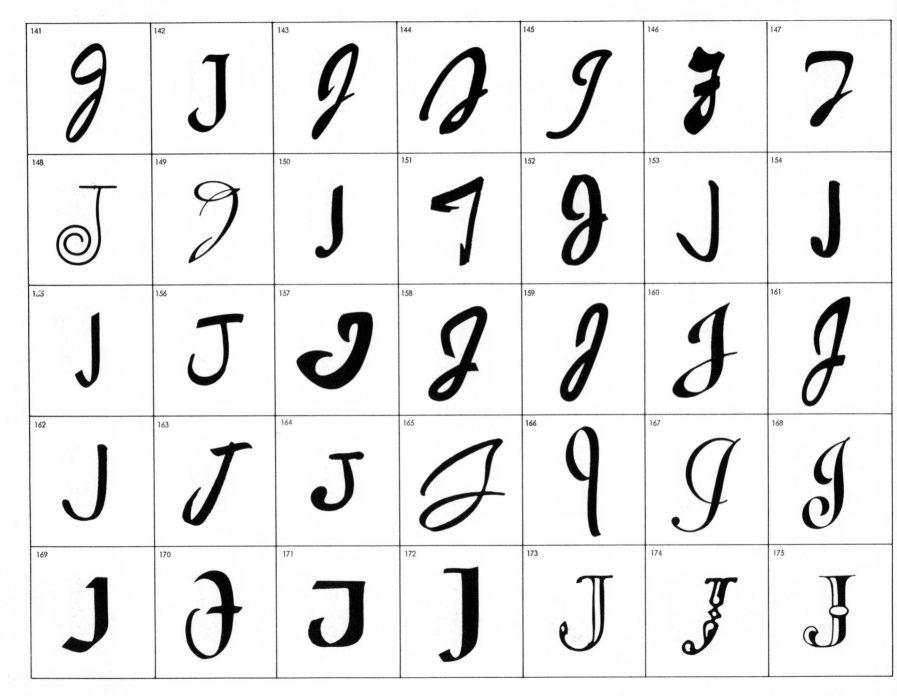

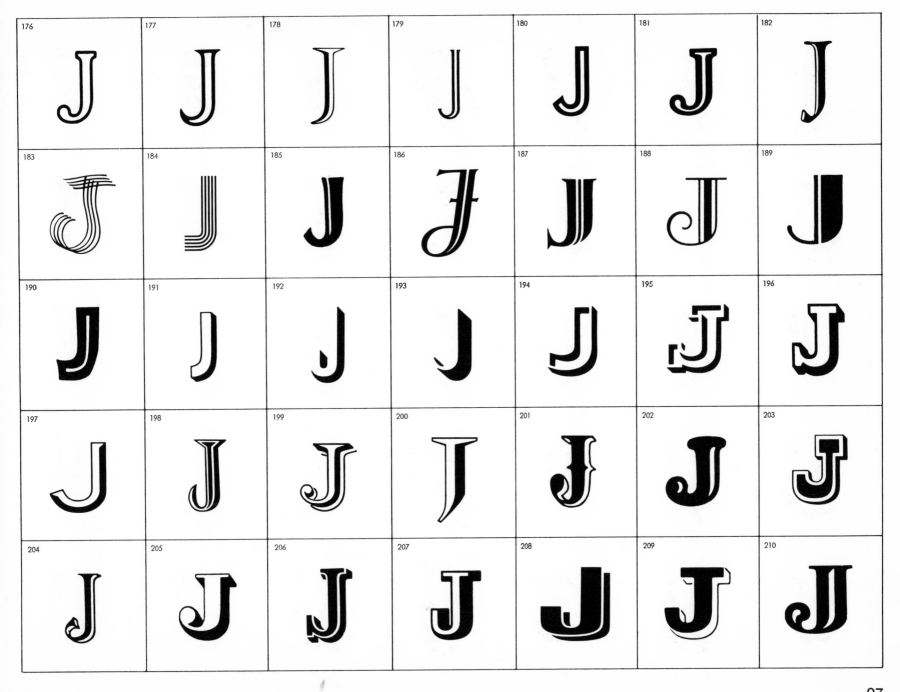

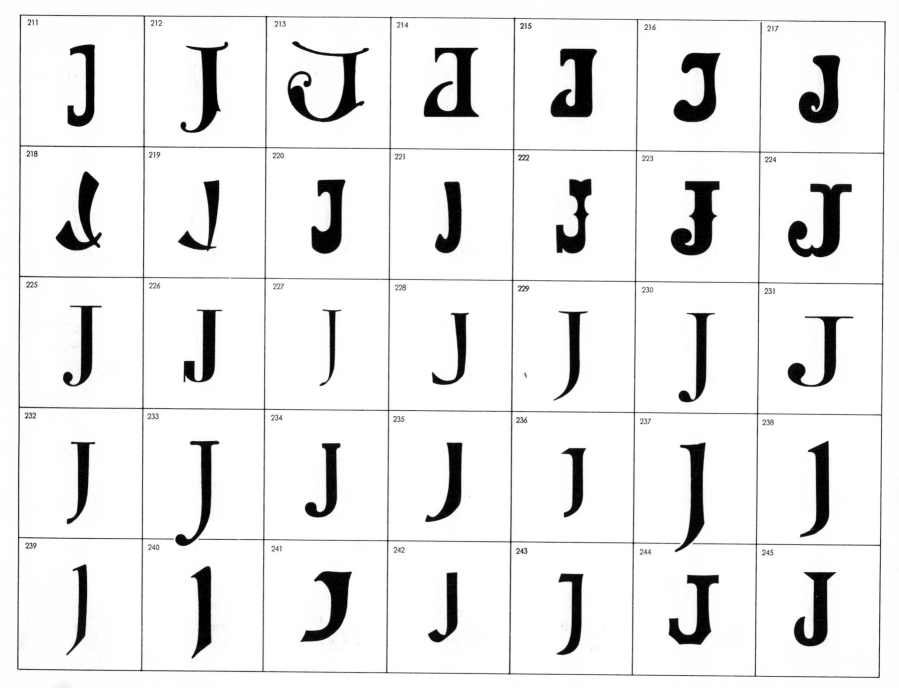

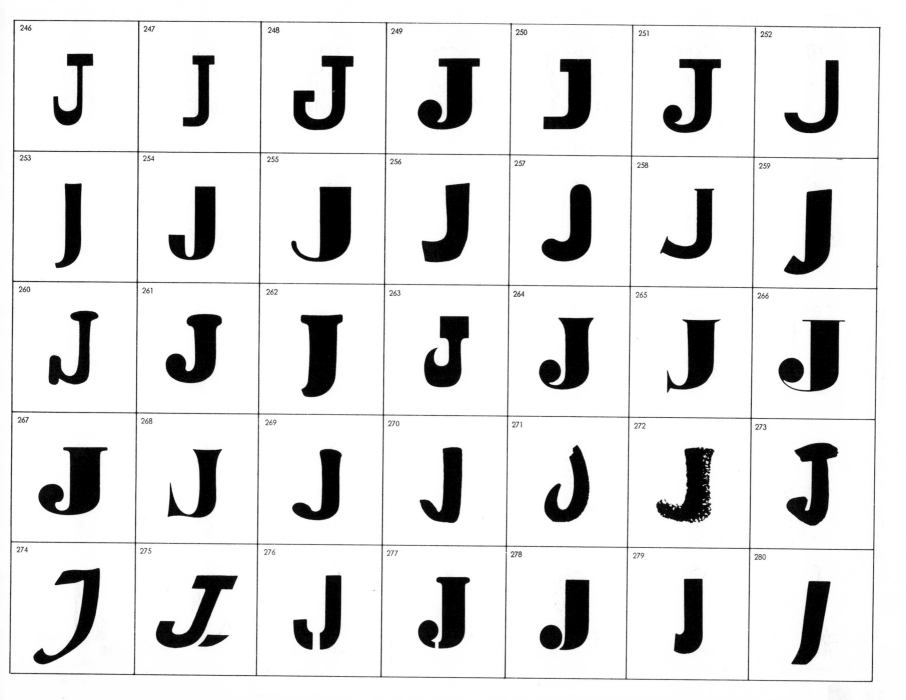

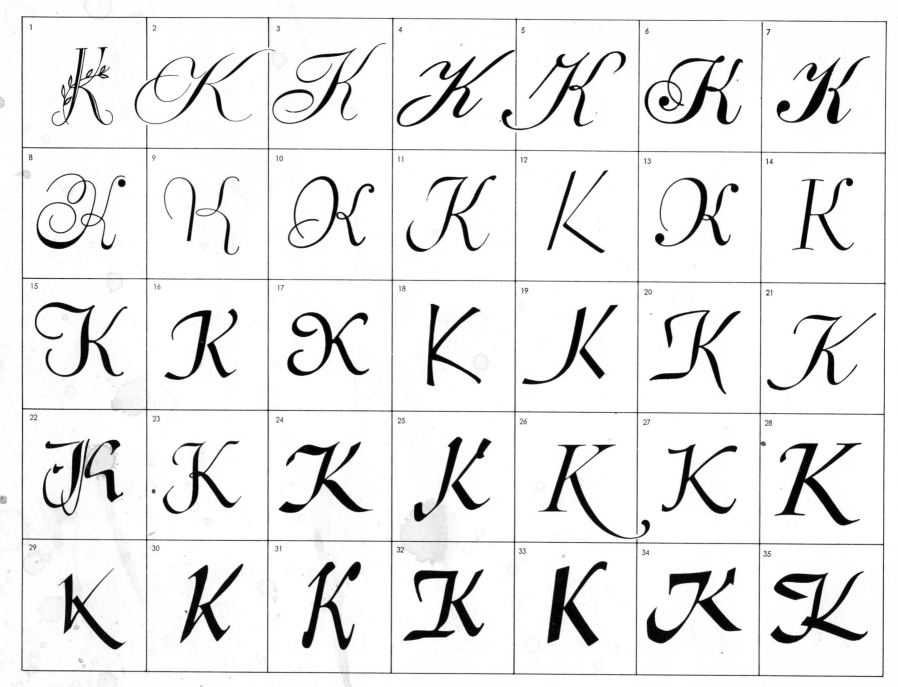

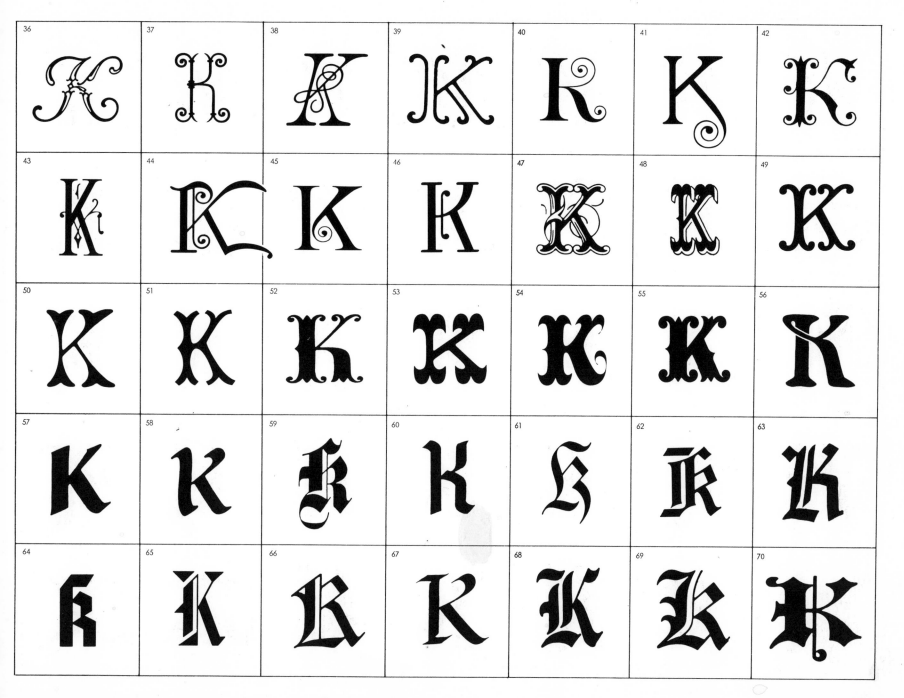

103

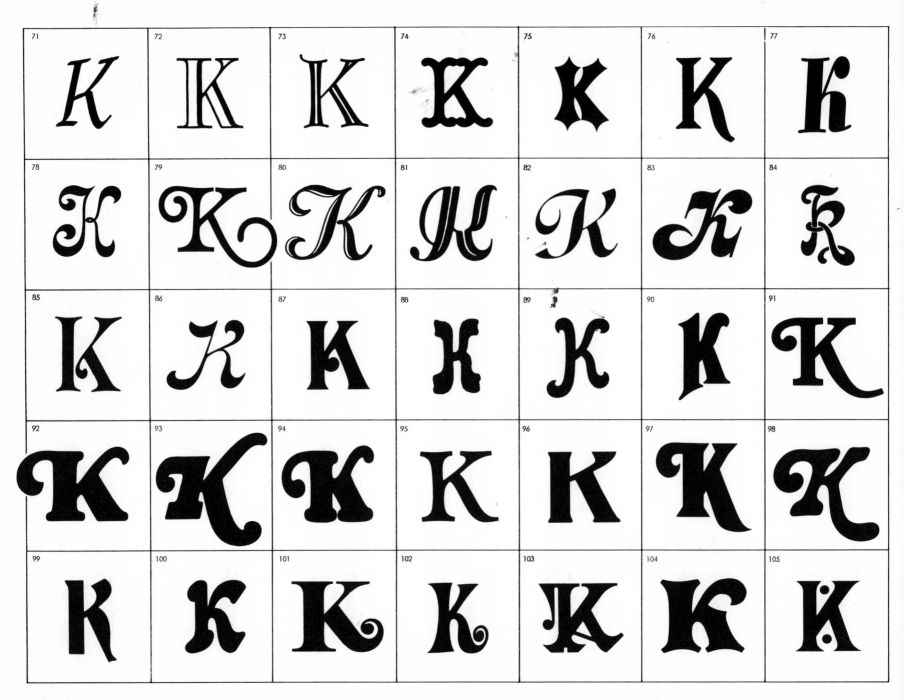

104

106	107	108	109	110	111	112
113	114	115	116	117	118	119
120	121	122	123	124	125	126
127	128	129	130	131	132	133
134	135	136	137	138	139	140

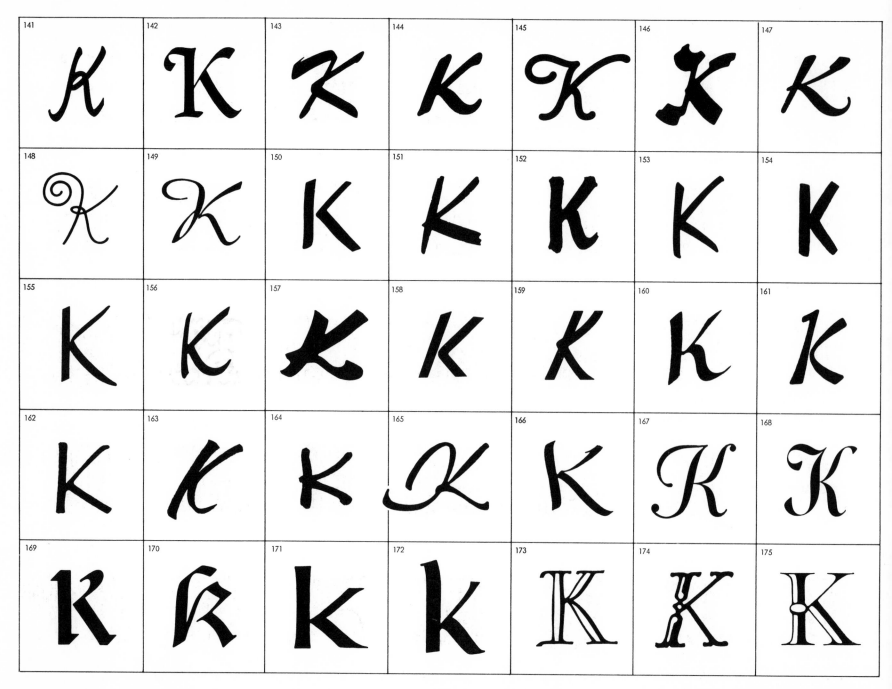

176 177 178 179 180 181 182
183 184 185 186 187 188 189
190 191 192 193 194 195 196
197 198 199 200 201 202 203
204 205 206 207 208 209 210

211	212	213	214	215	216	217
218	219	220	221	222	223	224
225	226	227	228	229	230	231
232	233	234	235	236	237	238
239	240	241	242	243	244	245

246	247	248	249	250	251	252
K	K	K	K	K	K	K

253	254	255	256	257	258	259
K	K	K	K	K	K	K

260	261	262	263	264	265	266
K	K	K	K	K	K	K

267	268	269	270	271	272	273
K	K	K	K	K	K	K

274	275	276	277	278	279	280
K	K	K	K	K	K	K

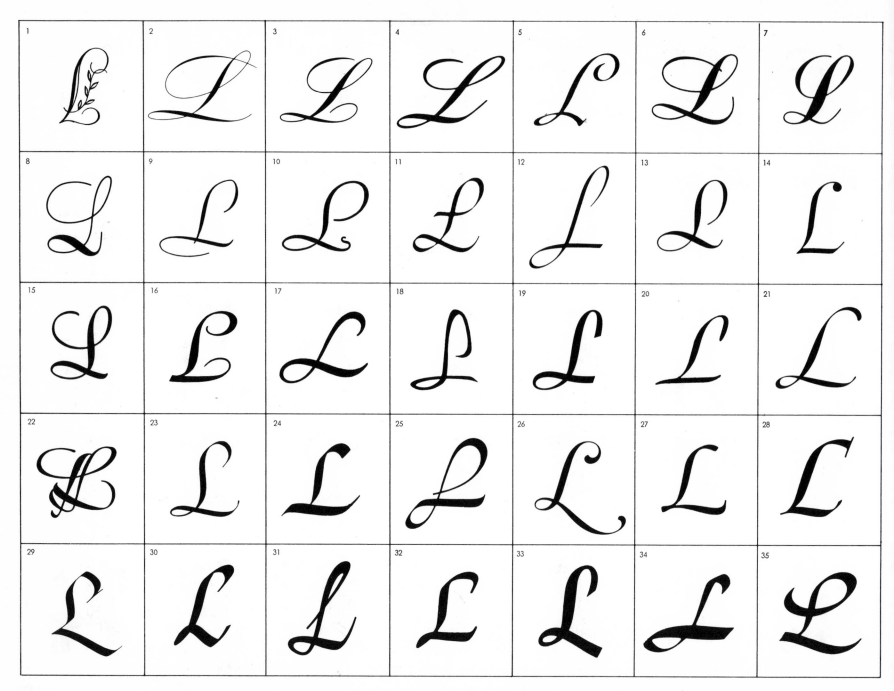

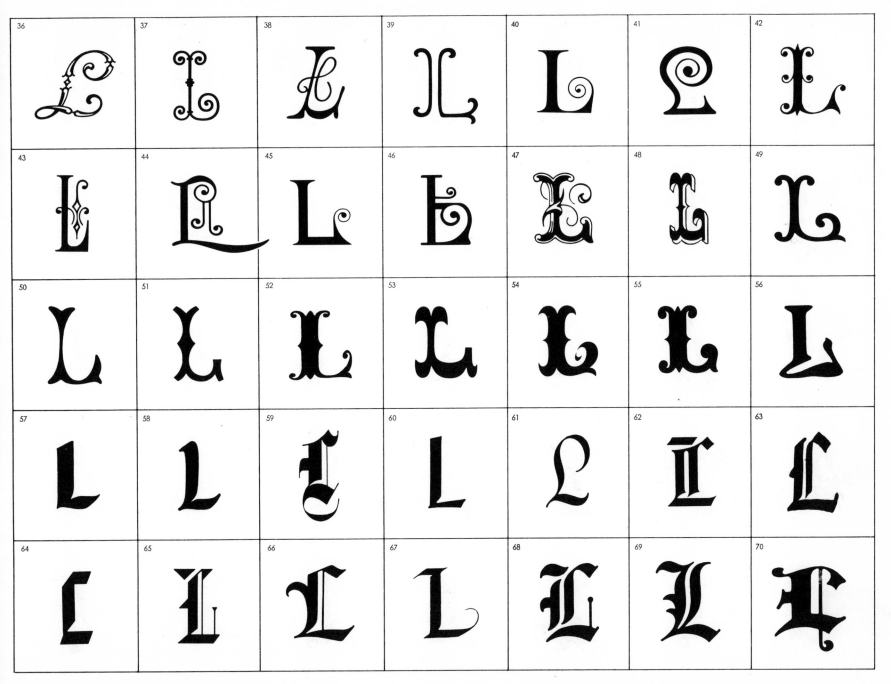

113

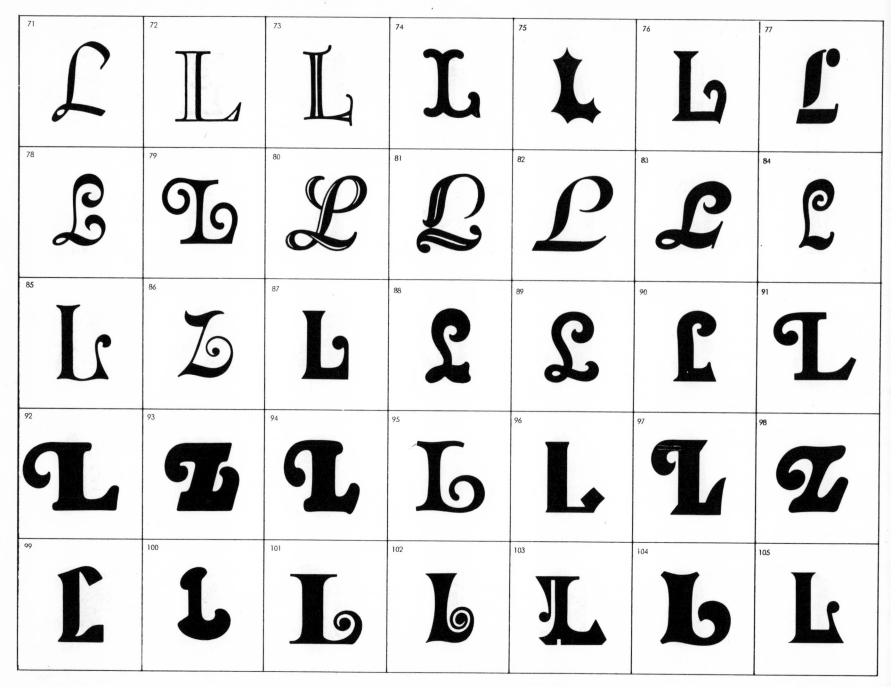

106	107	108	109	110	111	112
113	114	115	116	117	118	119
120	121	122	123	124	125	126
127	128	129	130	131	132	133
134	135	136	137	138	139	140

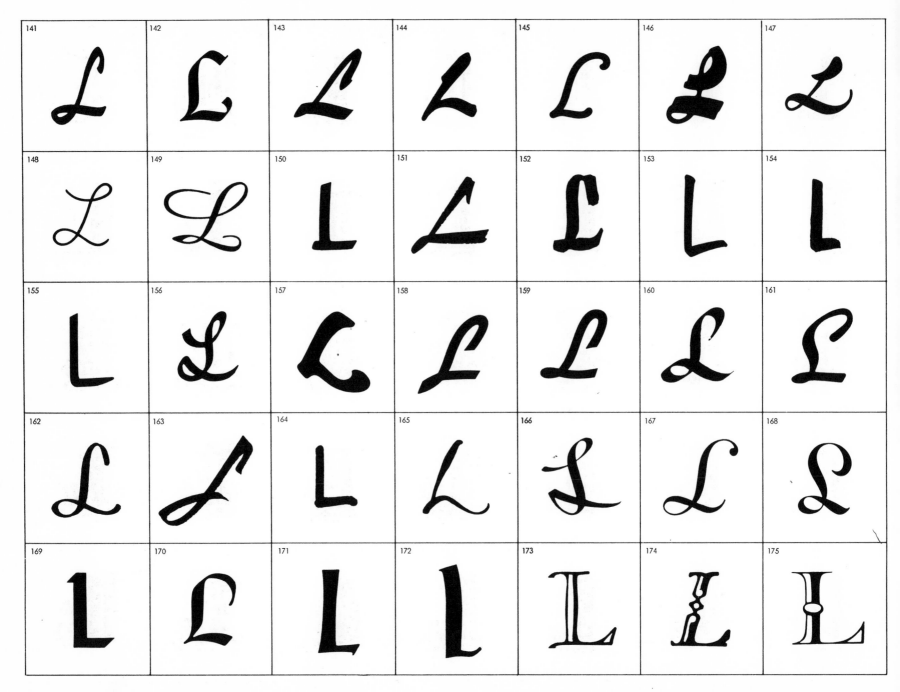

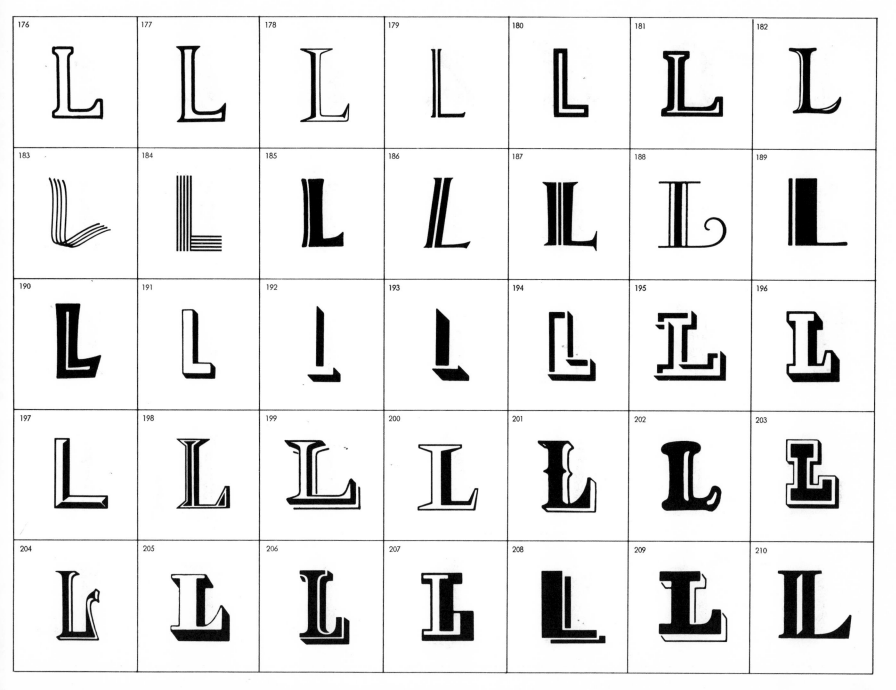

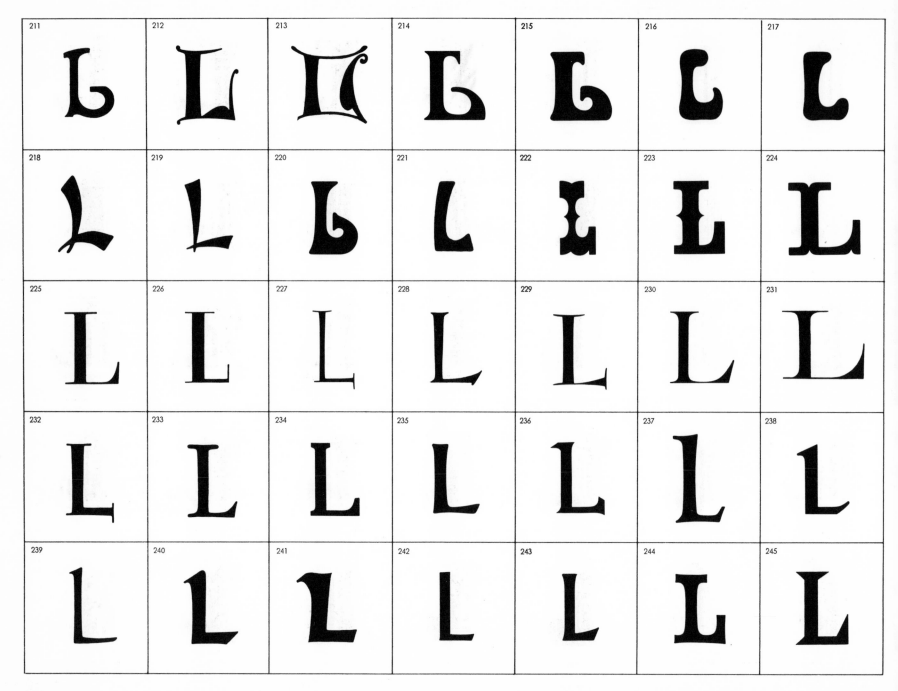

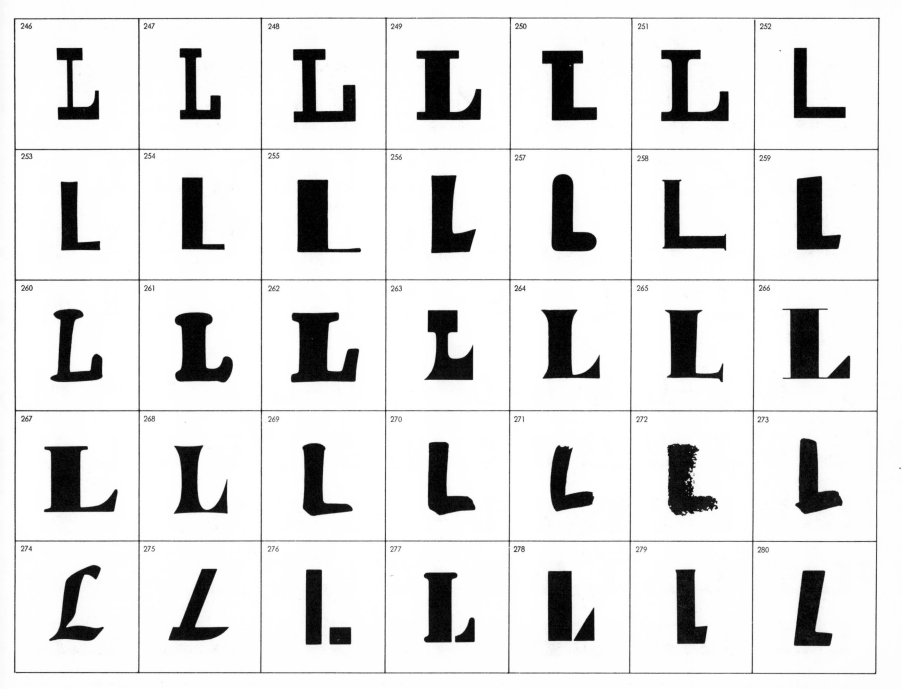

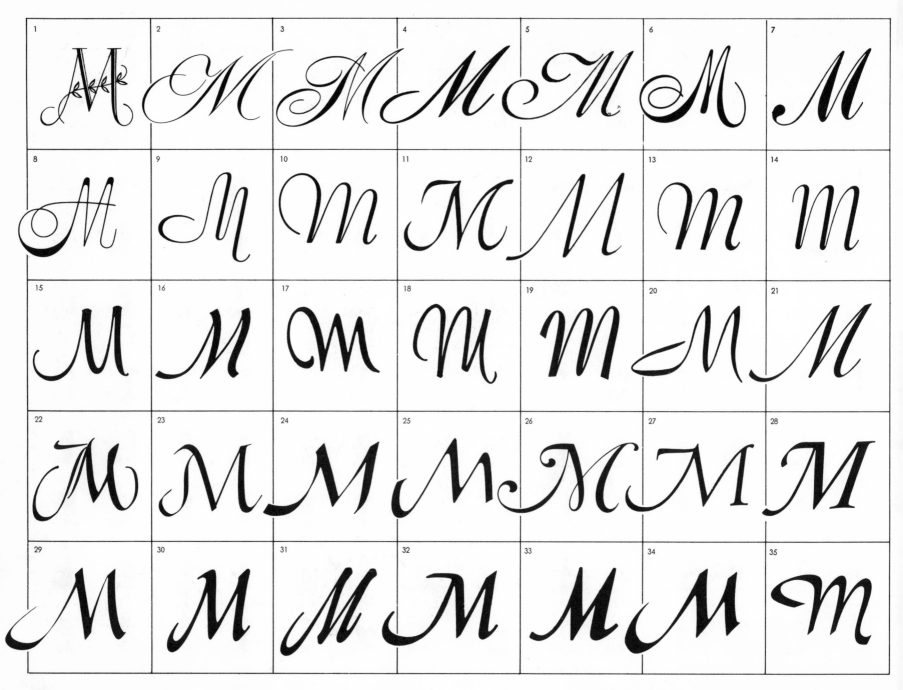

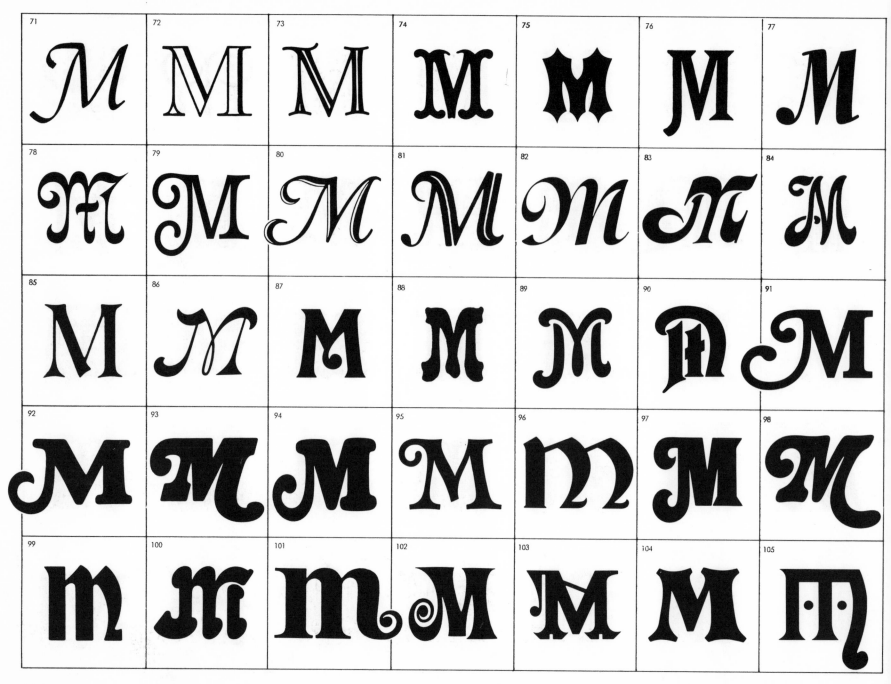

124

106	107	108	109	110	111	112
113	114	115	116	117	118	119
120	121	122	123	124	125	126
127	128	129	130	131	132	133
134	135	136	137	138	139	140

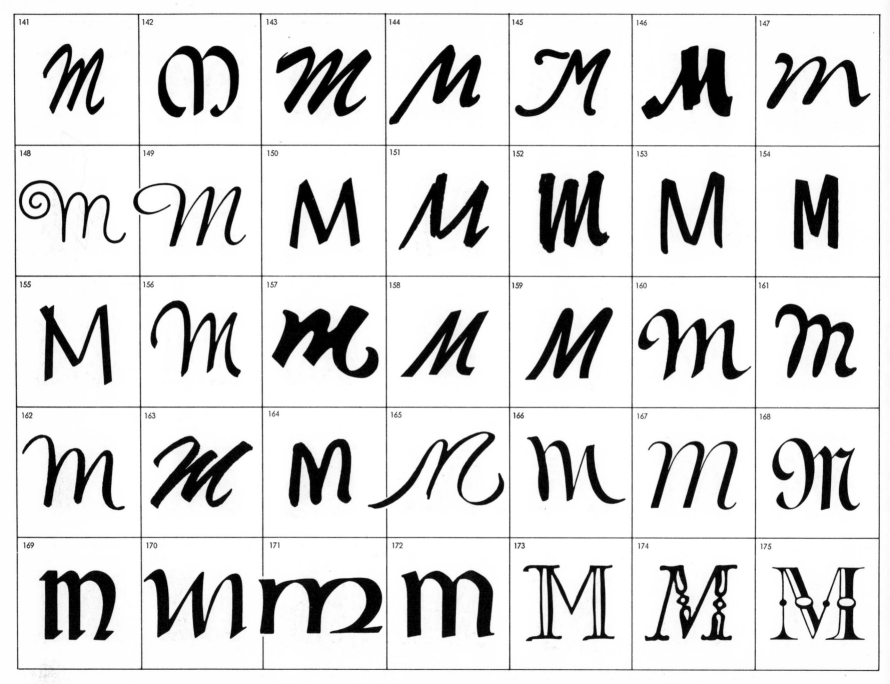

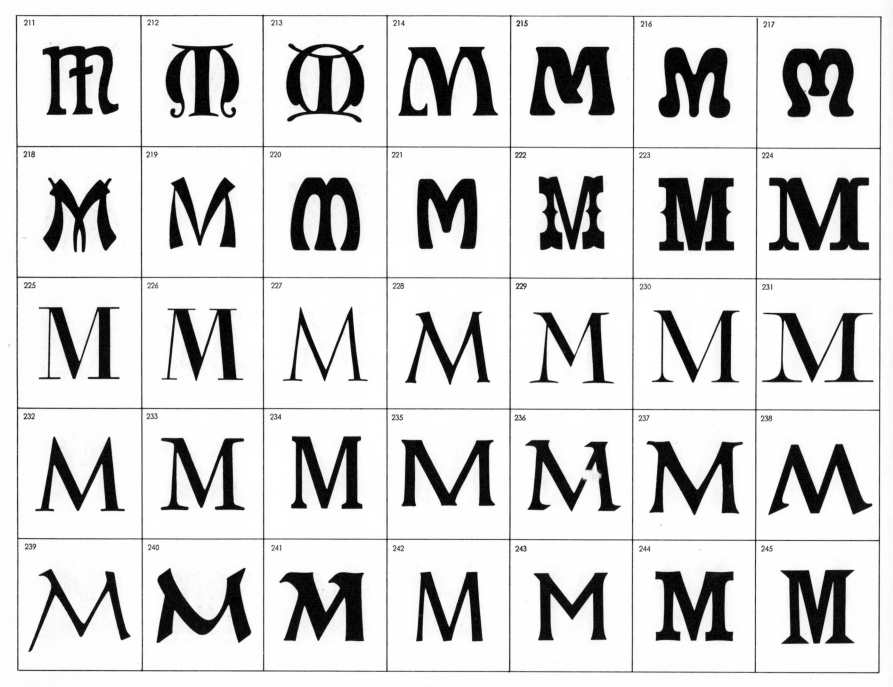

246	247	248	249	250	251	252
M	M	M	M	M	M	M

253	254	255	256	257	258	259
M	M	M	M	M	M	M

260	261	262	263	264	265	266
M	M	M	M	M	M	M

267	268	269	270	271	272	273
M	M	M	M	M	M	M

274	275	276	277	278	279	280
M	M	M	M	M	M	M

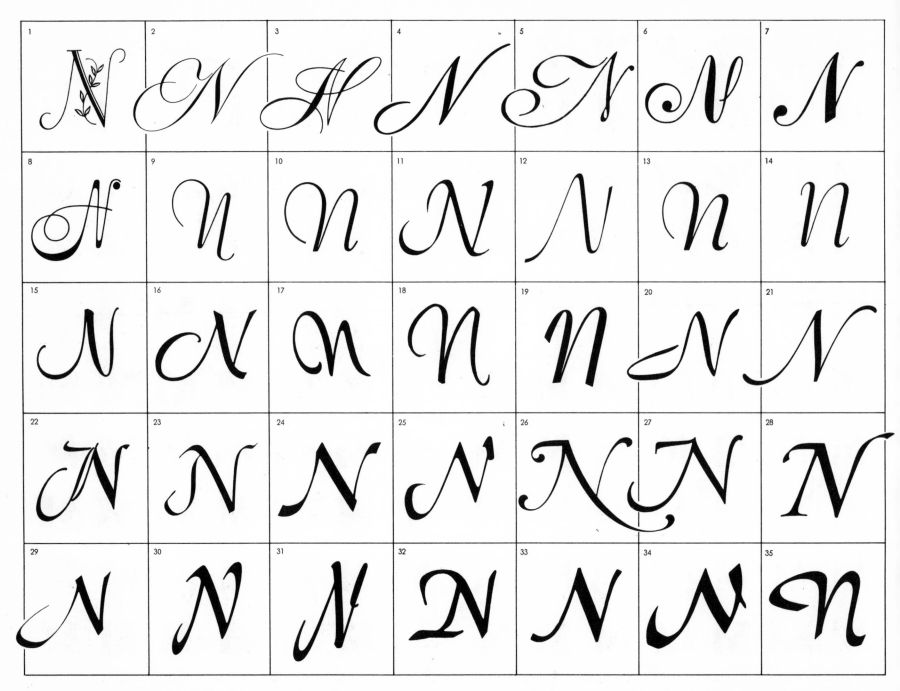

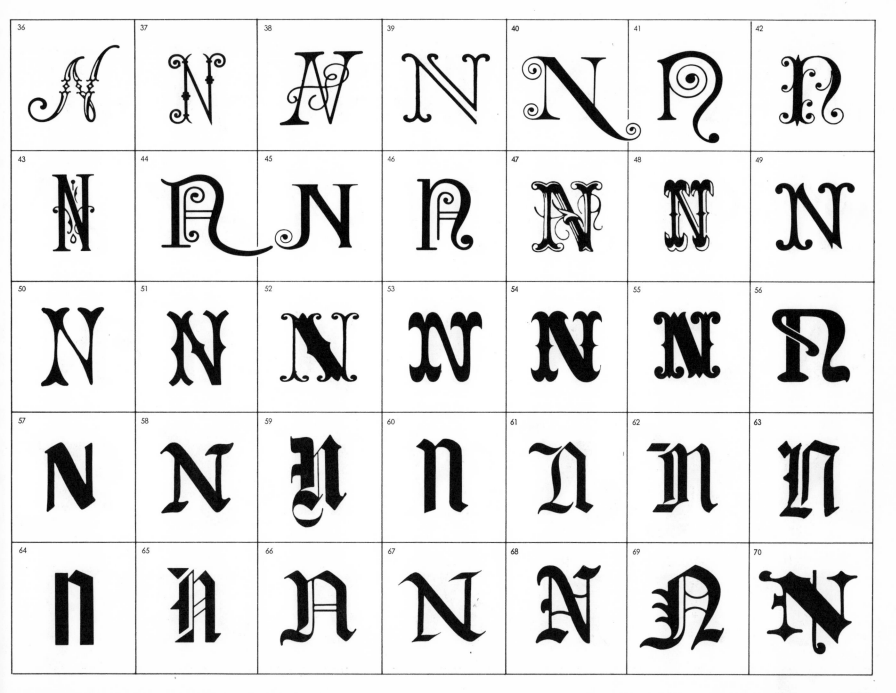

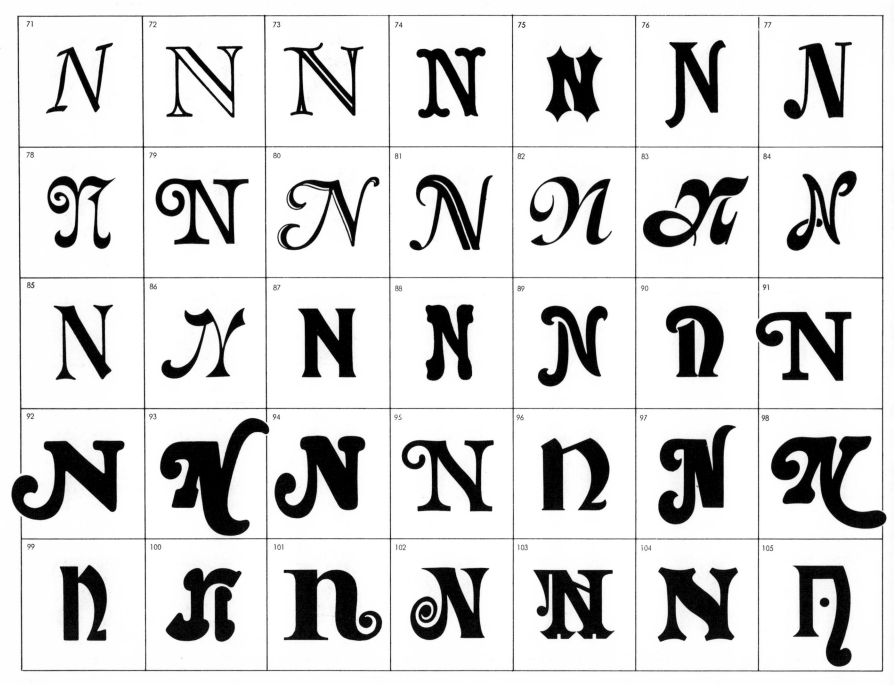

106 107 108 109 110 111 112
113 114 115 116 117 118 119
120 121 122 123 124 125 126
127 128 129 130 131 132 133
134 135 136 137 138 139 140

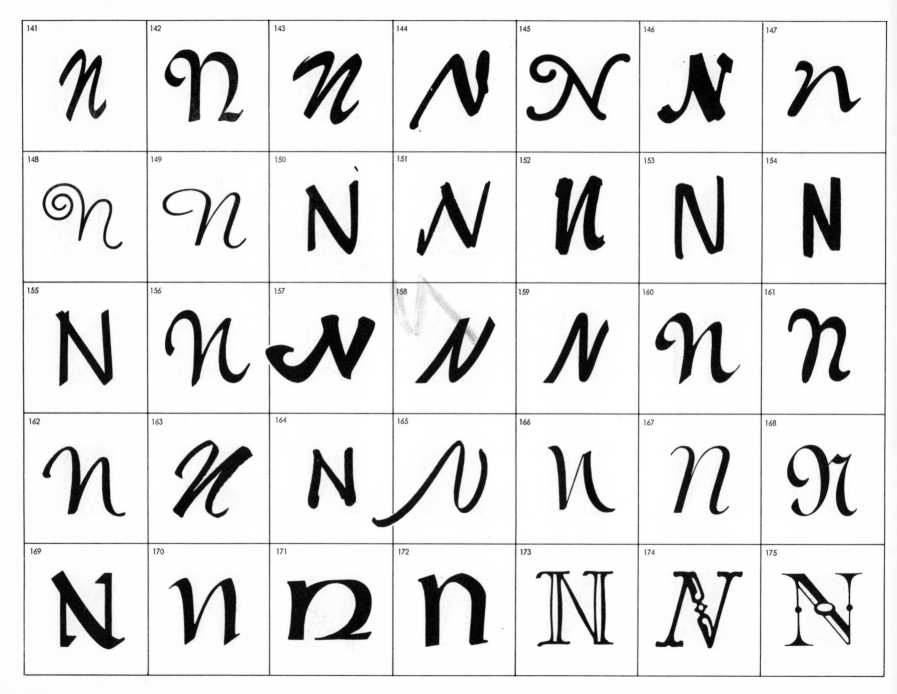

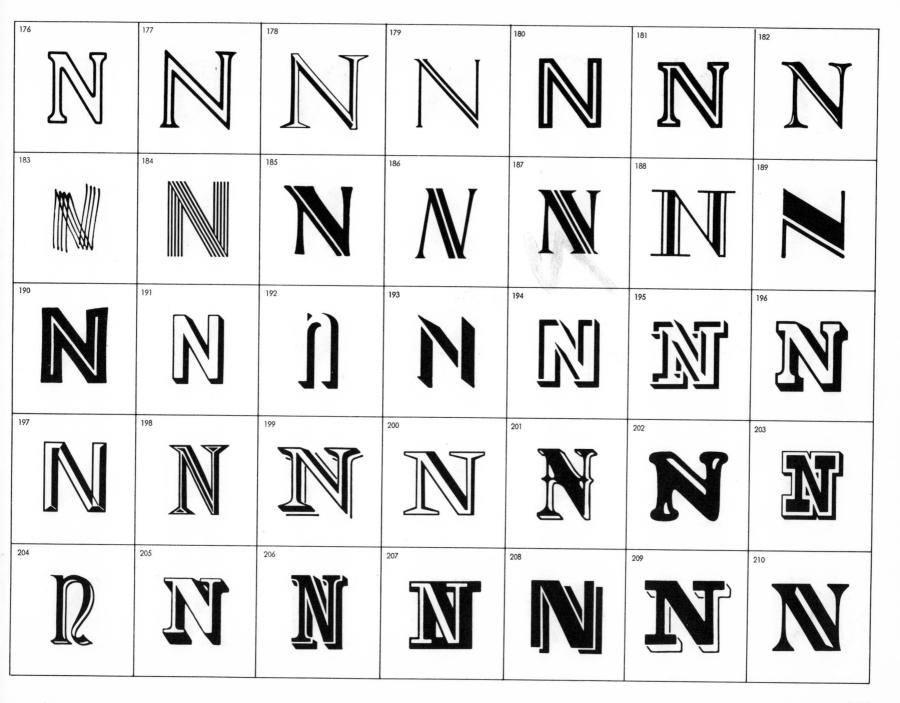

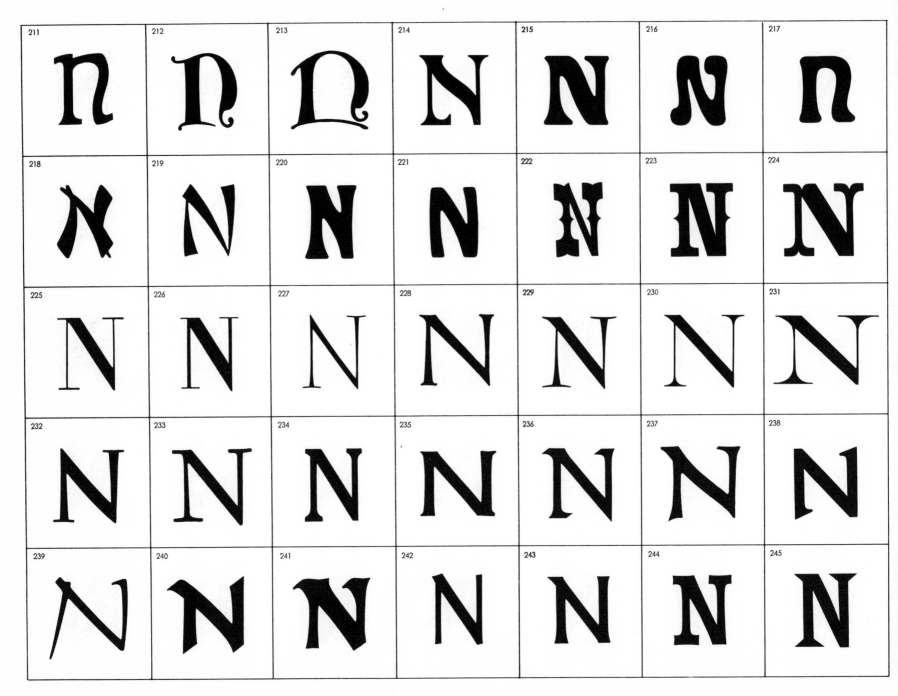

246	247	248	249	250	251	252
N	N	N	N	n	N	N

253	254	255	256	257	258	259
N	N	N	N	N	N	N

260	261	262	263	264	265	266
N	N	N	N	N	N	N

267	268	269	270	271	272	273
N	N	N	N	N	N	N

274	275	276	277	278	279	280
N	n	N	N	N	n	N

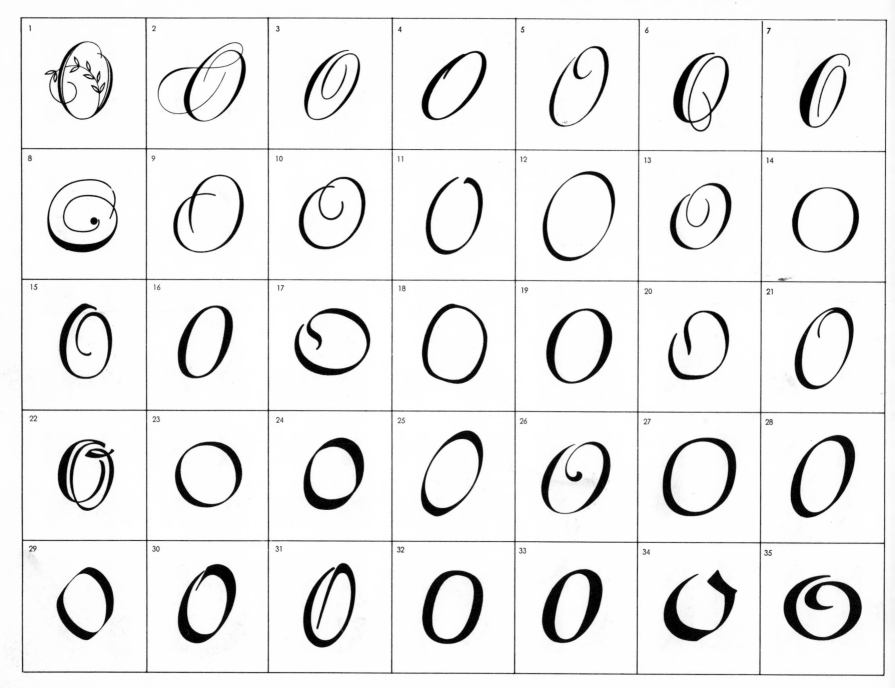

36	37	38	39	40	41	42
43	44	45	46	47	48	49
50	51	52	53	54	55	56
57	58	59	60	61	62	63
64	65	66	67	68	69	70

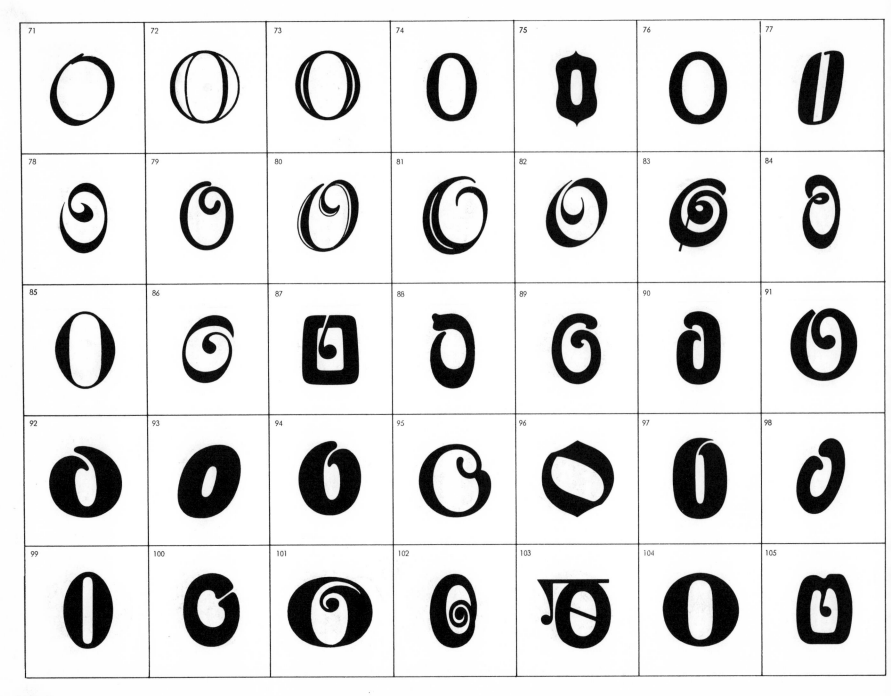

144

106 107 108 109 110 111 112

113 114 115 116 117 118 119

120 121 122 123 124 125 126

127 128 129 130 131 132 133

134 135 136 137 138 139 140

145

176 177 178 179 180 181 182
183 184 185 186 187 188 189
190 191 192 193 194 195 196
197 198 199 200 201 202 203
204 205 206 207 208 209 210

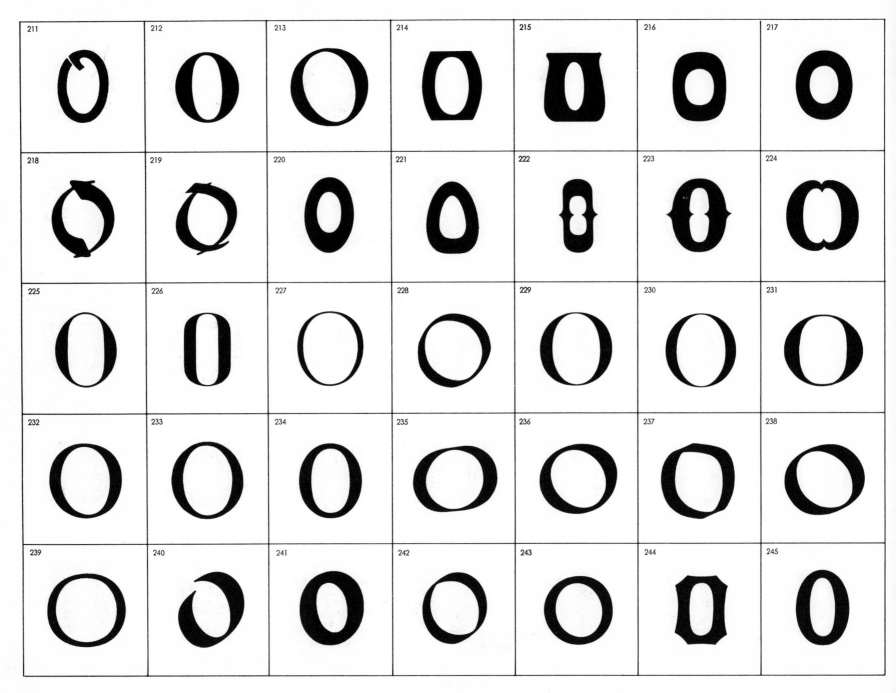

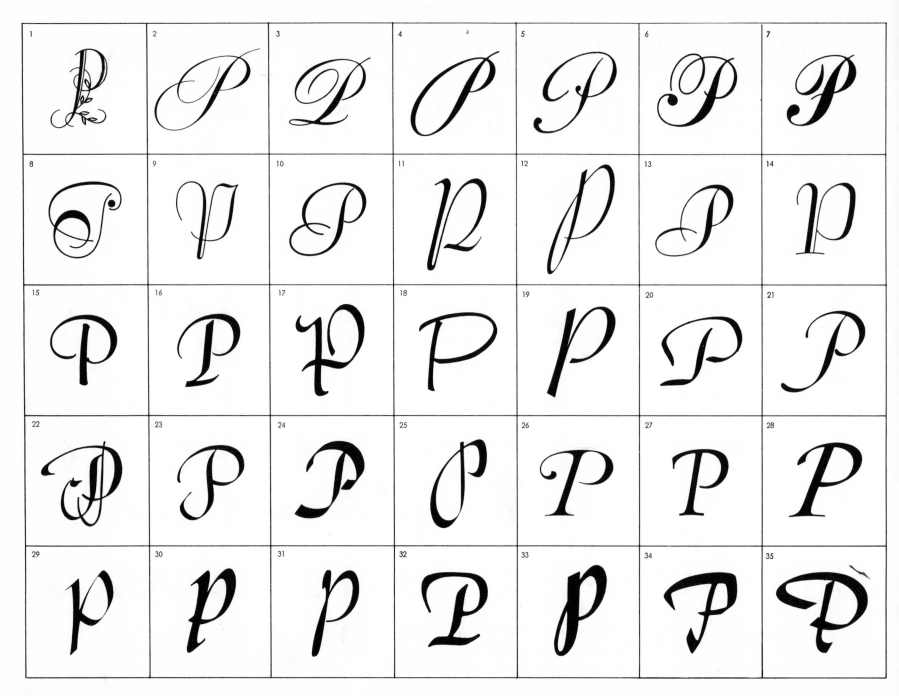

152

36	37	38	39	40	41	42
43	44	45	46	47	48	49
50	51	52	53	54	55	56
57	58	59	60	61	62	63
64	65	66	67	68	69	70

153

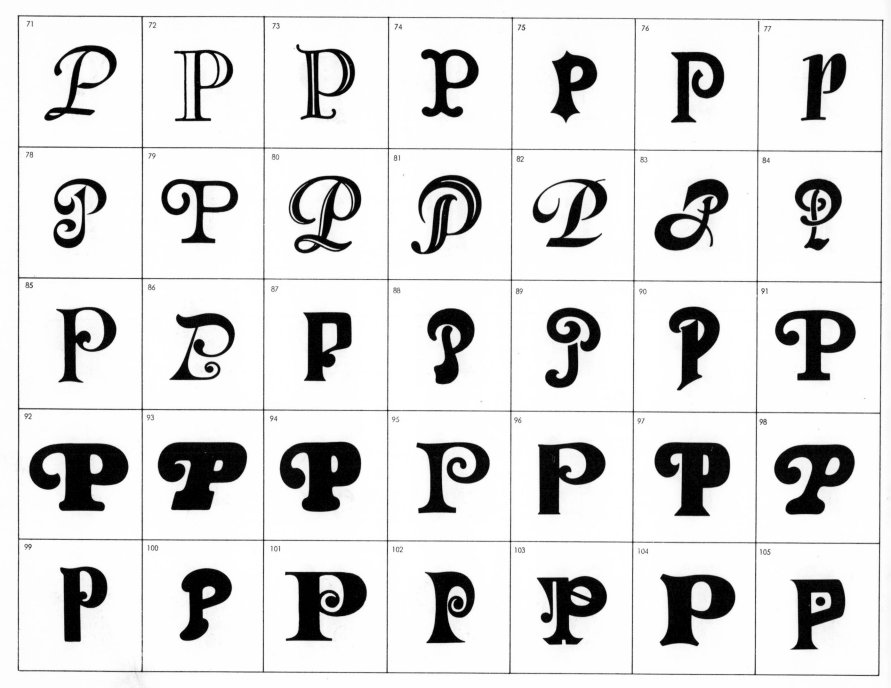

106	107	108	109	110	111	112
113	114	115	116	117	118	119
120	121	122	123	124	125	126
127	128	129	130	131	132	133
134	135	136	137	138	139	140

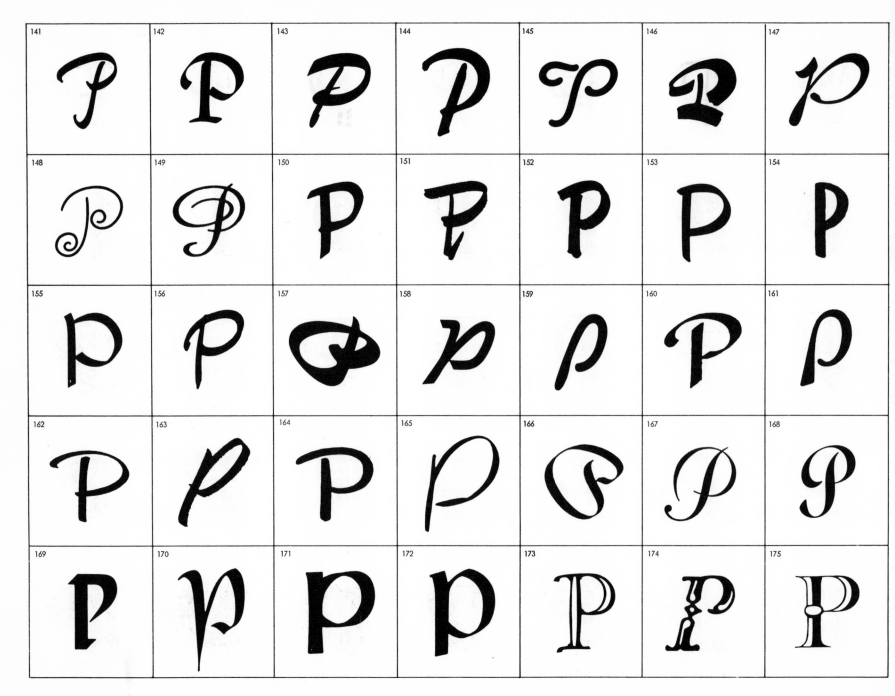

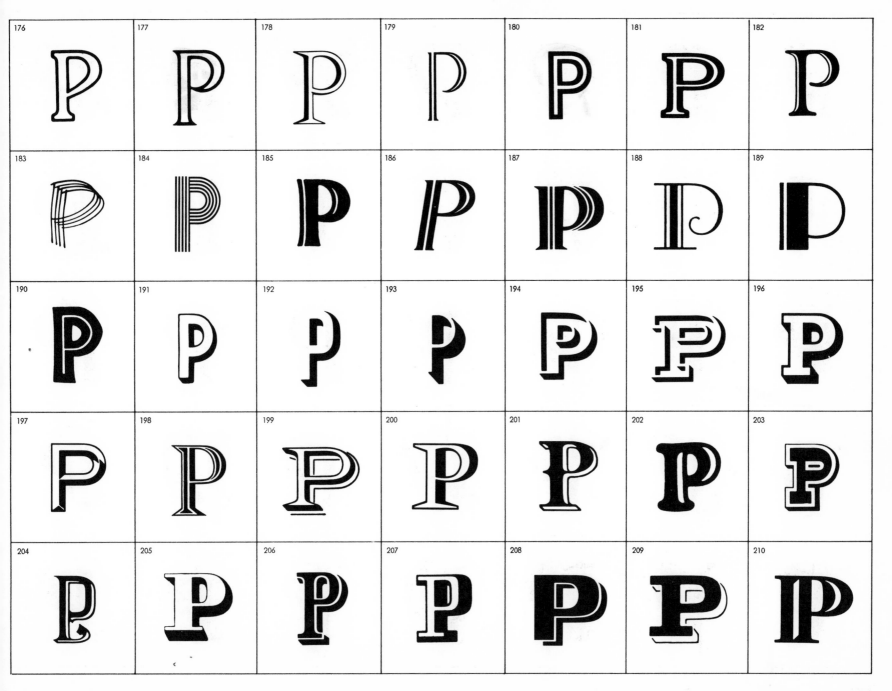

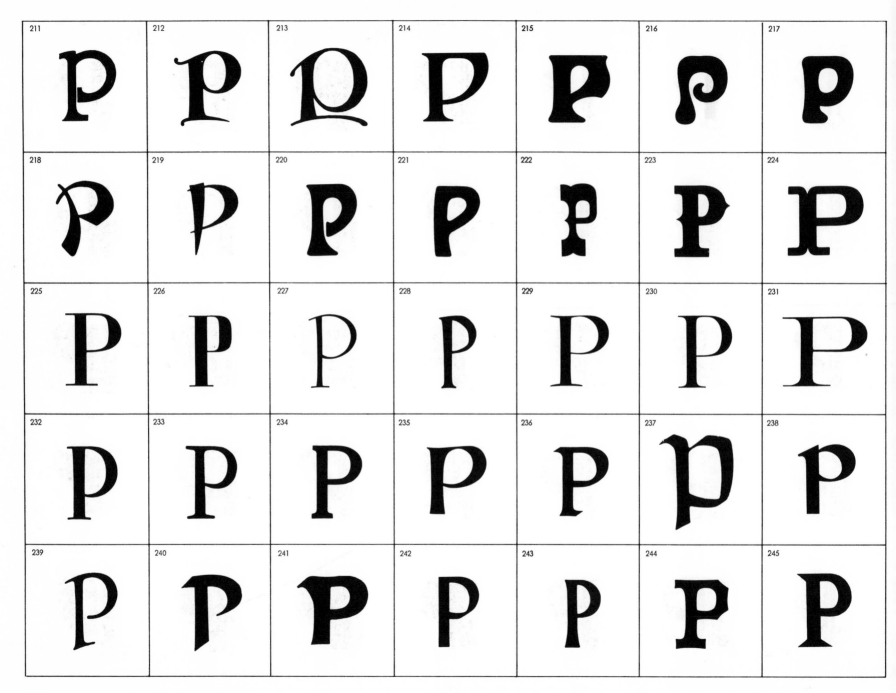

246	247	248	249	250	251	252
253	254	255	256	257	258	259
260	261	262	263	264	265	266
267	268	269	270	271	272	273
274	275	276	277	278	279	280

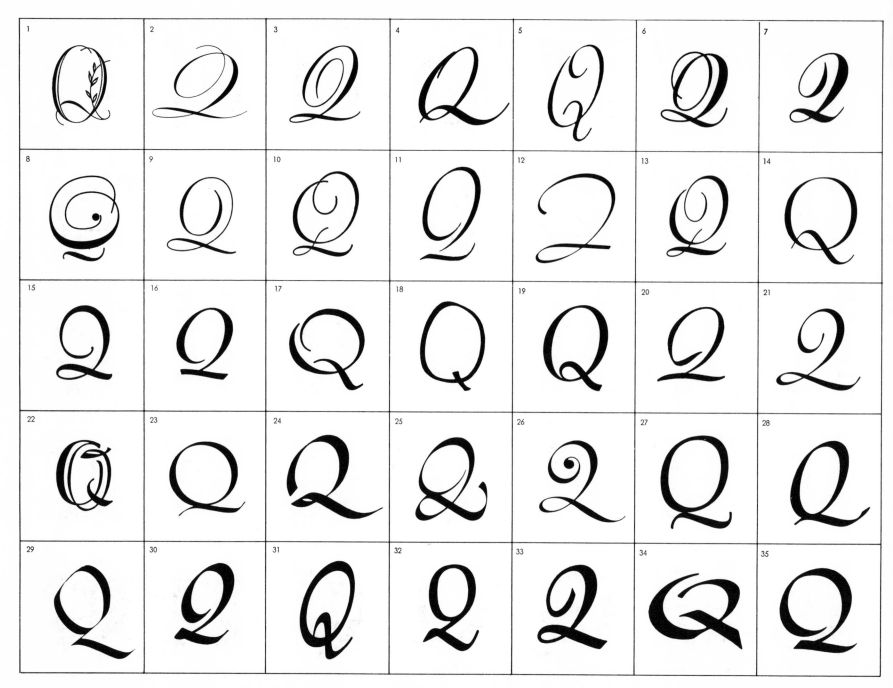

162

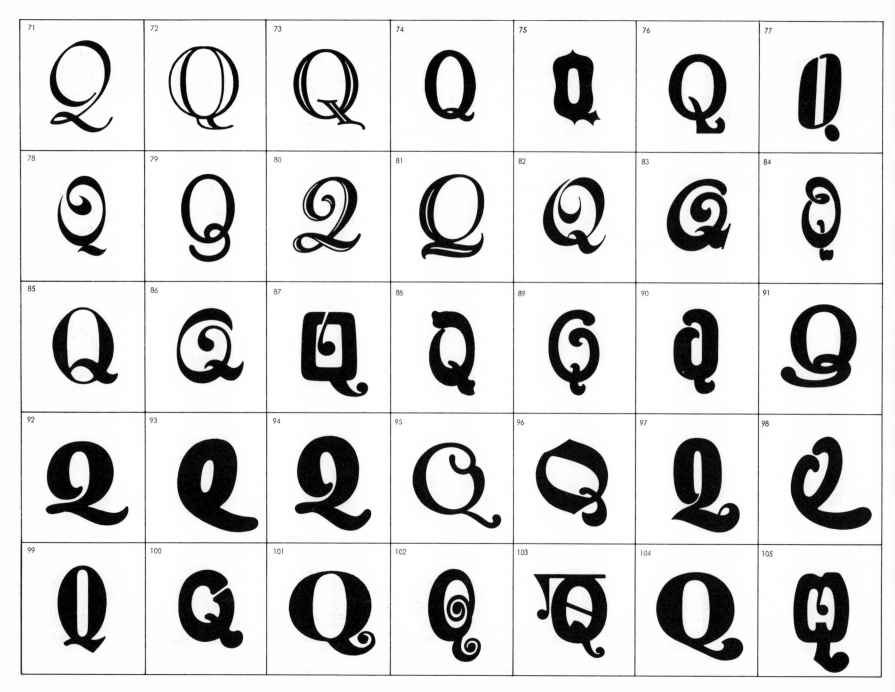

165

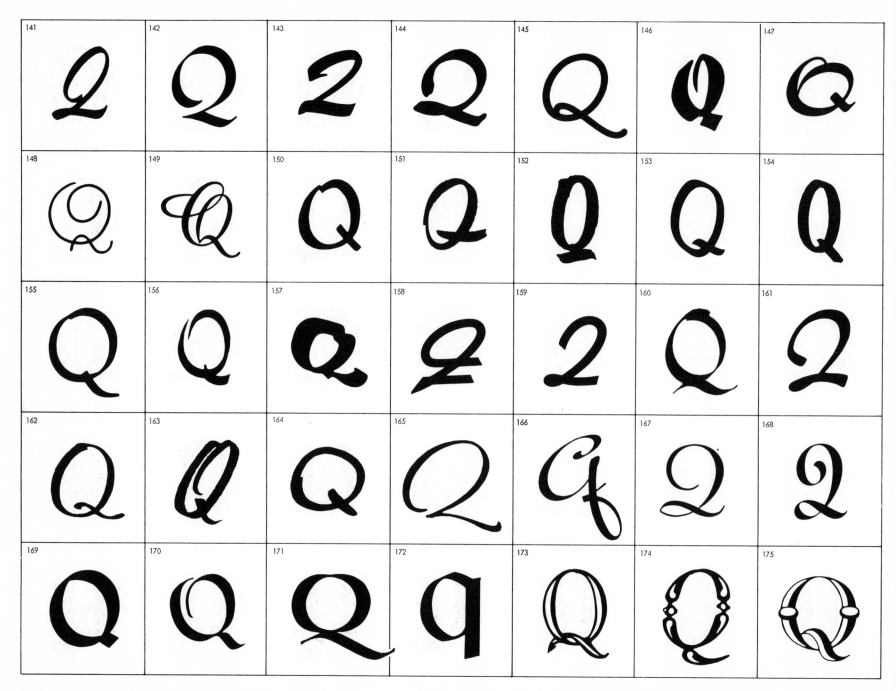

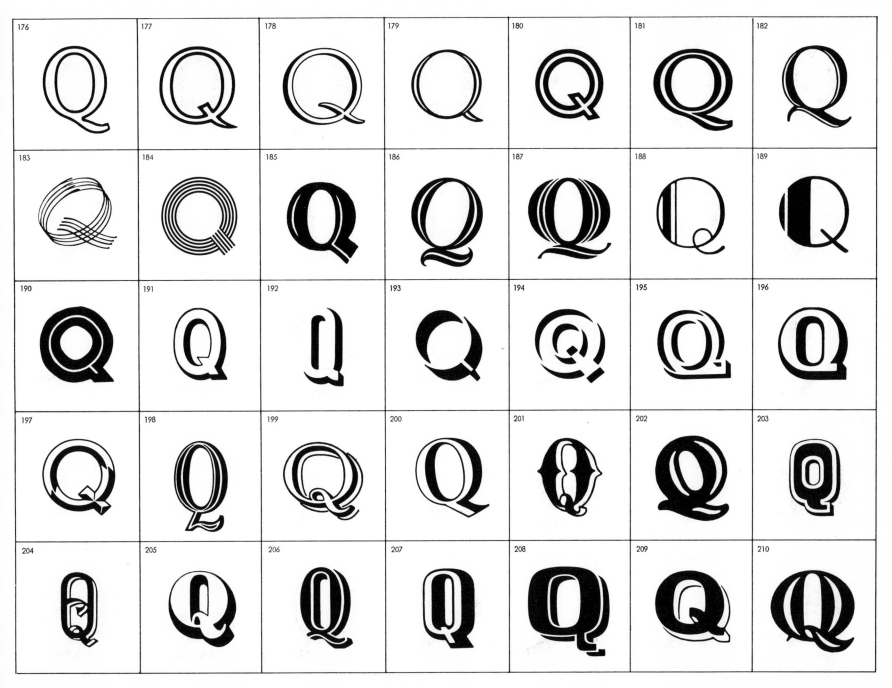

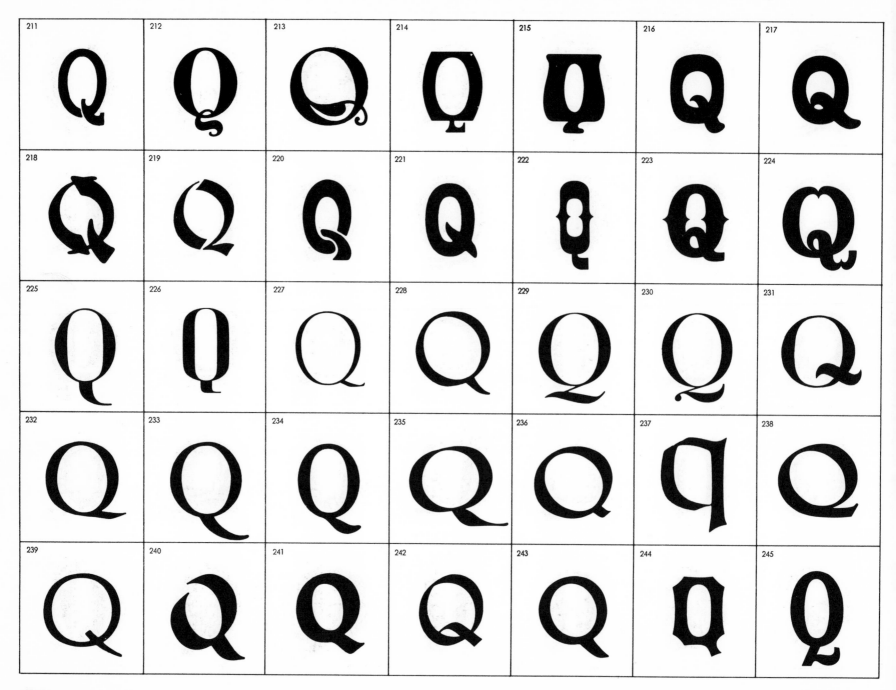

246	247	248	249	250	251	252
253	254	255	256	257	258	259
260	261	262	263	264	265	266
267	268	269	270	271	272	273
274	275	276	277	278	279	280

162

163

164

165

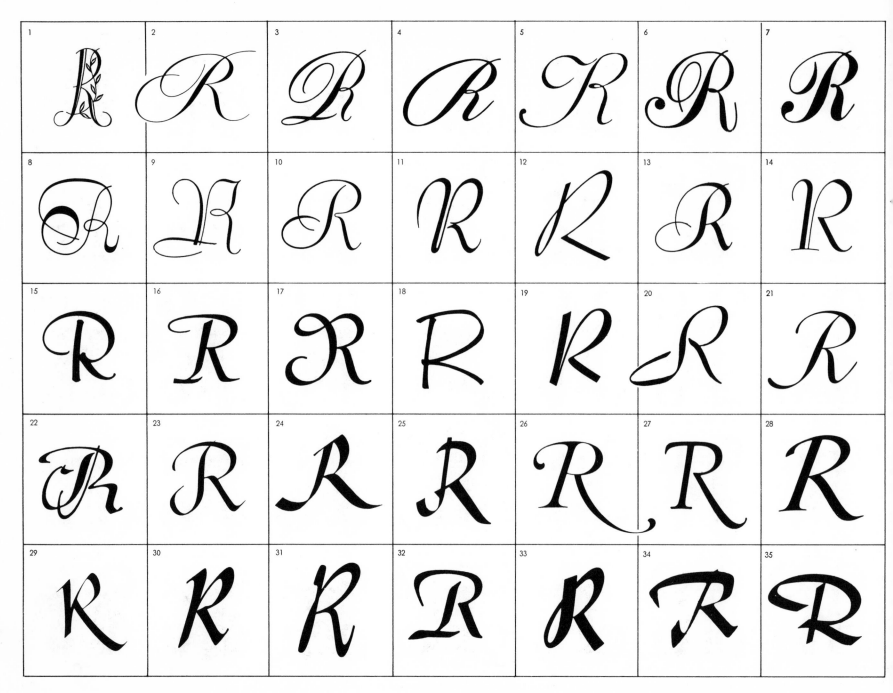

36	37	38	39	40	41	42
43	44	45	46	47	48	49
50	51	52	53	54	55	56
57	58	59	60	61	62	63
64	65	66	67	68	69	70

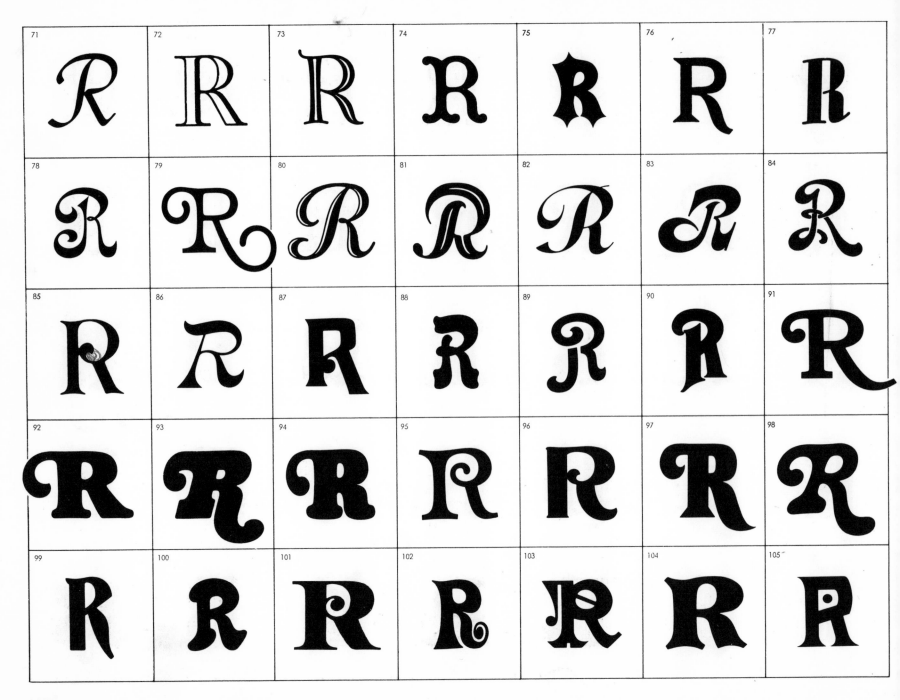

174

106 107 108 109 110 111 112
113 114 115 116 117 118 119
120 121 122 123 124 125 126
127 128 129 130 131 132 133
134 135 136 137 138 139 140

141	142	143	144	145	146	147
148	149	150	151	152	153	154
155	156	157	158	159	160	161
162	163	164	165	166	167	168
169	170	171	172	173	174	175

176

176	177	178	179	180	181	182
183	184	185	186	187	188	189
190	191	192	193	194	195	196
197	198	199	200	201	202	203
204	205	206	207	208	209	210

211	212	213	214	215	216	217
218	219	220	221	222	223	224
225	226	227	228	229	230	231
232	233	234	235	236	237	238
239	240	241	242	243	244	245

178

246	247	248	249	250	251	252
R	R	R	R	R	R	R

253	254	255	256	257	258	259
R	R	R	R	R	R	R

260	261	262	263	264	265	266
R	R	R	R	R	R	R

267	268	269	270	271	272	273
R	R	R	R	R	R	R

274	275	276	277	278	279	280
R	R	R	R	R	R	R

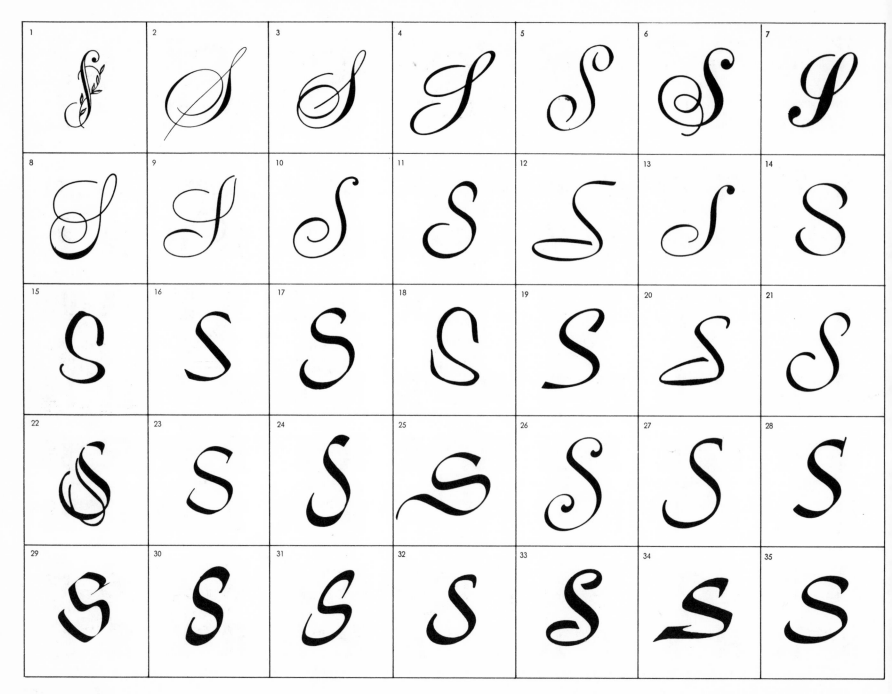

36	37	38	39	40	41	42
43	44	45	46	47	48	49
50	51	52	53	54	55	56
57	58	59	60	61	62	63
64	65	66	67	68	69	70

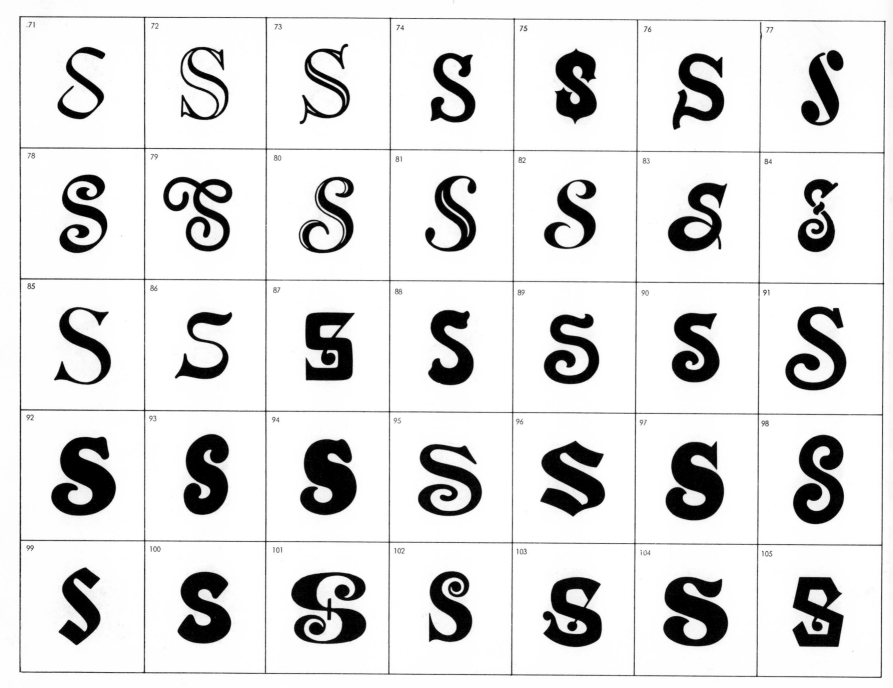

141	142	143	144	145	146	147
148	149	150	151	152	153	154
155	156	157	158	159	160	161
162	163	164	165	166	167	168
169	170	171	172	173	174	175

186

176	177	178	179	180	181	182
183	184	185	186	187	188	189
190	191	192	193	194	195	196
197	198	199	200	201	202	203
204	205	206	207	208	209	210

211	212	213	214	215	216	217
S	S	S	S	S	S	S

218	219	220	221	222	223	224
S	S	S	S	S	S	S

225	226	227	228	229	230	231
S	S	S	S	S	S	S

232	233	234	235	236	237	238
S	S	S	S	S	S	S

239	240	241	242	243	244	245
S	S	S	S	S	S	S

246	247	248	249	250	251	252
S	S	S	S	S	S	S
253	254	255	256	257	258	259
S	S	S	S	S	S	S
260	261	262	263	264	265	266
S	S	S	S	S	S	S
267	268	269	270	271	272	273
S	S	S	S	S	S	S
274	275	276	277	278	279	280
S	S	S	S	S	S	S

189

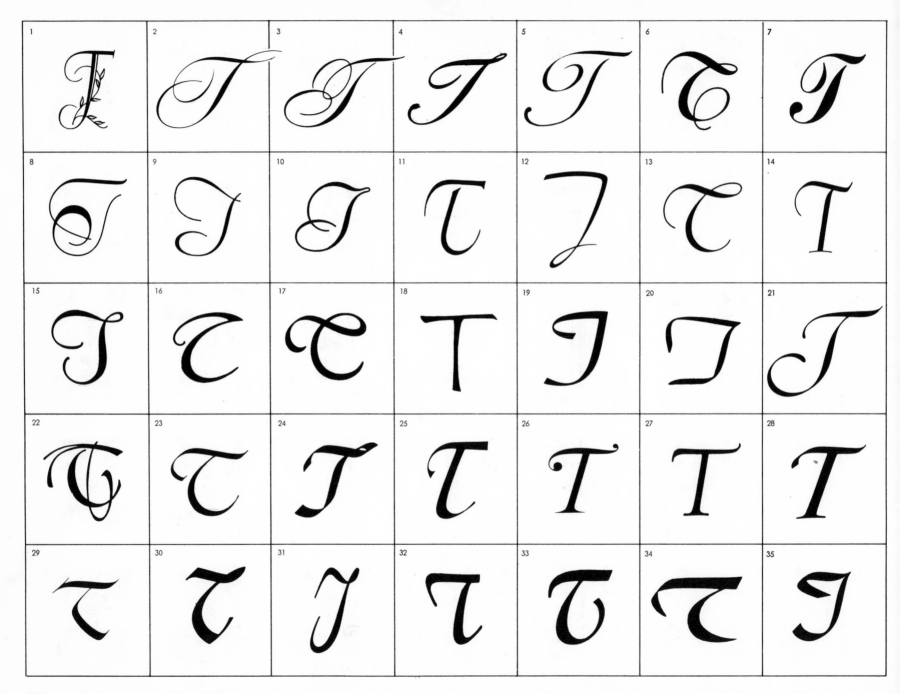

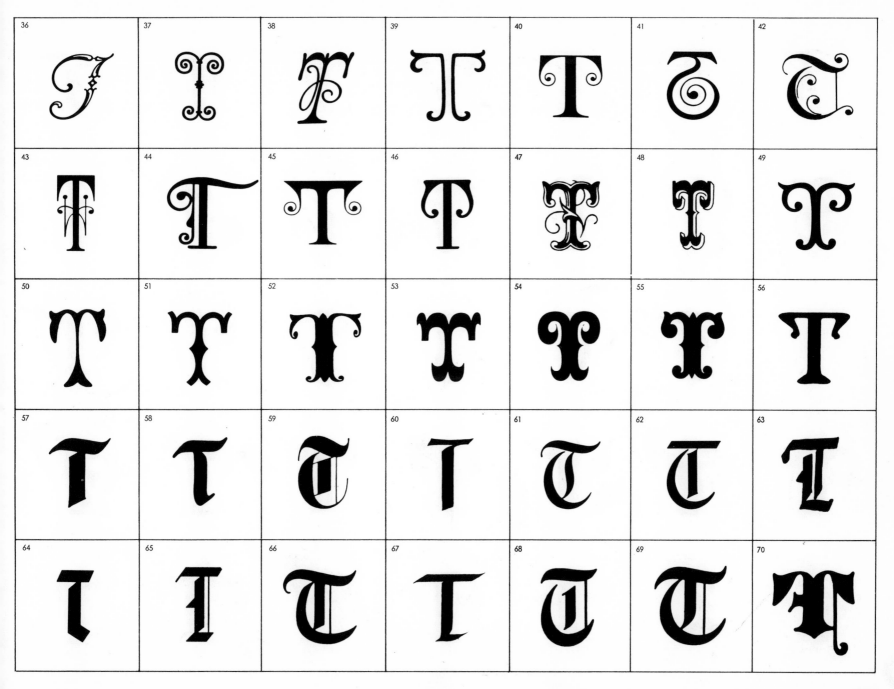

193

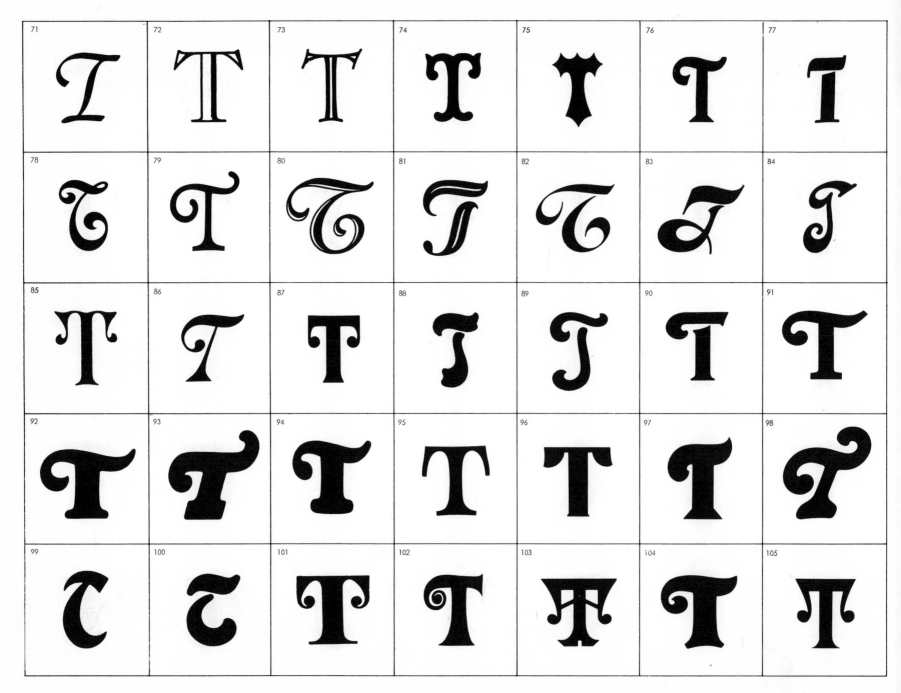

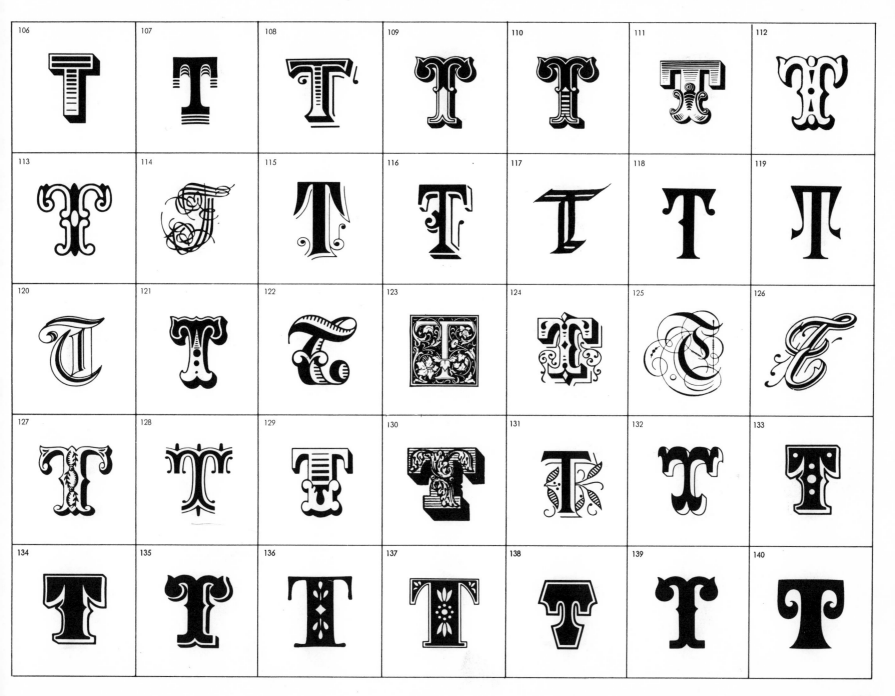

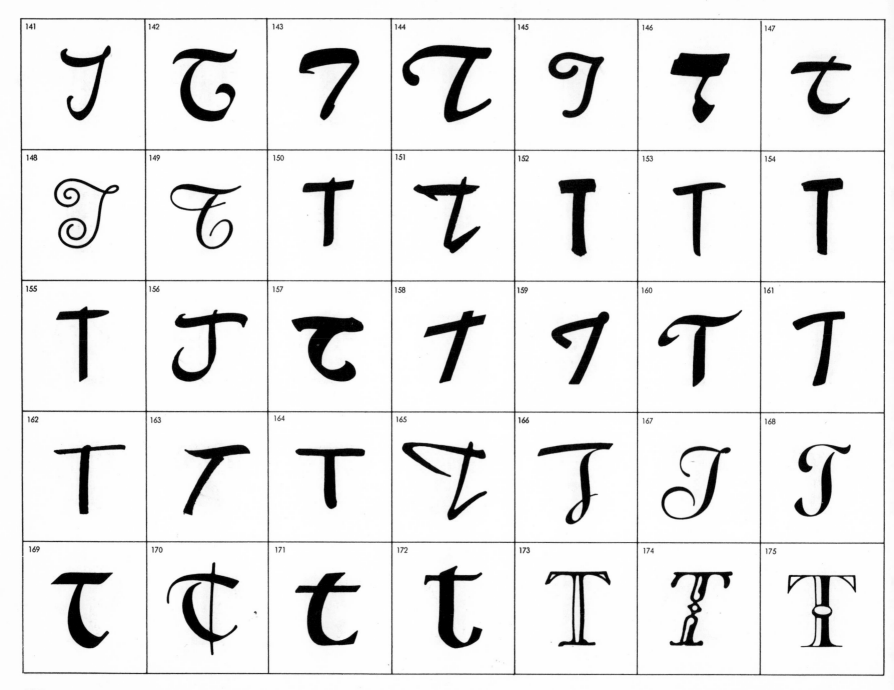

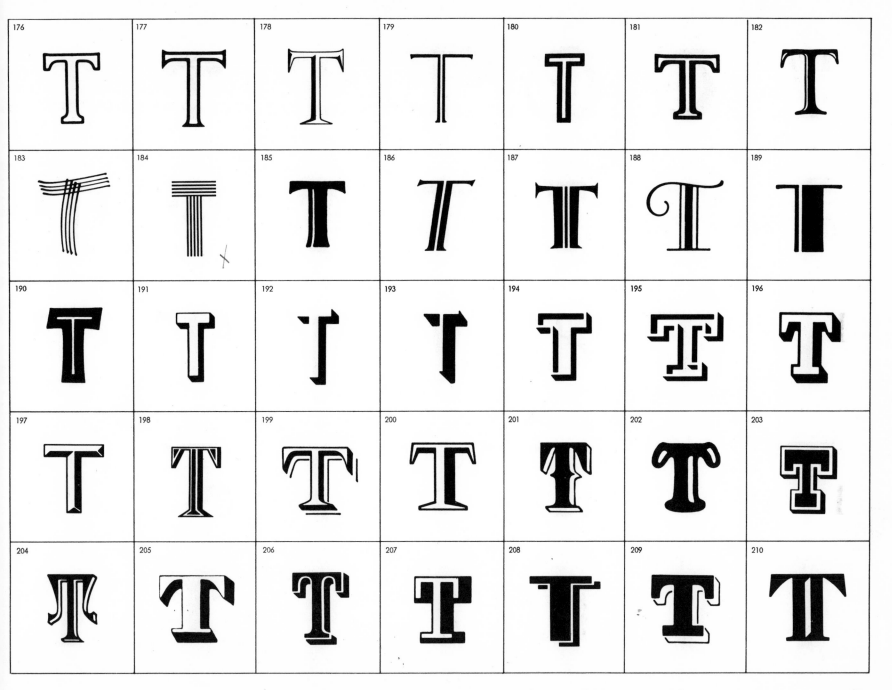

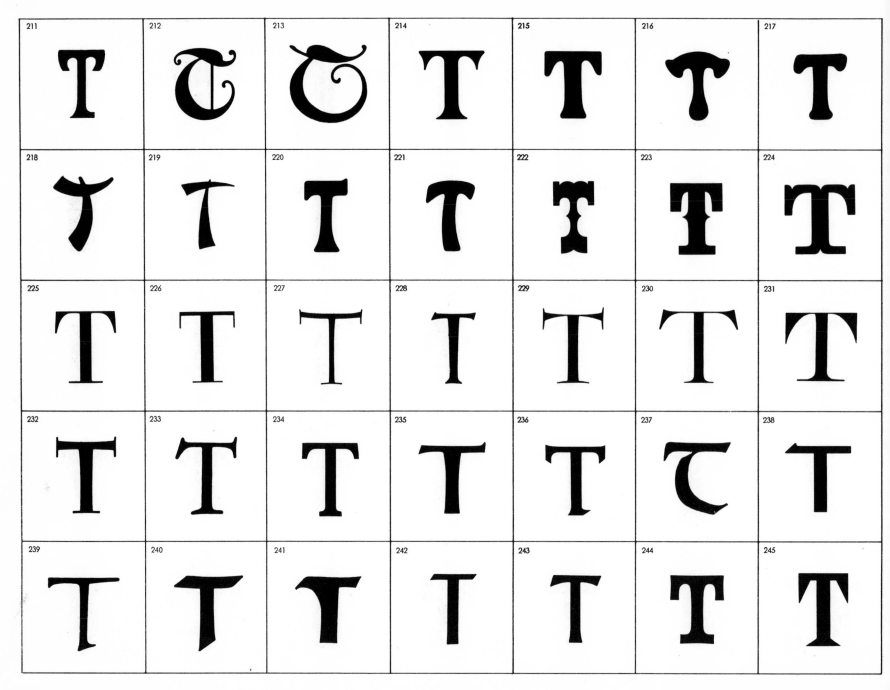

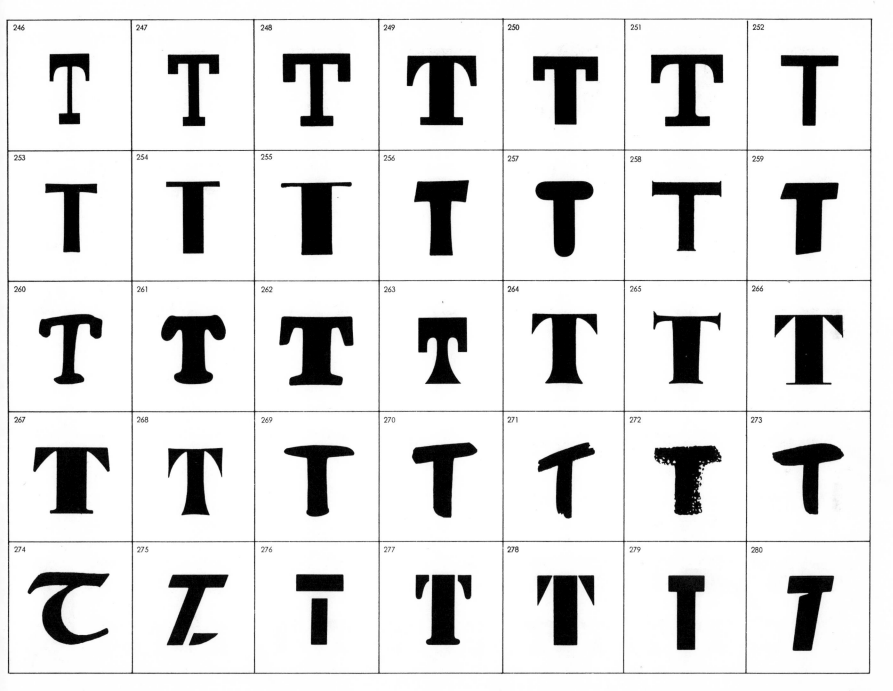

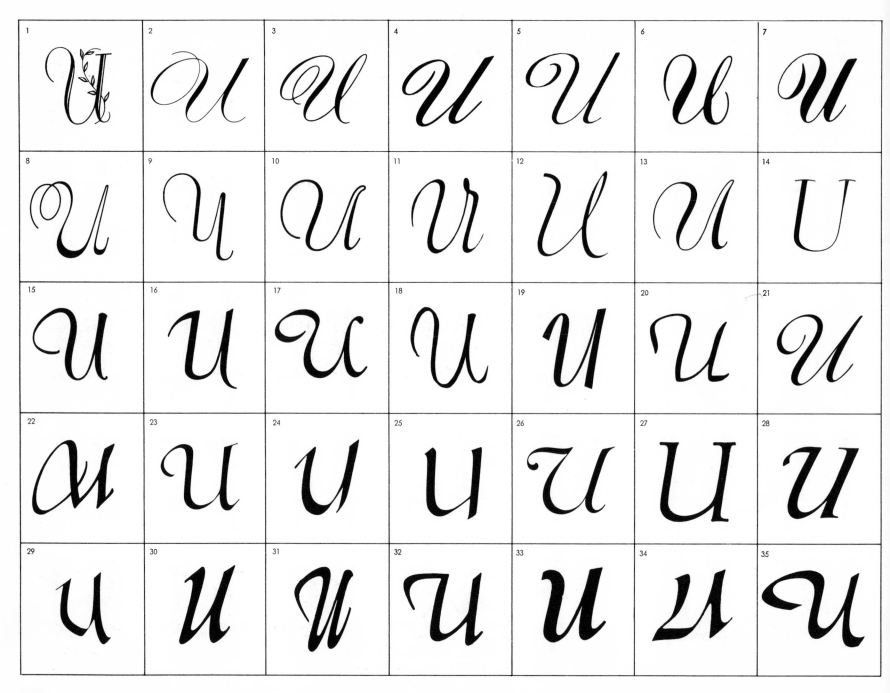

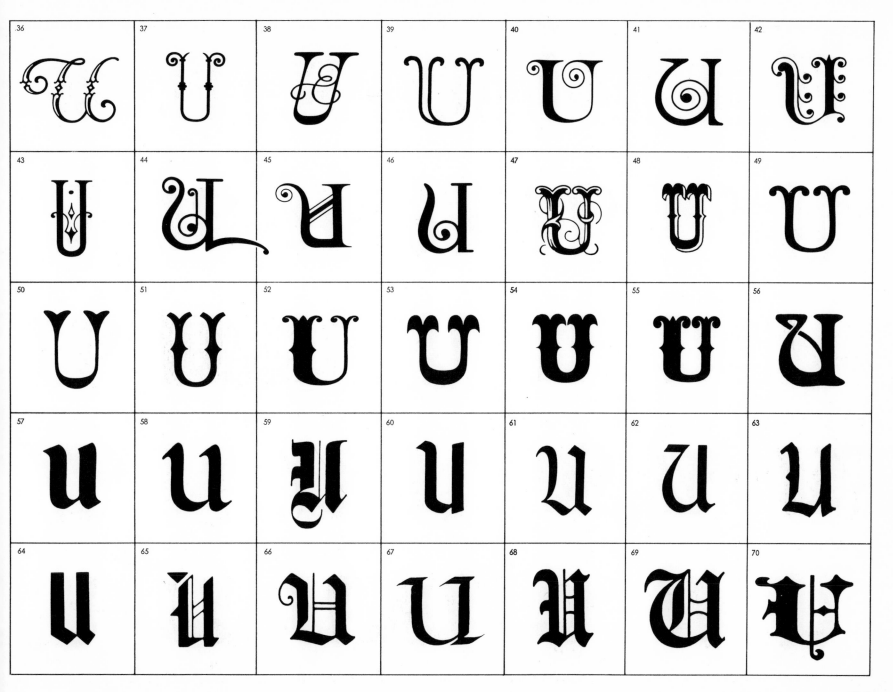

203

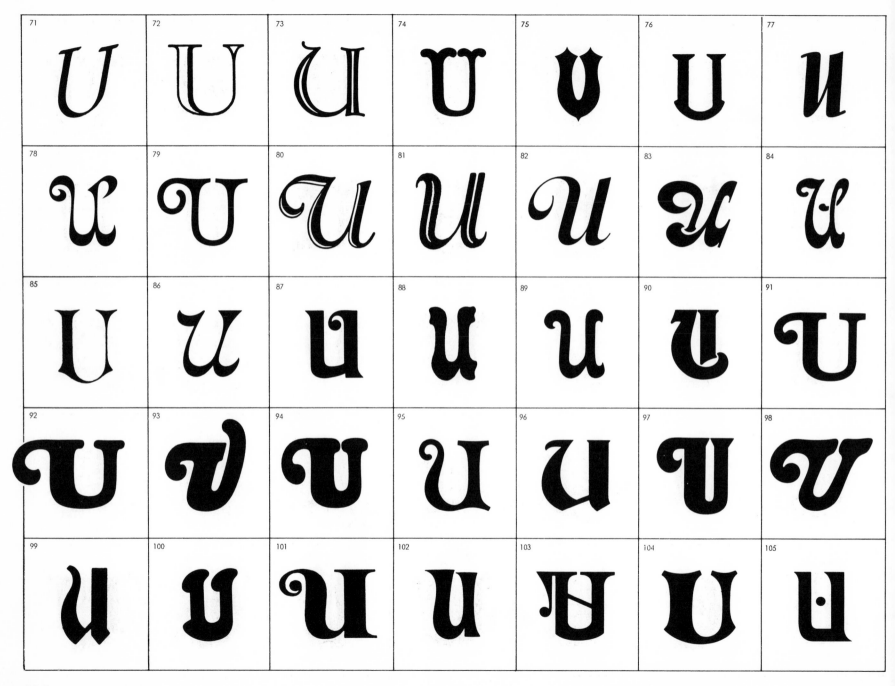

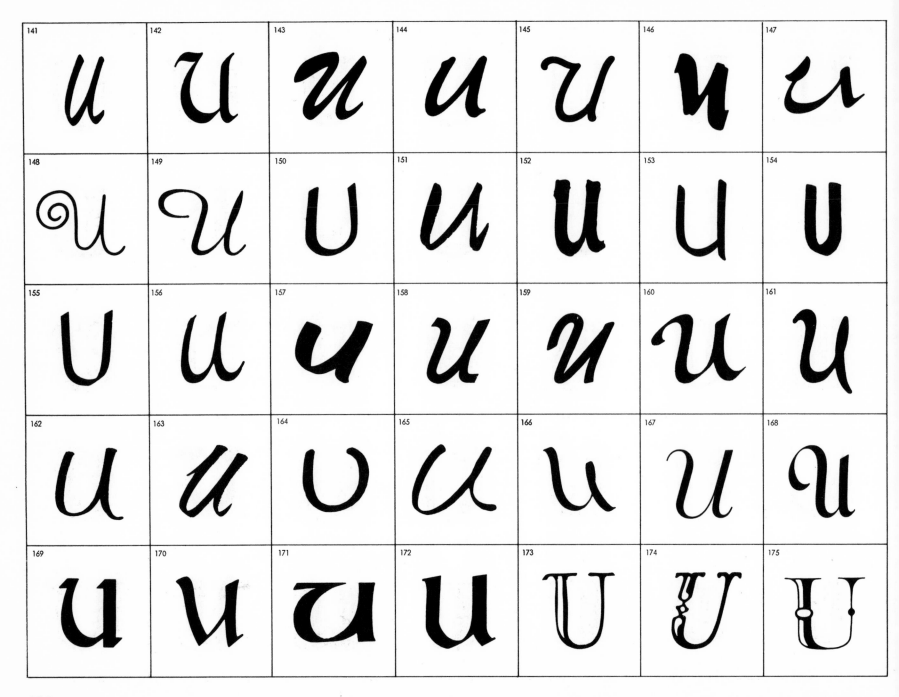

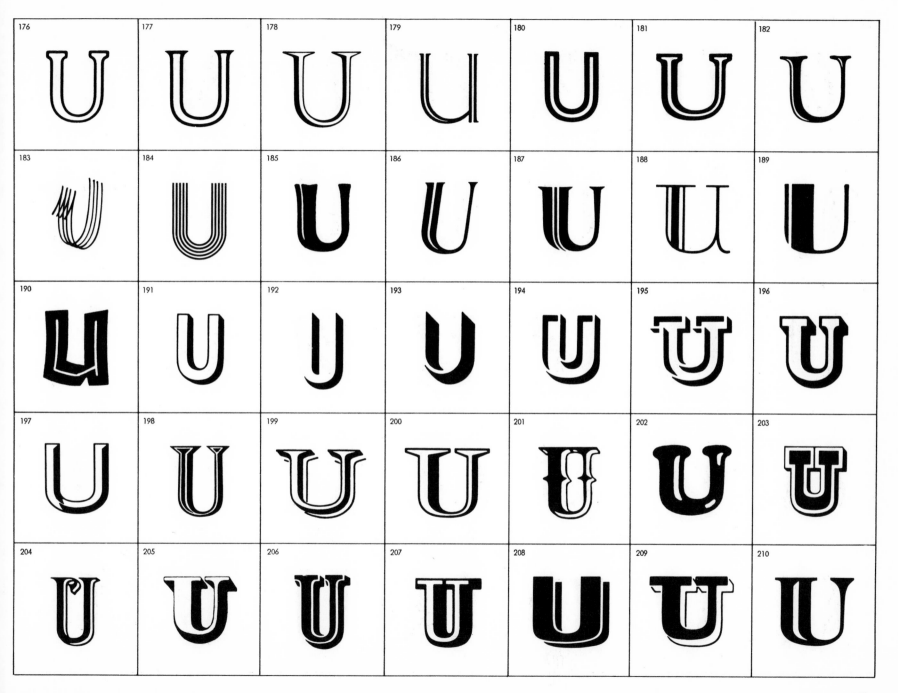

207

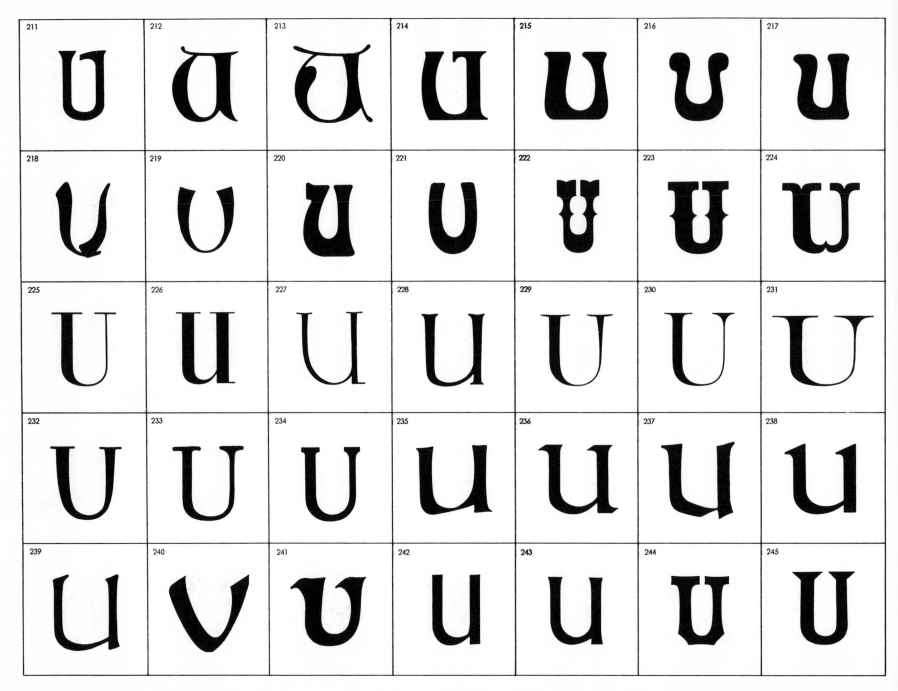

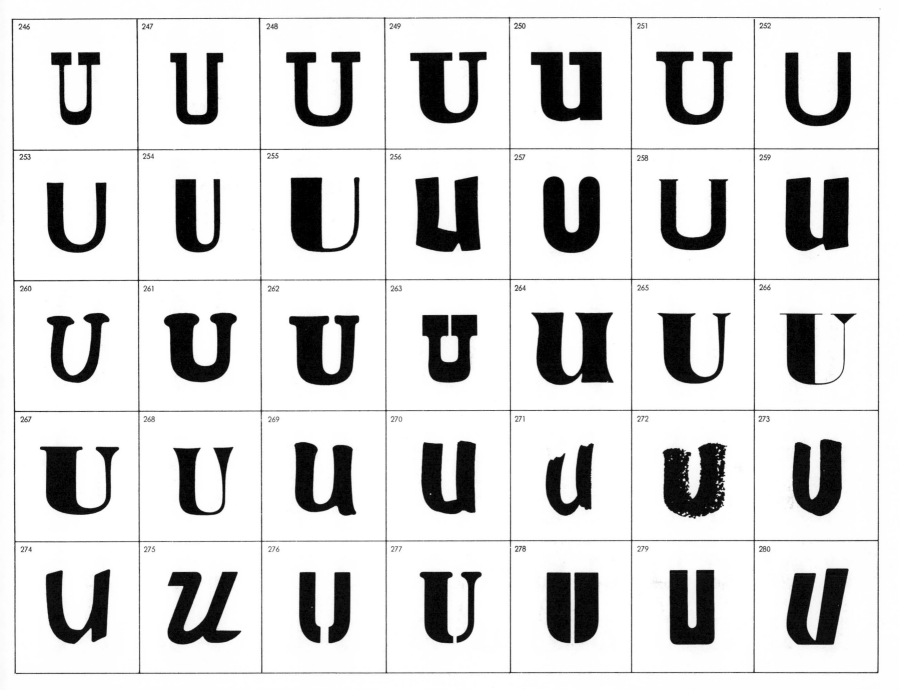

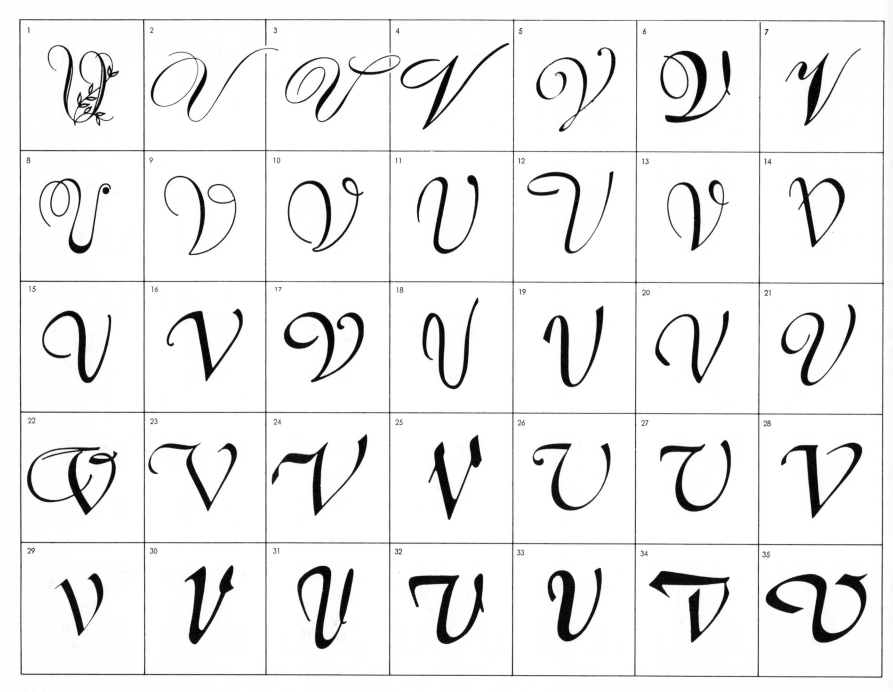

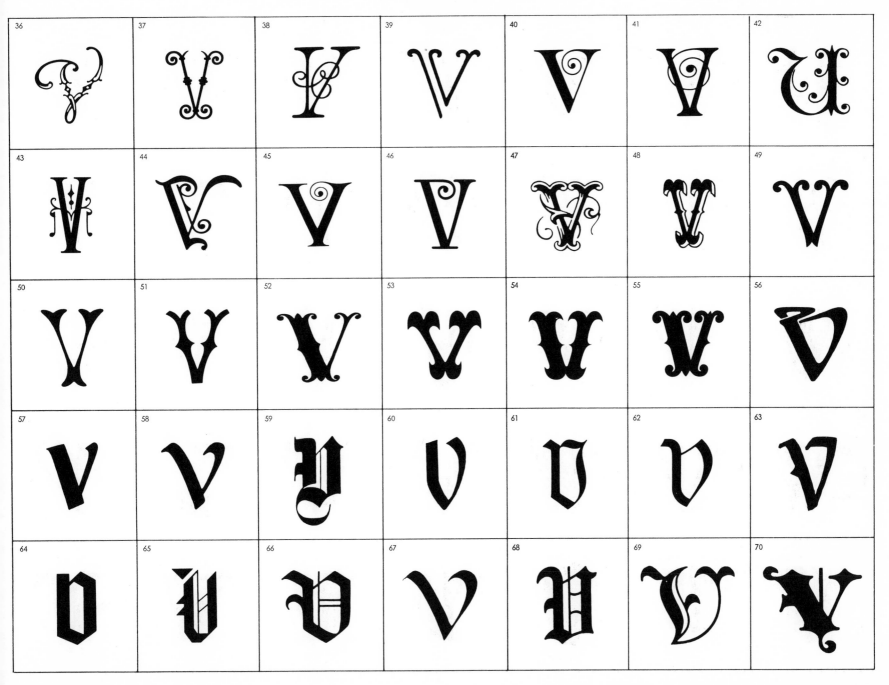

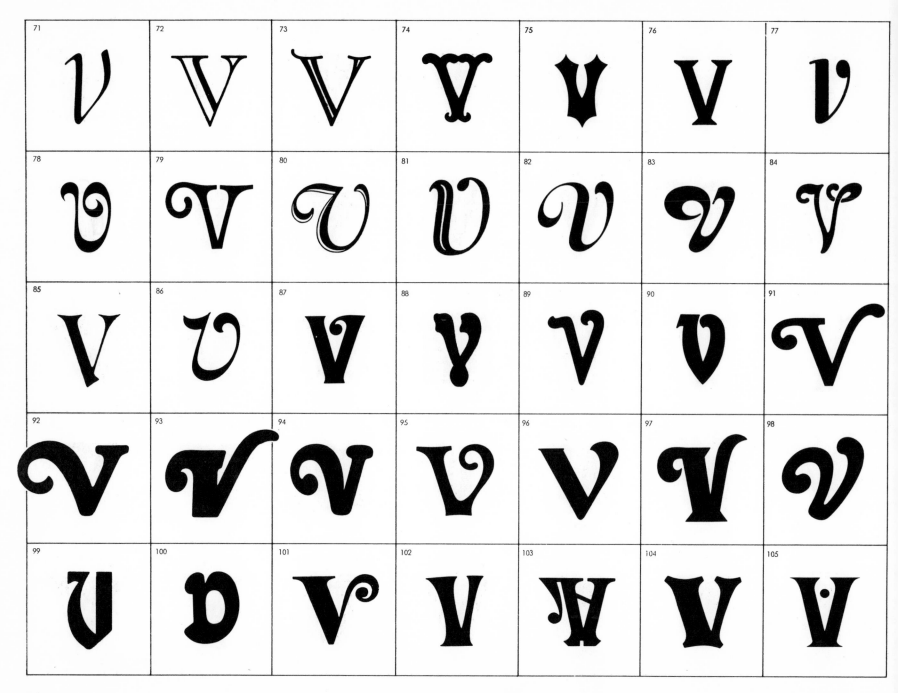

214

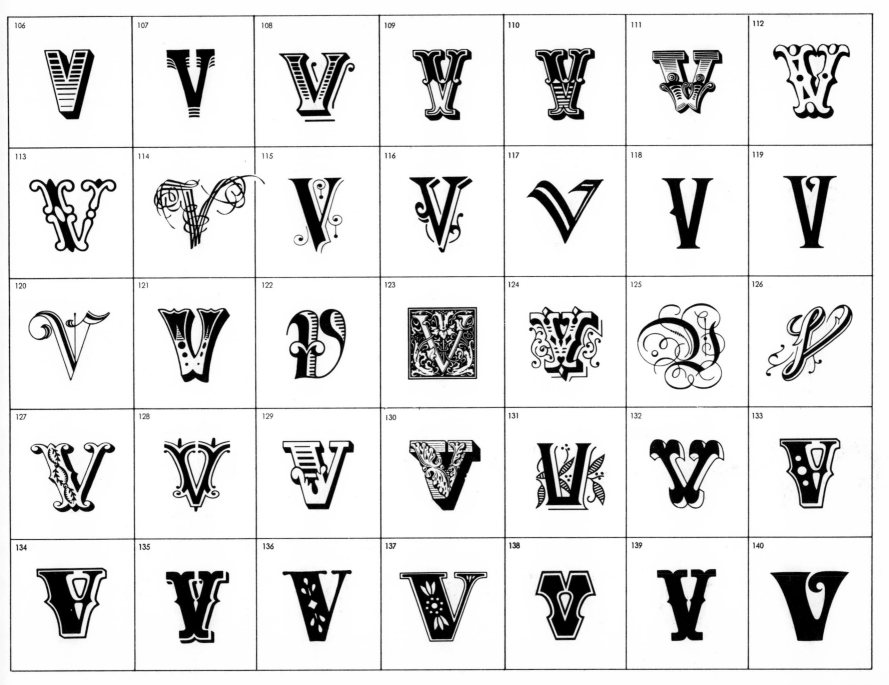

215

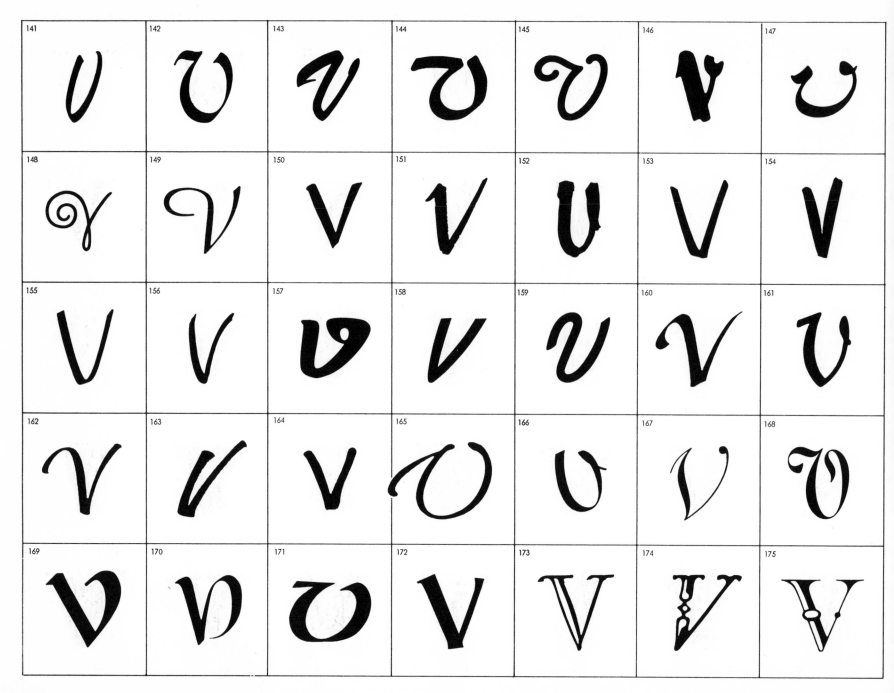

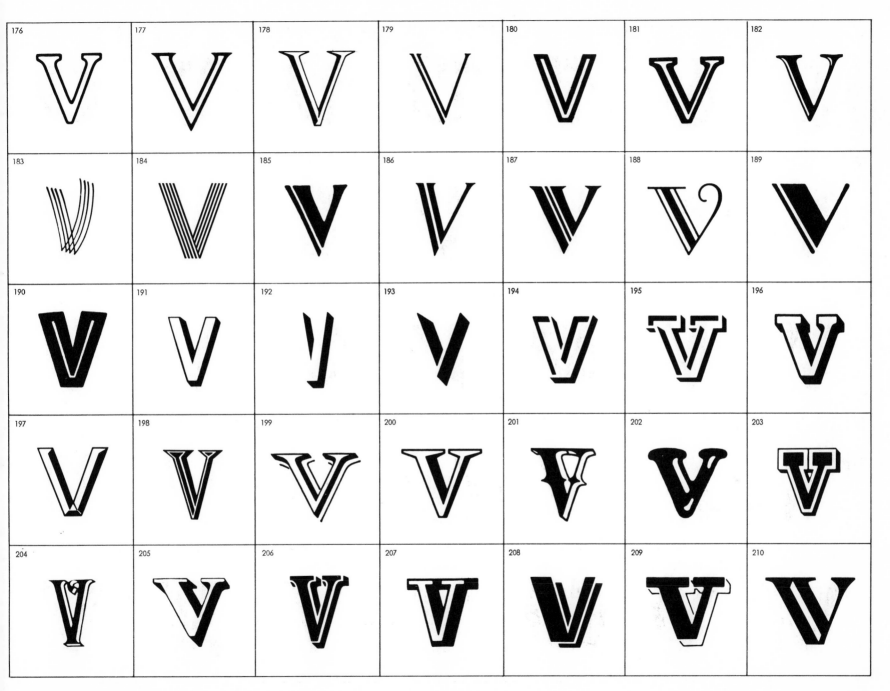

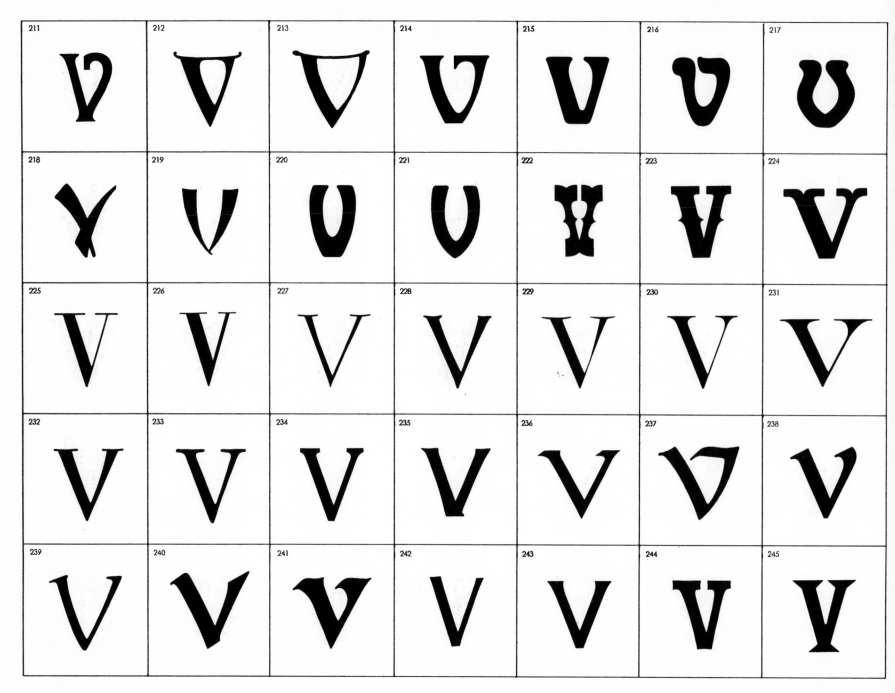

246	247	248	249	250	251	252
V	V	V	V	V	V	V

253	254	255	256	257	258	259
V	V	V	V	V	V	V

260	261	262	263	264	265	266
V	V	V	Y	V	V	V

267	268	269	270	271	272	273
V	V	V	V	V	V	V

274	275	276	277	278	279	280
V	V	V	V	V	U	V

219

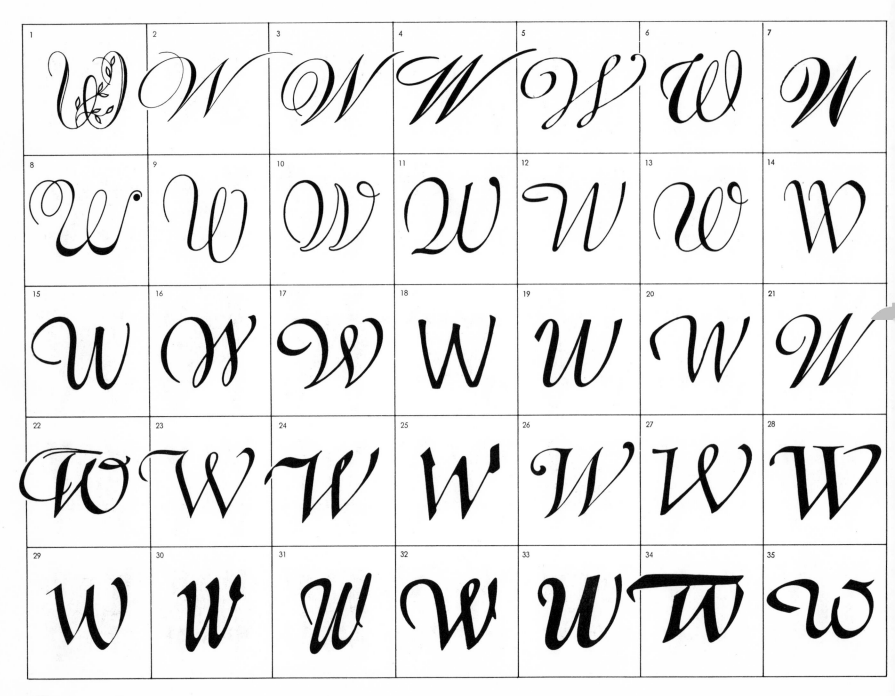

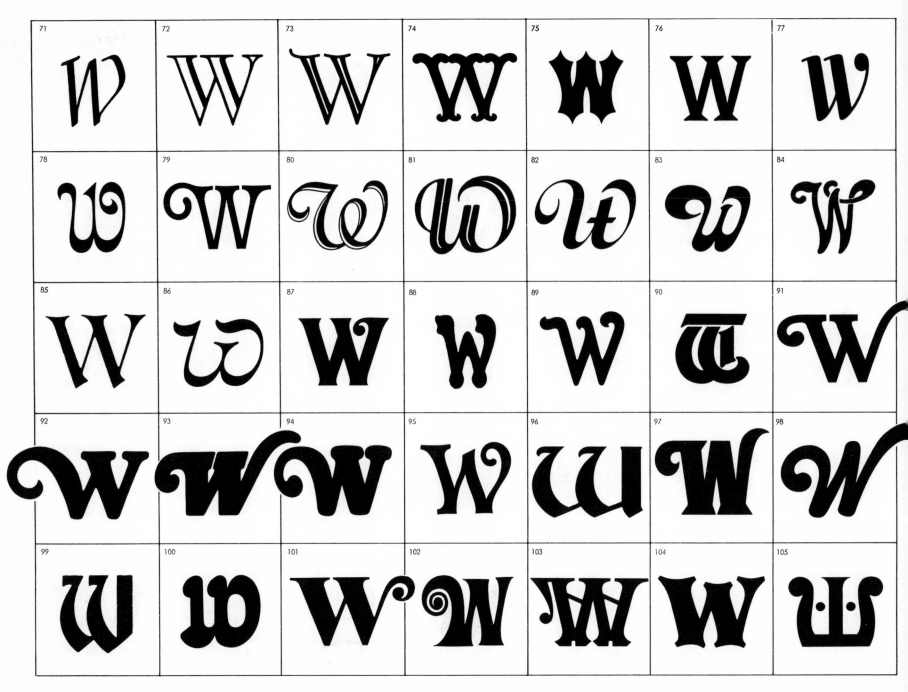

224

106 107 108 109 110 111 112

113 114 115 116 117 118 119

120 121 122 123 124 125 126

127 128 129 130 131 132 133

134 135 136 137 138 139 140

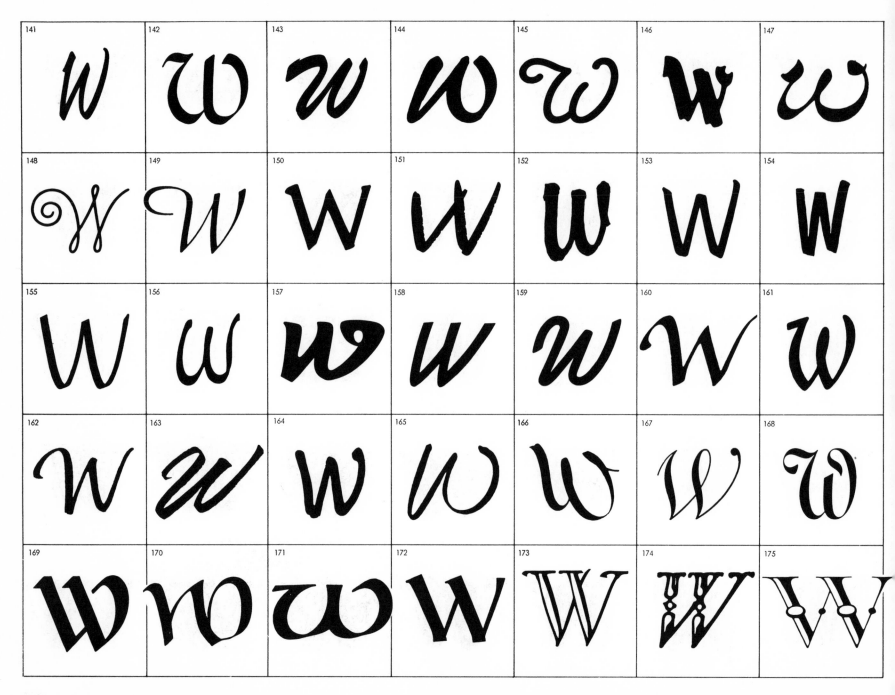

176	177	178	179	180	181	182
W	W	W	W	W	W	W
183	184	185	186	187	188	189
W	W	W	W	W	W	W
190	191	192	193	194	195	196
W	W	W	W	W	W	W
197	198	199	200	201	202	203
W	W	W	W	W	W	W
204	205	206	207	208	209	210
W	W	W	W	W	W	W

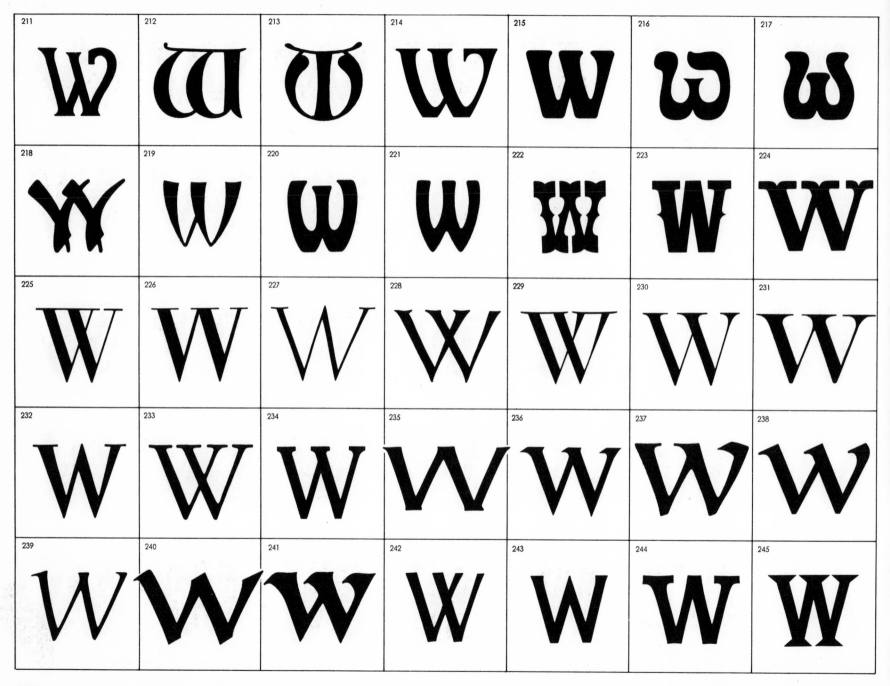

246 247 248 249 250 251 252

253 254 255 256 257 258 259

260 261 262 263 264 265 266

267 268 269 270 271 272 273

274 275 276 277 278 279 280

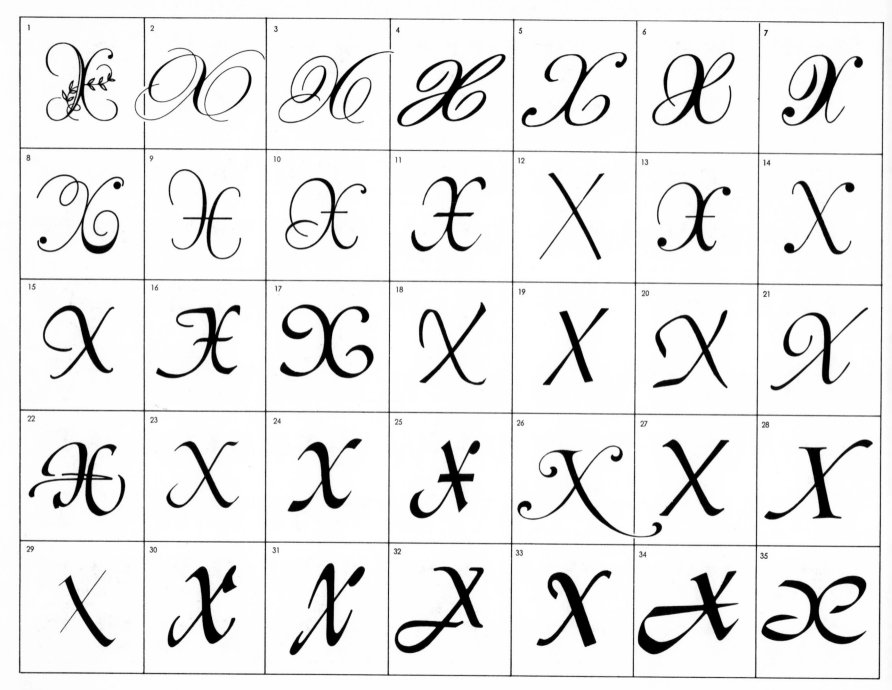

232

71 72 73 74 75 76 77
78 79 80 81 82 83 84
85 86 87 88 89 90 91
92 93 94 95 96 97 98
99 100 101 102 103 104 105

234

106	107	108	109	110	111	112
113	114	115	116	117	118	119
120	121	122	123	124	125	126
127	128	129	130	131	132	133
134	135	136	137	138	139	140

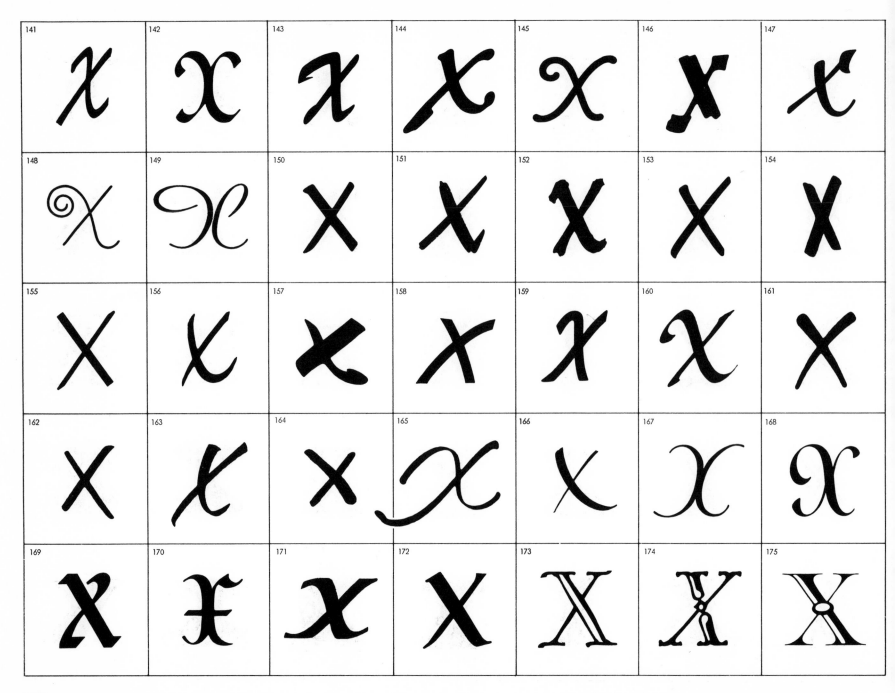

211	212	213	214	215	216	217
218	219	220	221	222	223	224
225	226	227	228	229	230	231
232	233	234	235	236	237	238
239	240	241	242	243	244	245

246	247	248	249	250	251	252
253	254	255	256	257	258	259
260	261	262	263	264	265	266
267	268	269	270	271	272	273
274	275	276	277	278	279	280

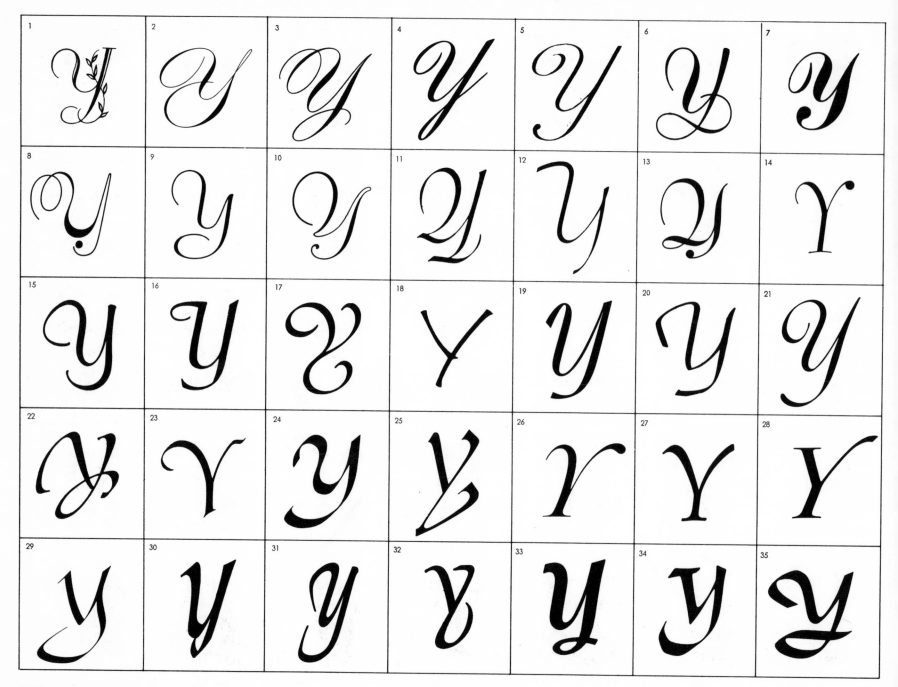

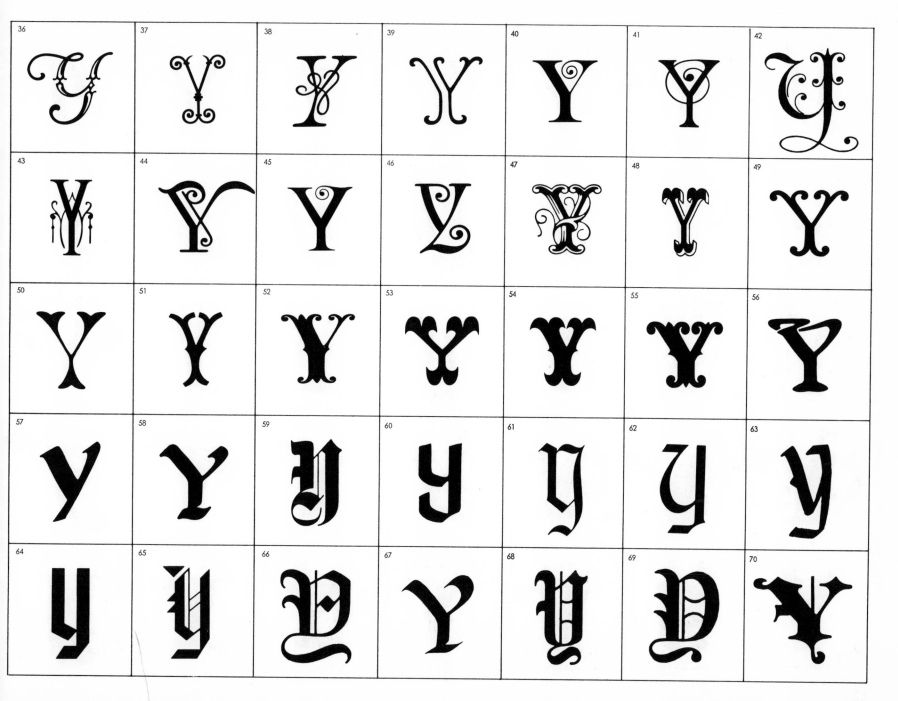

243

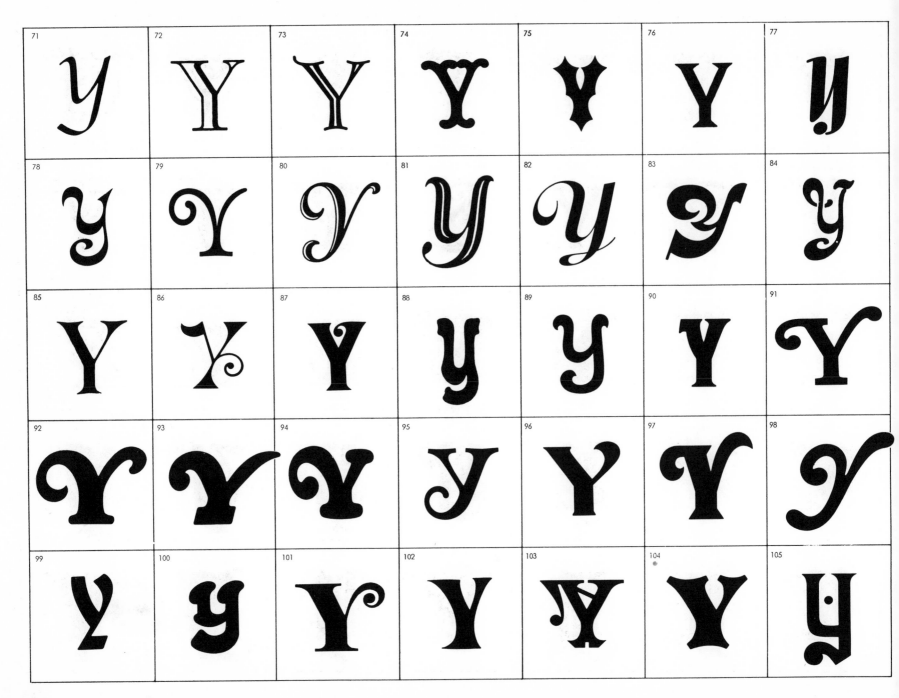

106	107	108	109	110	111	112
113	114	115	116	117	118	119
120	121	122	123	124	125	126
127	128	129	130	131	132	133
134	135	136	137	138	139	140

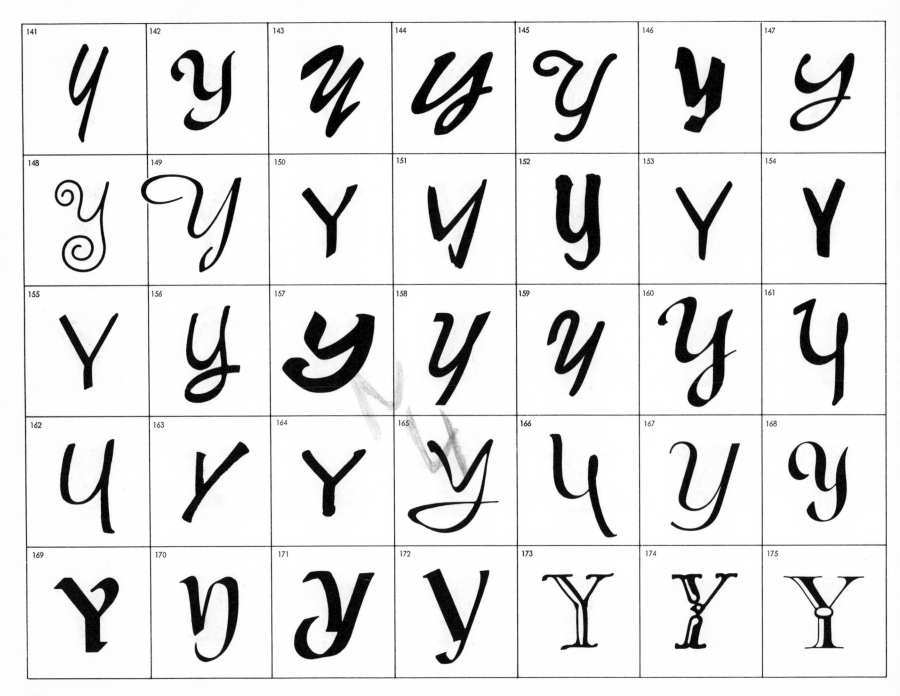

246

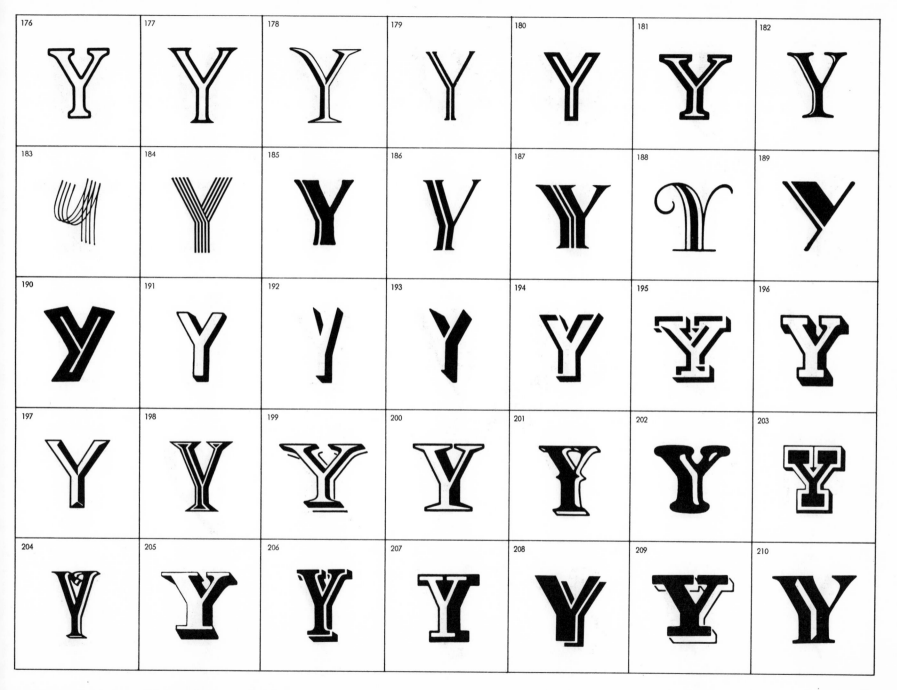

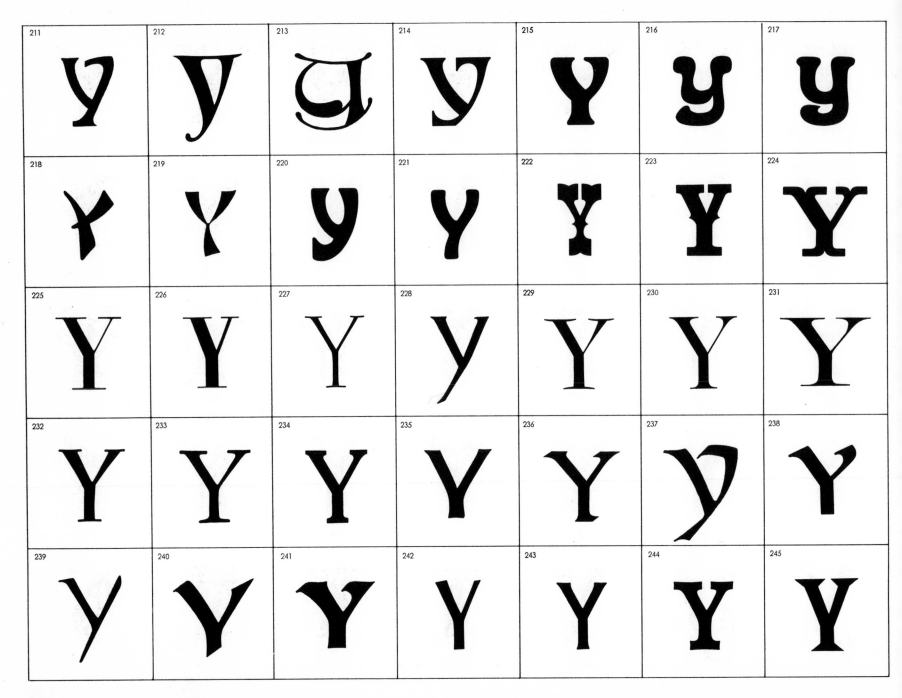

246	247	248	249	250	251	252
Y	Y	Y	Y	y	Y	Y

253	254	255	256	257	258	259
Y	Y	Y	Y	Y	Y	Y

260	261	262	263	264	265	266
Y	Y	Y	Y	Y	Y	Y

267	268	269	270	271	272	273
Y	Y	Y	Y	Y	Y	Y

274	275	276	277	278	279	280
y	y	Y	Y	Y	Y	y

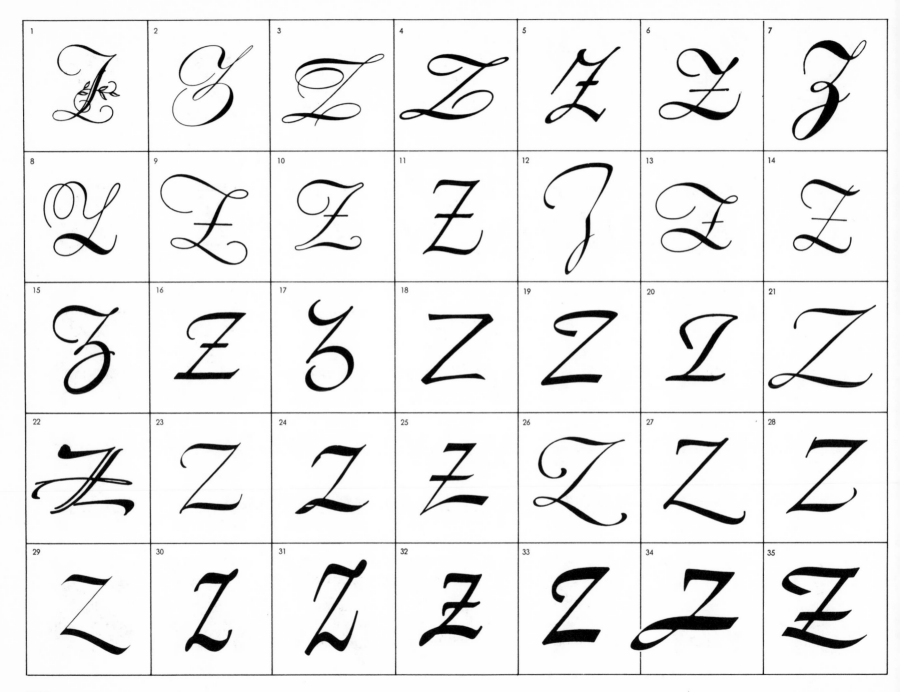

71	72	73	74	75	76	77
Z	Z	Z	Z	Z	Z	Z

78	79	80	81	82	83	84
Z	Z	Z	Z	Z	Z	Z

85	86	87	88	89	90	91
Z	Z	Z	Z	Z	Z	Z

92	93	94	95	96	97	98
Z	Z	Z	Z	Z	Z	Z

99	100	101	102	103	104	105
Z	Z	Z	Z	Z	Z	Z

106 107 108 109 110 111 112

113 114 115 116 117 118 119

120 121 122 123 124 125 126

127 128 129 130 131 132 133

134 135 136 137 138 139 140

141 142 143 144 145 146 147

148 149 150 151 152 153 154

155 156 157 158 159 160 161

162 163 164 165 166 167 168

169 170 171 172 173 174 175

176 177 178 179 180 181 182
183 184 185 186 187 188 189
190 191 192 193 194 195 196
197 198 199 200 201 202 203
204 205 206 207 208 209 210

211	212	213	214	215	216	217
218	219	220	221	222	223	224
225	226	227	228	229	230	231
232	233	234	235	236	237	238
239	240	241	242	243	244	245

258

LOWER CASE

jklmnopqrstuvwxyzabcdefghijklmnopqrstuvwxyzabcdefghijklmnopqrstuvwxyzabcdefghijklmnopqrstuvwxyz

2

abcdefghijklmnopqrstuvwxyz

3

abcdefghijklmnopqrstuvwxyz

4

abcdefghijklmnopqrstuvwxyz

5

abcdefghijklmnopqrstuvwxyz

6

abcdefghijklmnopqrstuvwxyz

All lower case alphabets correspond to their capitals by grid numbers. Wherever a lower case alphabet has not been designed, the grid number is omitted.

7 abcdefghijklmnopqrstuvwxyz

8 abcdefghijklmnopqrstuvwxyz

10 abcdefghijklmnopqrstuvwxyz

11 abcdefghijklmnopqrstuvwxyz

12 abcdefghijklmnopqrstuvwxyz

13 abcdefghijklmnopqrstuvwxyz

14 abcdefghijklmnopqrstuvwxyz

15 abcdefghijklmnopqrstuvwxyz

16 abcdefghijklmnopqrstuvwxyz

17 abcdefghijklmnopqrstuvwxyz

18 abcdefghijklmnopqrstuvwxyz

19 abcdefghijklmnopqrstuvwxyz

20 abcdefghijklmnopqrstuvwxyz

21 abcdefghijklmnopqrstuvwxyz

23 abcdefghijklmnopqrstuvwxyz

All lower case alphabets correspond to their capitals by grid numbers. Wherever a lower case alphabet has not been designed, the grid number is omitted.

24

abcdefghijklmnopqrstuvwxyx

25

abcdefghijklmnopqrstuvwxyz

26

abcdefghijklmnopqrstuvwxyz

27

abcdefghijklmnopqrstuvwxyz

28

abcdefghijklmnopqrstuvwxyz

29

abcdef ghijklmnopqrstuvwxyz

30

abcdefghijklmnopqrstuvwxyz

31

abcdefghijklmnopqrstuvwxyz

32

abcdefghijklmnopqrstuvwxyz

33

abcdefghijklmnopqrstuvwxyz

34

abcdefghijklmnopqrstuvwxyz

35

abcdefghijklmnopqrstuvwxyz

38

abcdefghijklmnopqrstuvwxyz

40

abcdefghijklmnopqrstuvwxyz

41

abcdefghilmnoprstuvwxyz

44

abcdefghijklmnopqrstuvwxyz

45

abcdefghijklmnopqrstuvwxyz

46

abcdefghijklmnopqrstuvwxyz

51

abcdefghijklmnopqrstuvwxyz

54

abcdefghijklmnopqrstuvwxyz

55

abcdefghijklmnopqrstuvwxyz

56

abcdefghijklmnopqrstuvwxyz

57

abcdefghijklmnopqrstuvwxyz

58

abcdefghijklmnopqrstuvwxyz

59

abcdefghijklmnopqrstuvwxyz

60 abcdefghijklmnopqrstuvwxyz

61 abcdefghijklmnopqrstuvwxyz

62 abcdefghijklmnopqrstuvwxyz

63 abcdefghijklmnopqrstuvwxyz

64 abcdefghijklmnopqrstuvwxyz

65 abcdefghijklmnopqrstuvwxyz

66 abcdefghijklmnopqrtsuvwxyz

67 abcdefghijklmnopqrstuvwxyz

68 abcdefghijklmnopqrtsuvwxyz

69 abcdefghijklmnopqrstuvwxyz

70

abcdefghijklmnopqrstuvwxyz

71

abcdefghijklmnopqrstuvwxyz

72

abcdefghijklmnopqrstuvwxyz

76

abcdefghijklmnopqrstuvwxyz

77

abcdefghijklmnopqrstuvwxyz

All lower case alphabets correspond to their capitals by grid numbers. Wherever a lower case alphabet has not been designed, the grid number is omitted.

275

78 abcdefghijklmnopqrstuvxyz

79 abcdefghijklmnopqrstuvwxyz

80 abcdefghijklmnopqrstuvwxyz

81 abcdefghijklmnopqrstuvwxyz

82 abcdefghijklmnopqrstuvwxyz

83

abcdefghijklmnopqrstuvwxyz

84

abcdefghijklmnopqrstuvwxyz

85

abcdefghijklmnopqrstuvwxyz

86

abcdefghijklmnopqrstuvwxyz

88

abcdefghijklmnopqrstuvwxyz

89 abcdefghijklmnopqrstuvwxyz

90 abcdefghijklmnopqrstuvwxyz

91 abcdefghijklmnopqrstuvwxyz

92 abcdefghijklmnopqrstuvwxyz

93 abcdefghijklmnopqrstuvwxyz

94

abcdefghijklmnopqrstuvwxyz

96

abcdefghijklmnopqrstuvwxyz

97

abcdefghijklmnopqrstuvwxyz

98

abcdefghijklmnopqrstuvwx yz

99

abcdefghijklmnopqrstuvwxyz

100

abcdefghijklmnopqrstuvwxyz

101

abcdefghijklmnopqrstuvwxyz

102

abcdefghijklmnopqrstuvwxyz

103

abcdefghijklmnopqrstuvwxyz

104

abcdefghijklmnopqrstuvwxyz

105

abcdefghijklmnopqrstuvwxyz

109

abcdefghijklmnopqrstuvwxyz

110

abcdefghijklmnopqrstuvwxyz

115

abcdefghijklmnopqrstuvwxyz

117

abcdefghijklmnopqrstuvwxyz

118

abcdefghijklmnopqrstuvwxyz

119

abcdefghijklmnoprstuvwxyz

120

abcdefghijklmnopqrstuvwxyz

122

abcdefghijklmnopqrstuvwxyz

124

abcdefghijklmnopqrstuvwxyz

126
abcdefghijklmnopqrstuvwxyz

128
abcdefghijklmnopqrstuvwxyz

129
abcdefghijklmnopqrstuvwxyz

133
abcdefghijklmnopqrstuvwxyz

abcdefghijklmnopqrstuvwxyz

All lower case alphabets correspond to their capitals by grid numbers. Wherever a lower case alphabet has not been designed, the grid number is omitted.

abcdefghijklmnopqrstuvwxyz

abcdefghijklmnopqrstuvwxyz

138

abcdefghijklmnopqrstuvwxyz

abcdefghijklmnopqrstuvwxyz

140

abcdefghijklmnopqrstuvwxyz

141

abcdefghijklmnopqrstuvwxyz

142

abcdefghijklmnopqrstuvwxyz

143

abcdefghijklmnopqrstuvwxyz

144

abcdefghijklmnopqrstuvwxyz

145

abcdefghijklmnopqrstuvwxyz

146 abcdefghijklmnopqrstuvwxyz

147 abcdefghijklmnopqrstuvwxyz

148 abcdefghijklmnopqrstuvwxyz

149 abcdefghijklmnopqrsstuvwxyzz

151 abcdefghijklmnopqrstuvwxyz

abcdefghijklmnopqrstuvwxyz

abcdefghijklmnopqrstuvwxyz

abcdefghijklmnopqrstuvwxyz

abcdefghijklmnopqrstuvwxyz

abcdefghijklmnopqrstuvwxyz

All lower case alphabets correspond to their capitals by grid numbers. Wherever a lower case alphabet has not been designed, the grid number is omitted.

157

abcdefghijklmnopqrstuvwxyz

158

abcdefghijklmnopqrstuvwxyz

159

abcdefghijklmnopqrstuvwxyz

160

abcdefghijklmnopqrstuvwxyz

161

abcdefghijklmnopqrstuvwxyz

162

abcdefghijklmnopqrstuvwxyz

163

abcdefghijklmnopqrstuvwxyz

164

abcdefghijklmnopqrstuvwxyz

165

abcdefghijklmnopqrstuvwxyz

166

abcdefghiljklmnopqrstuvwxyz

167

abcdefghijklmnopqrstuvwxyz

168

abcdefghijklmnopqrstuvwxyz

169

abcdefghijklmnopqrstuvwxyz

170

abcdefghijklmnopqrstuvwxyz

171

abcdefghijklmnopqrstuvwxyz

172

ABCDEFGHIJKLMNOPQRSTUVWXYZ

176

abcdefghijklmnopqrstuvwxyz

181

abcdefghijklmnopqrstuvwxyz

182

abcdefghijklmnopqrtsuvwxyz

183

abcdefghijklmnopqrstuvwxyz

All lower case alphabets correspond to their capitals by grid numbers. Wherever a lower case alphabet has not been designed, the grid number is omitted.

186

abcdefghijklmnopqrstuvwxyz

194

abcdefghijklmnopqrstuvwxyz

198

abcdefghijklmnopqrstuvwxyz

202

abcdefghijklmnopqrstuvwxyz

204

abcdefghijklmnopqrstuvwxyz

206

abcdefghijklmnopqrstuvwxyz

208

abcdefghijklmnopqrstuvwxyz

211

abcdefghijklmnopqrstuvwxyz

212

abcdefghijklmnopqrstuvwxyz

214

abcdefghijklmnopqrstuvwxyz

215

abcdefghijklmnopqrstuvwxyz

220

abcdefghijklmnopqrstuvwxyz

221

abcdefghijklmnopqrstuvwxyz

223

abcdefghijklmnopqrstuvwxyz

224

abcdefghijklmnopqrstuvwxyz

225

abcdefghijklmnopqrtsuvwxyz

226

abcdefghijklmnopqrstuvwxyz

228

abcdefghijklmnopqrstuvwxyz

229

abcdefghijklmnopqrstuvwxyz

230

abcdefghijklmnopqrstuvwxyz

All lower case alphabets correspond to their capitals by grid numbers. Wherever a lower case alphabet has not been designed, the grid number is omitted.

233
abcdefghijklmnopqrstuvwxyz

234
abcdefghijklmnopqrrstuvwxyz

235
abcdefghijklmnopqrstuvwxyz

236
abcdefghijklmnopqrstuvwxyz

238
abcdefghijklmnopqrstuvwxyz

239 abcdefghijklmnopqrstuvwxyz

240 abcdefghijklmnopqrstuvwxyz

241 abcdefghijklmnopqrstuvwxyz

242 abcdefghijklmnopqrstuvwxyz

243 abcdefghijklmnopqrstuvwxyz

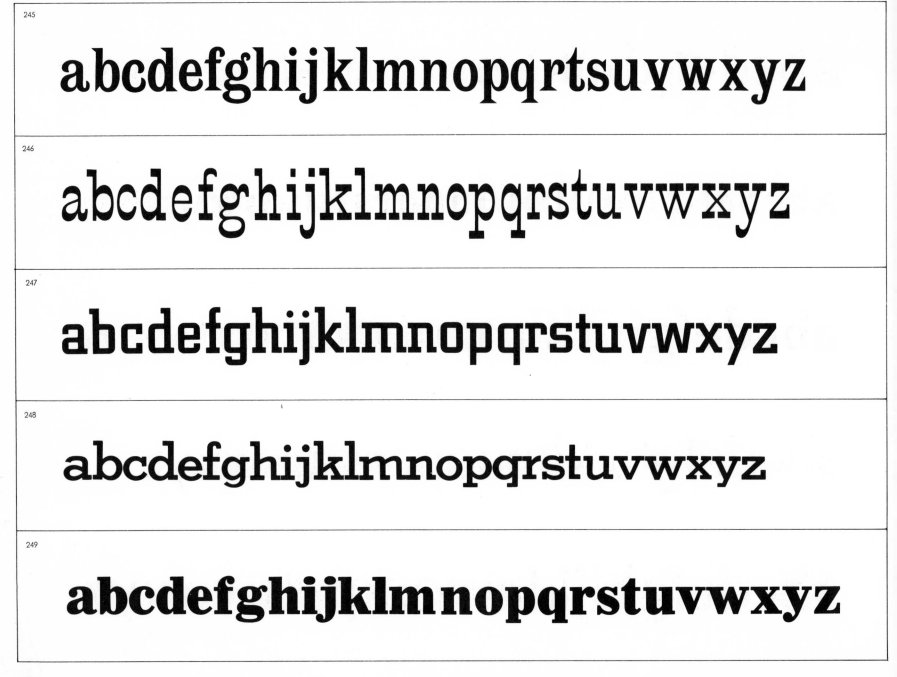

245

abcdefghijklmnopqrtsuvwxyz

246

abcdefghijklmnopqrstuvwxyz

247

abcdefghijklmnopqrstuvwxyz

248

abcdefghijklmnopqrstuvwxyz

249

abcdefghijklmnopqrstuvwxyz

251

abcdefghijklmnopqrstuvwxyz

252

abcdefghijklmnopqrstuvwxyz

253

abcdefghijklmnopqrstuvwxyz

254

abcdefghijklmnopqrstuvwxyz

257

abcdefghijklmnopqrstuvwxyz

All lower case alphabets correspond to their capitals by grid numbers. Wherever a lower case alphabet has not been designed, the grid number is omitted.

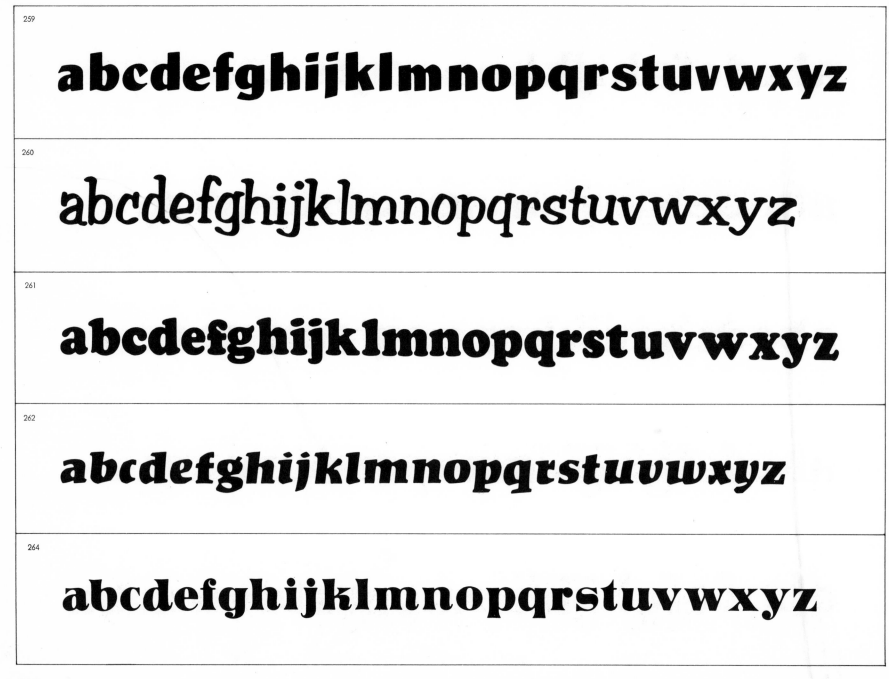

259 abcdefghijklmnopqrstuvwxyz

260 abcdefghijklmnopqrstuvwxyz

261 abcdefghijklmnopqrstuvwxyz

262 abcdefghijklmnopqrstuvwxyz

264 abcdefghijklmnopqrstuvwxyz

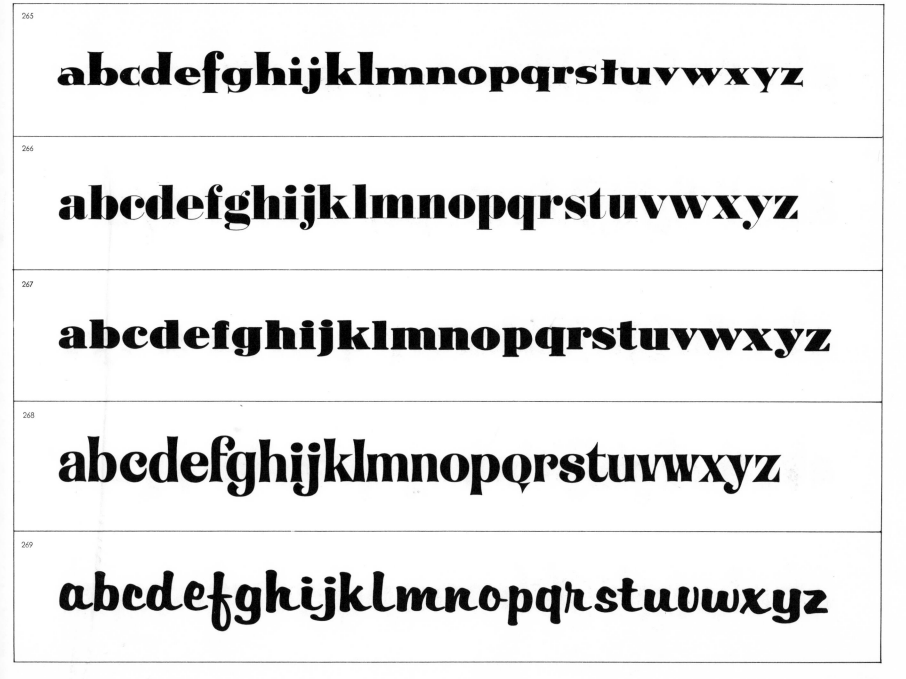

265 abcdefghijklmnopqrstuvwxyz

266 abcdefghijklmnopqrstuvwxyz

267 abcdefghijklmnopqrstuvwxyz

268 abcdefghijklmnopqrstuvwxyz

269 abcdefghijklmnopqrstuvwxyz

270

abcdefghijklmnopqrstuvwxyz

271

abcdefghijklmnopqrstuvwxyz

272

abcdefghijklmnopqrstuvwxyz

273

abcdefghijklmnopqrstuvwxyz

274

abcdefghijklmnopqrstuvwxyz

275

abcdefghijklmnopqrstuvwxyz

278

abcdefghijklmnopqrstuvwxyz

279

abcdefghijklmnopqrtsuvwxyz

NUMERALS

567890123456789012345678901234567890123456789012345678901234567890123456789012345678901234567890123456789012345678901234567890

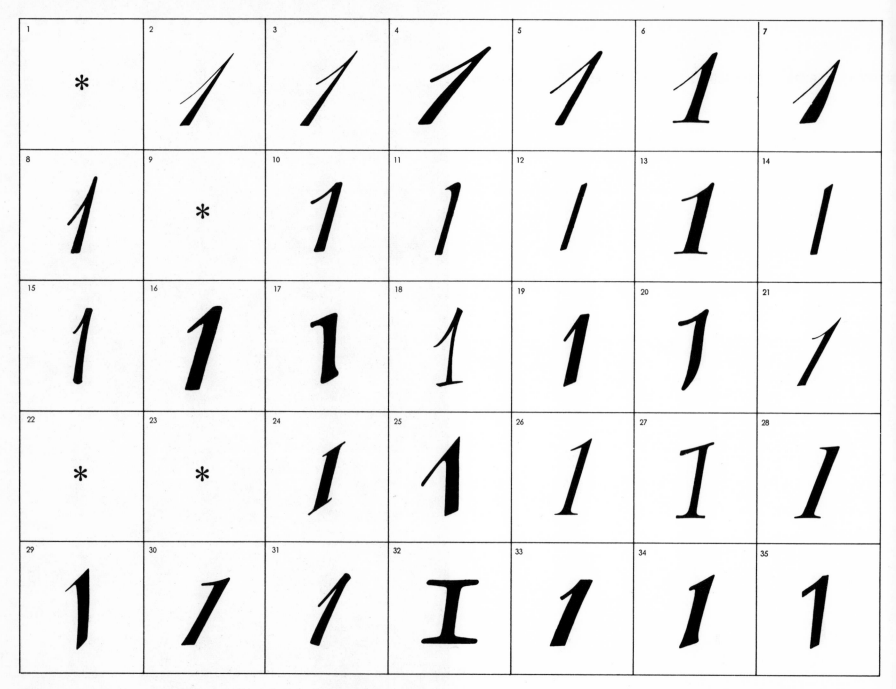

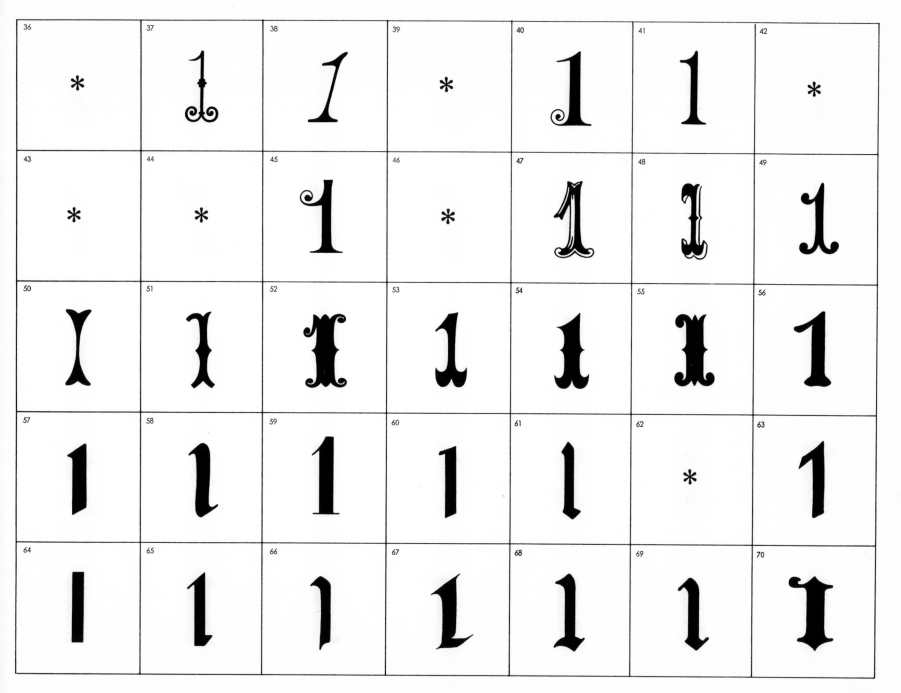

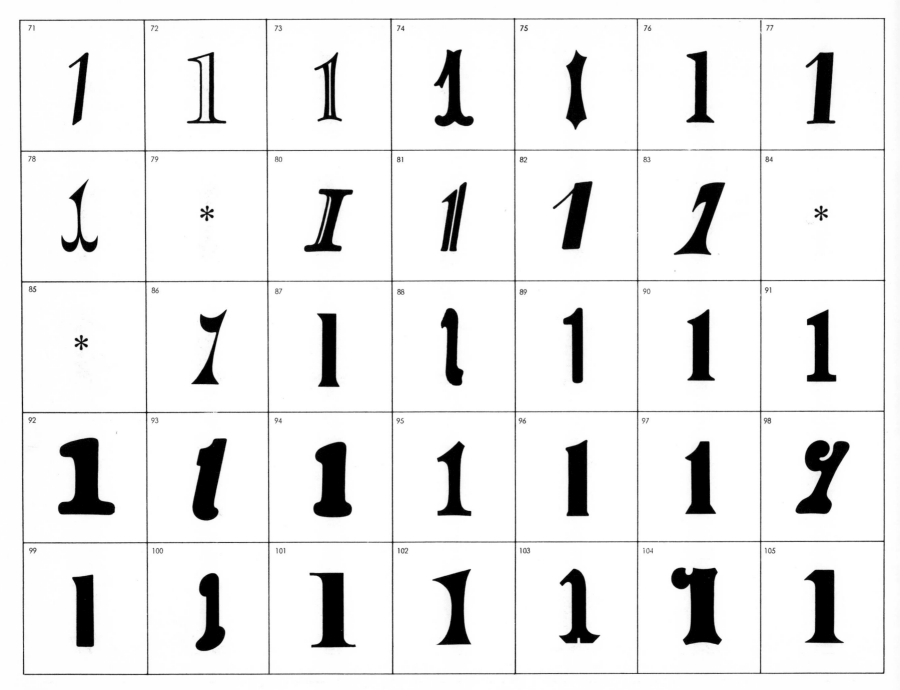

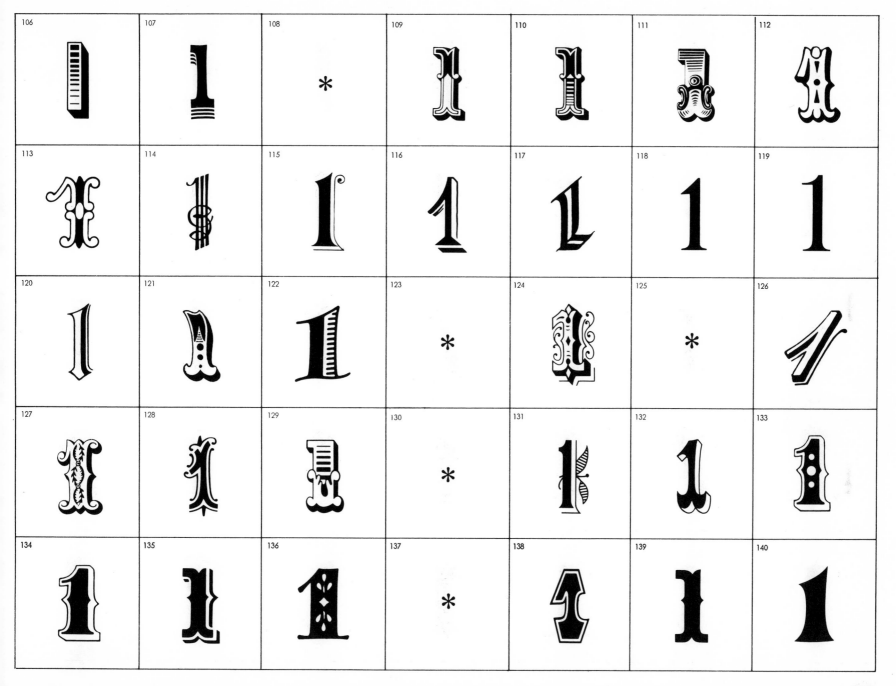

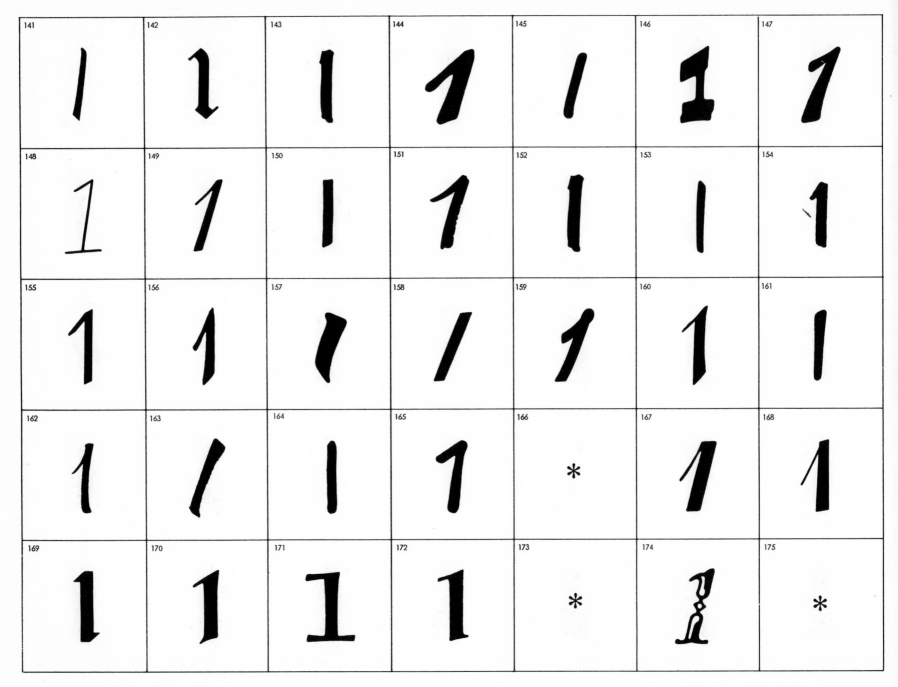

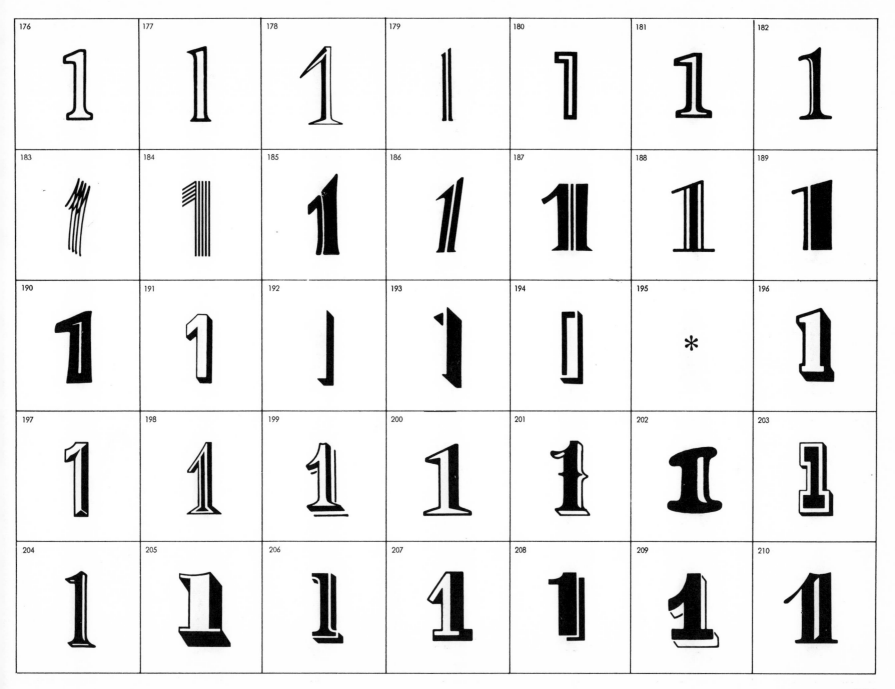

311

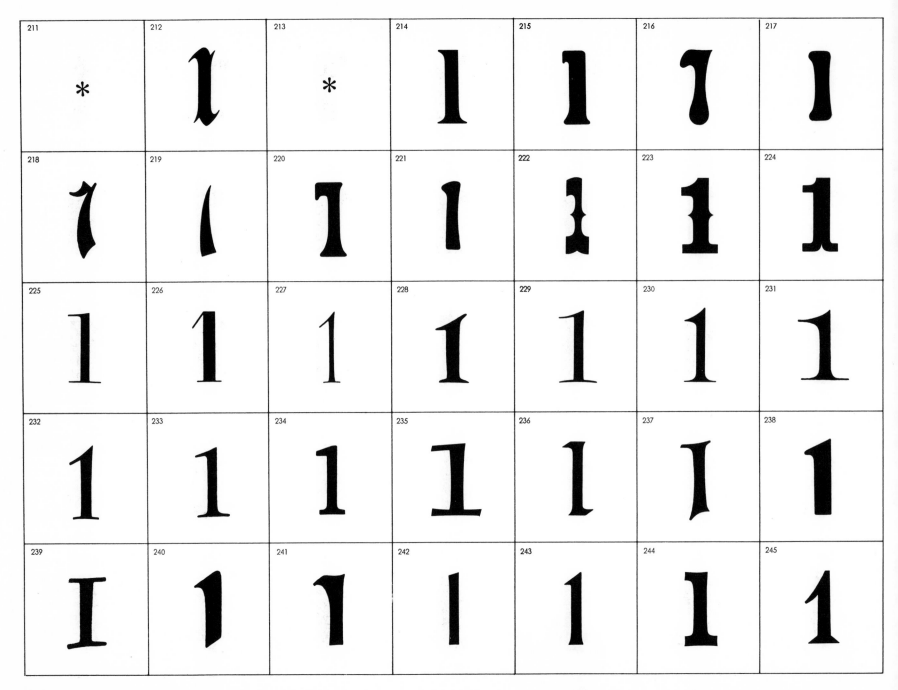

36 *	37	38	39 *	40	41	42 *
43 *	44 *	45	46 *	47	48	49
50	51	52	53	54	55	56
57	58	59	60	61	62 *	63
64	65	66	67	68	69	70

*Denotes that no numerals have been designed.

317

106	107	108 *	109	110	111	112
113	114	115	116	117	118	119
120	121	122	123 *	124	125 *	126
127	128	129	130 *	131	132	133
134	135	136	137 *	138	139	140

141	142	143	144	145	146	147
2	2	2	2	2	2	2

148	149	150	151	152	153	154
2	2	2	2	2	2	2

155	156	157	158	159	160	161
2	2	2	2	2	2	2

162	163	164	165	166	167	168
2	2	2	2	*	2	2

169	170	171	172	173	174	175
2	2	2	2	*	2	*

211	212	213	214	215	216	217
*	2	*	Z	Z	2	2

218	219	220	221	222	223	224
2	2	2	2	2	2	2

225	226	227	228	229	230	231
2	2	2	2	2	2	2

232	233	234	235	236	237	238
2	2	2	2	2	2	2

239	240	241	242	243	244	245
2	2	2	2	2	2	2

246	247	248	249	250	251	252
2	2	2	2	2	2	2

253	254	255	256	257	258	259
2	2	2	2	2	2	2

260	261	262	263	264	265	266
2	2	2	2	2	2	2

267	268	269	270	271	272	273
2	2	2	2	2	2	*

274	275	276	277	278	279	280
2	2	2	2	2	2	2

323

71	72	73	74	75	76	77
78	79	80	81	82	83	84
85	86	87	88	89	90	91
92	93	94	95	96	97	98
99	100	101	102	103	104	105

36 *	37 3	38 3	39 *	40 3	41 3	42 *
43 *	44 *	45 3	46 *	47 3	48 3	49 3
50 3	51 3	52 3	53 3	54 3	55 3	56 3
57 3	58 3	59 3	60 3	61 3	62 *	63 3
64 3	65 3	66 3	67 3	68 3	69 3	70 3

*Denotes that no numerals have been designed.

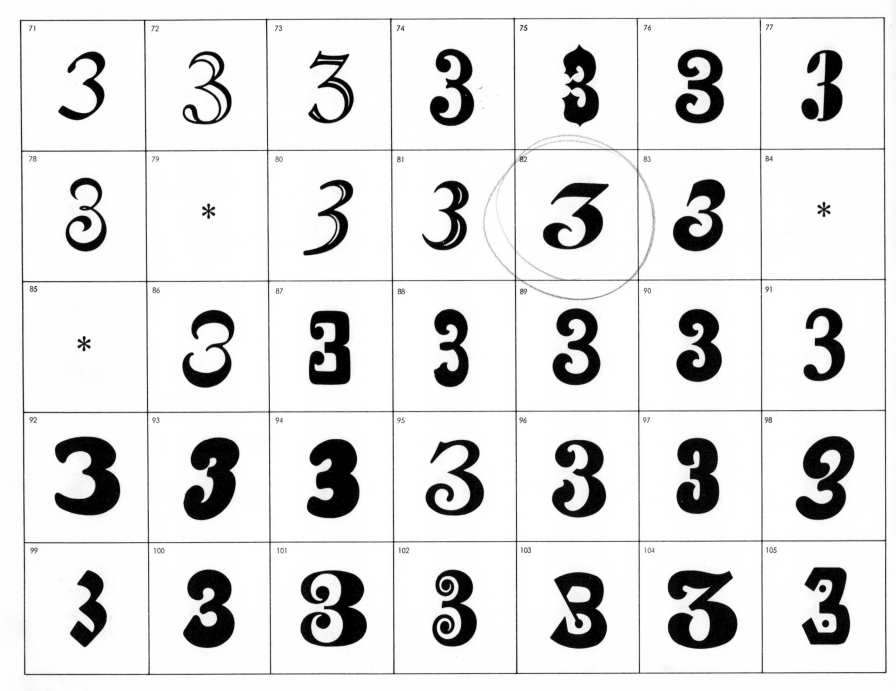

106	107	108	109	110	111	112
3	3	*	3	3	3	3

113	114	115	116	117	118	119
3	3	3	3	3	3	3

120	121	122	123	124	125	126
3	3	3	*	3	*	3

127	128	129	130	131	132	133
3	3	3	*	3	3	3

134	135	136	137	138	139	140
3	3	3	*	3	3	3

141	142	143	144	145	146	147
3	3	3	3	3	3	3

148	149	150	151	152	153	154
3	3	3	3	3	3	3

155	156	157	158	159	160	161
3	3	3	3	3	3	3

162	163	164	165	166	167	168
3	3	3	3	*	3	3

169	170	171	172	173	174	175
3	3	3	3	*	3	*

176	177	178	179	180	181	182
3	3	3	3	3	3	3

183	184	185	186	187	188	189
3	3	3	3	3	3	3

190	191	192	193	194	195	196
3	3	3	3	3	*	3

197	198	199	200	201	202	203
3	3	3	3	3	3	3

204	205	206	207	208	209	210
3	3	3	3	3	3	3

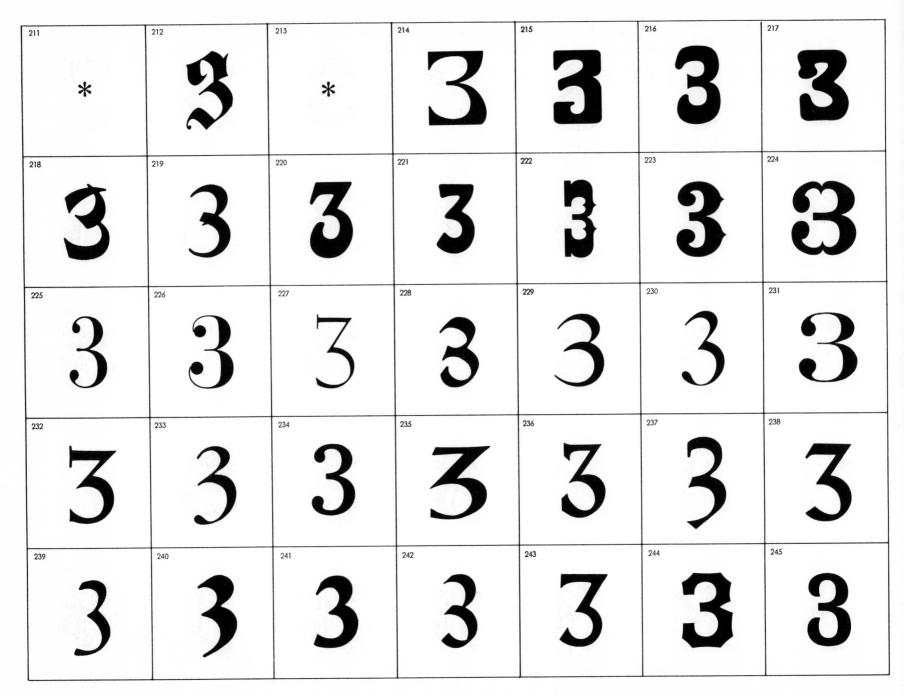

246	247	248	249	250	251	252
3	3	3	3	3	3	3
253	254	255	256	257	258	259
3	3	3	3	3	3	3
260	261	262	263	264	265	266
3	3	3	3	3	3	3
267	268	269	270	271	272	273
3	3	3	3	3	3	*
274	275	276	277	278	279	280
3	3	3	3	3	3	3

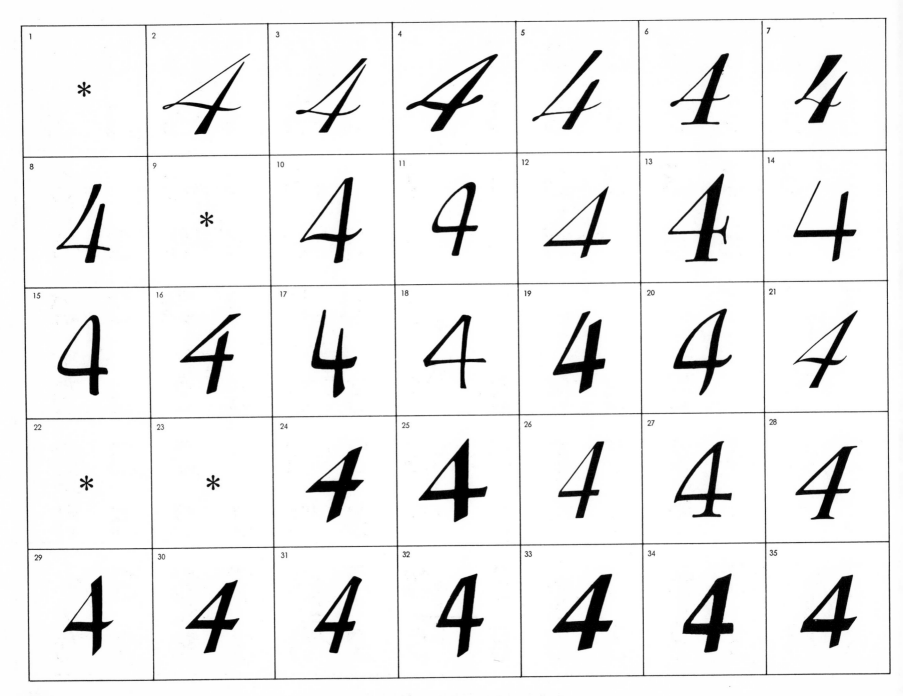

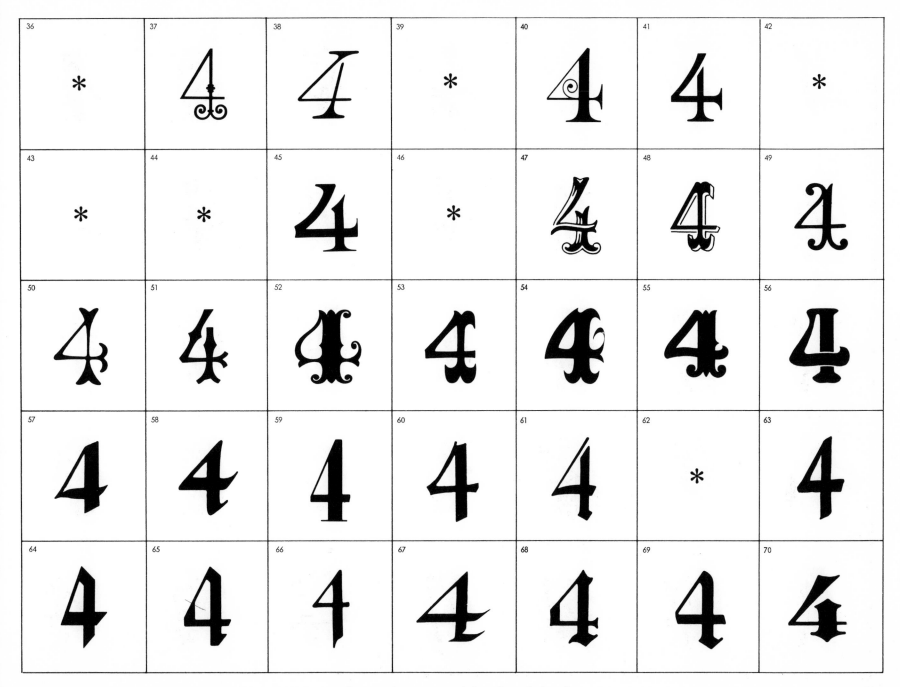

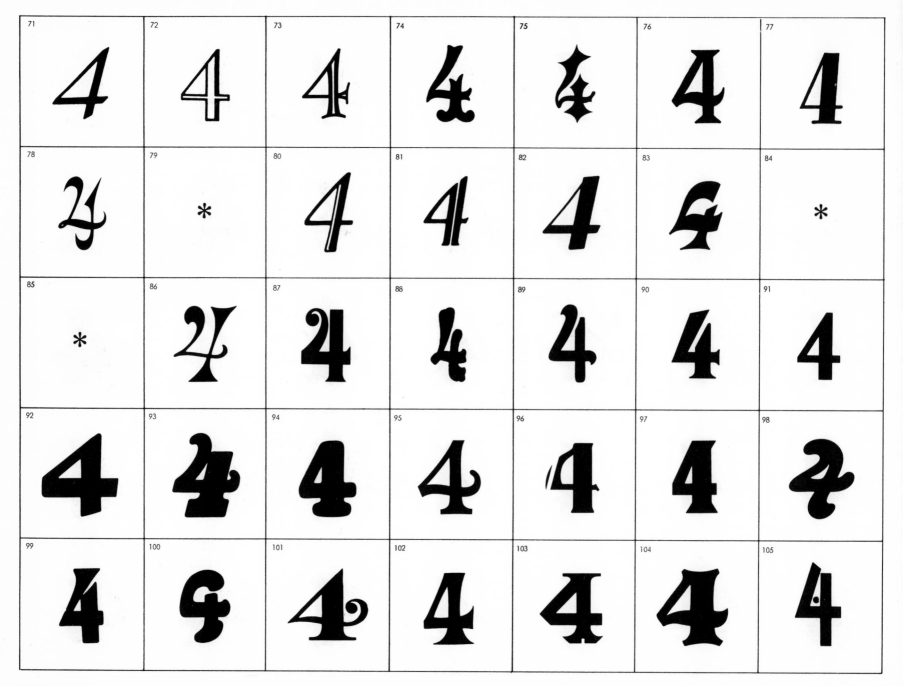

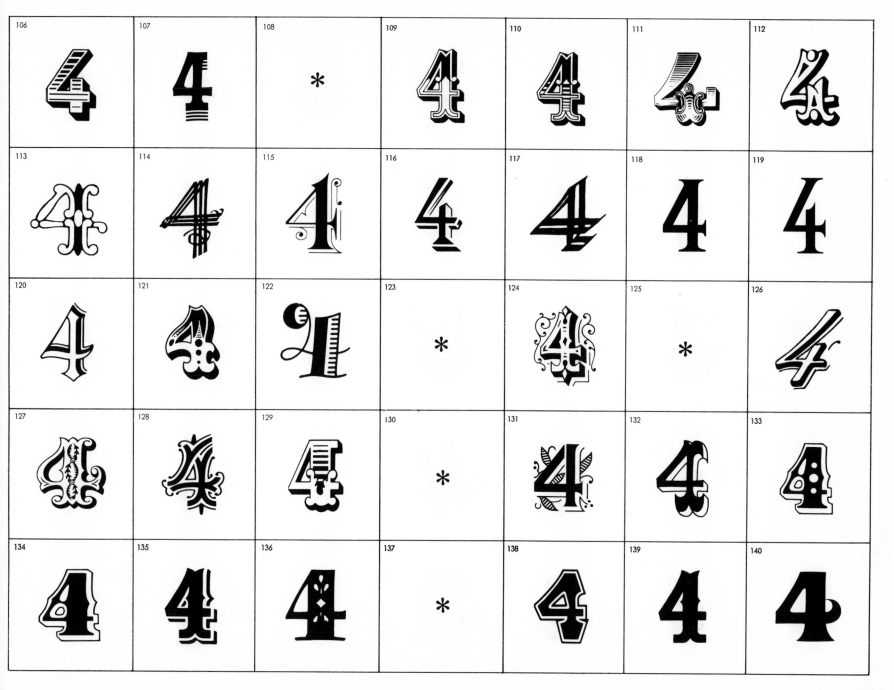

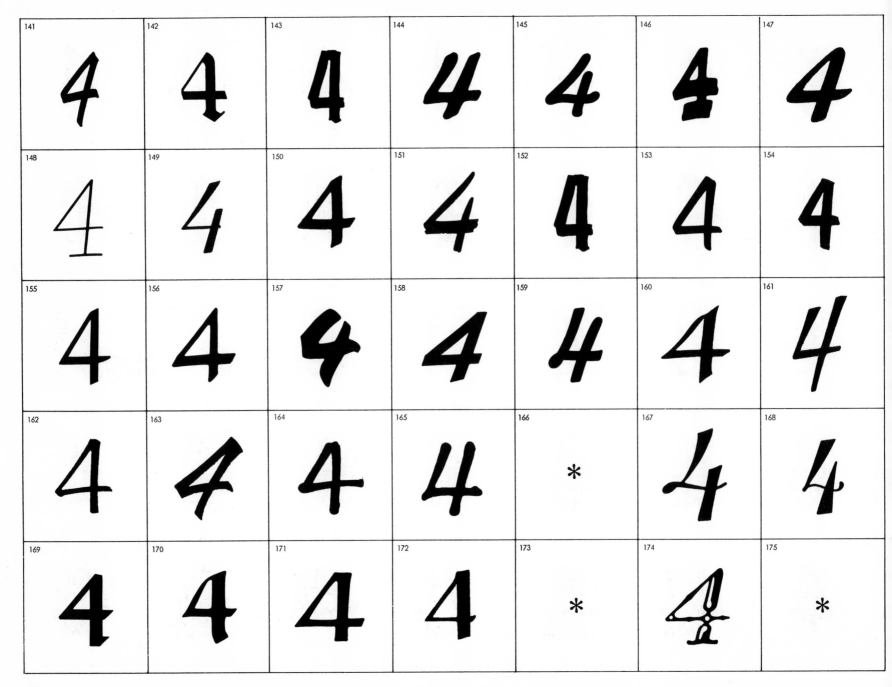

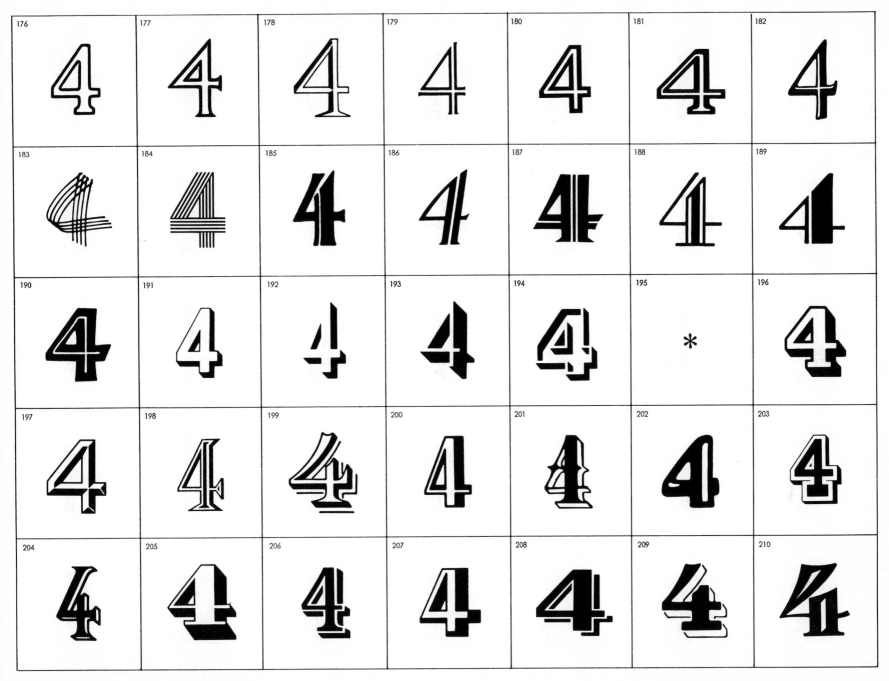

246	247	248	249	250	251	252
253	254	255	256	257	258	259
260	261	262	263	264	265	266
267	268	269	270	271	272	273 *
274	275	276	277	278	279	280

336

337

338

339

340

341

342

343

36	37	38	39	40	41	42
*	5	5	*	5	5	*
43	44	45	46	47	48	49
*	*	5	*	5	5	5
50	51	52	53	54	55	56
5	5	5	5	5	5	5
57	58	59	60	61	62	63
5	5	5	5	5	*	5
64	65	66	67	68	69	70
5	5	5	5	5	5	5

*Denotes that no numerals have been designed.

176	177	178	179	180	181	182
5	5	5	5	5	5	5

183	184	185	186	187	188	189
5	5	5	5	5	5	5

190	191	192	193	194	195	196
5	5	5	5	5	*	5

197	198	199	200	201	202	203
5	5	5	5	5	5	5

204	205	206	207	208	209	210
5	5	5	5	5	5	5

246	247	248	249	250	251	252
5	5	5	5	5	5	5

253	254	255	256	257	258	259
5	5	5	5	5	5	5

260	261	262	263	264	265	266
5	5	5	5	5	5	5

267	268	269	270	271	272	273
5	5	5	5	5	5	*

274	275	276	277	278	279	280
5	5	5	5	5	5	5

36	37	38	39	40	41	42
*	6	6	*	6	6	*

43	44	45	46	47	48	49
*	*	6	*	6	6	6

50	51	52	53	54	55	56
6	6	6	6	6	6	6

57	58	59	60	61	62	63
6	6	6	6	6	*	6

64	65	66	67	68	69	70
6	6	6	6	6	6	6

*Denotes that no numerals have been designed.

357

358

106	107	108 *	109	110	111	112
113	114	115	116	117	118	119
120	121	122	123 *	124	125 *	126
127	128	129	130 *	131	132	133
134	135	136	137 *	138	139	140

359

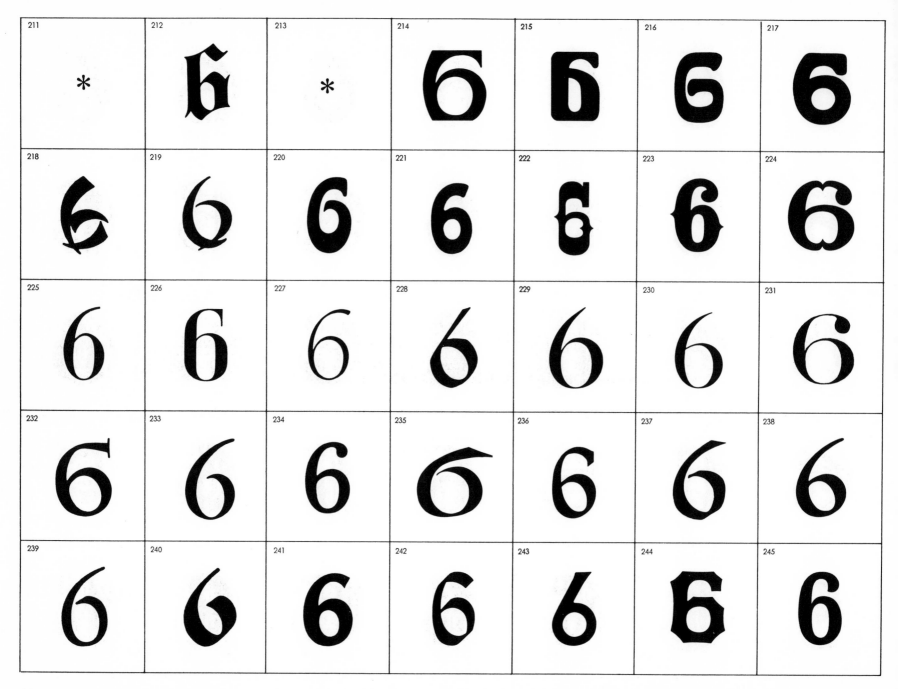

246 247 248 249 250 251 252

253 254 255 256 257 258 259

260 261 262 263 264 265 266

267 268 269 270 271 272 273 *

274 275 276 277 278 279 280

356

357

358

359

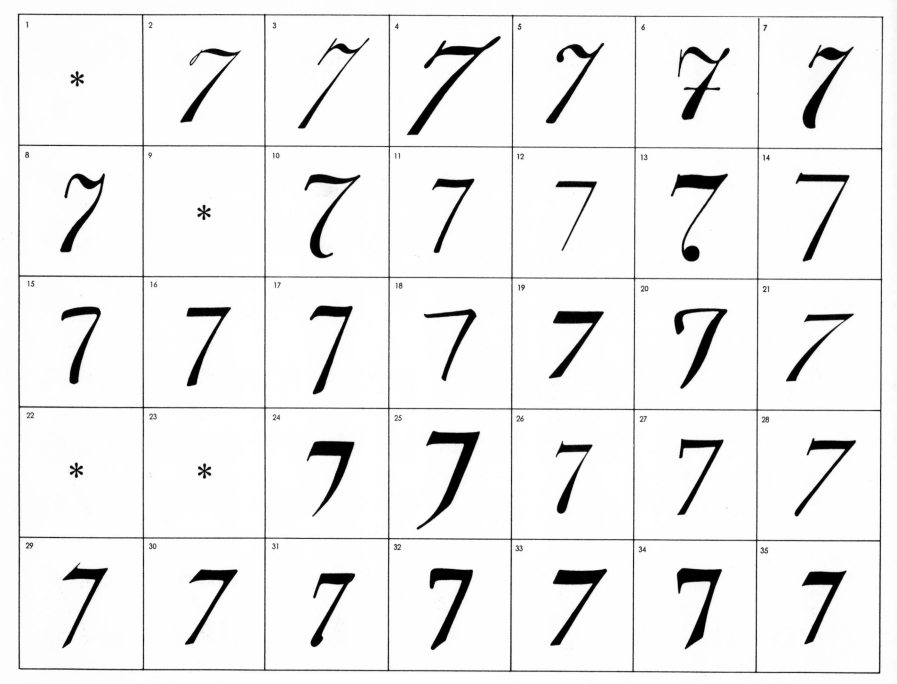

36	37	38	39	40	41	42
*	7	7	*	7	7	*

43	44	45	46	47	48	49
*	*	7	*	7	7	7

50	51	52	53	54	55	56
7	7	7	7	7	7	7

57	58	59	60	61	62	63
7	7	7	7	7	*	7

64	65	66	67	68	69	70
7	7	7	7	7	7	7

*Denotes that no numerals have been designed.

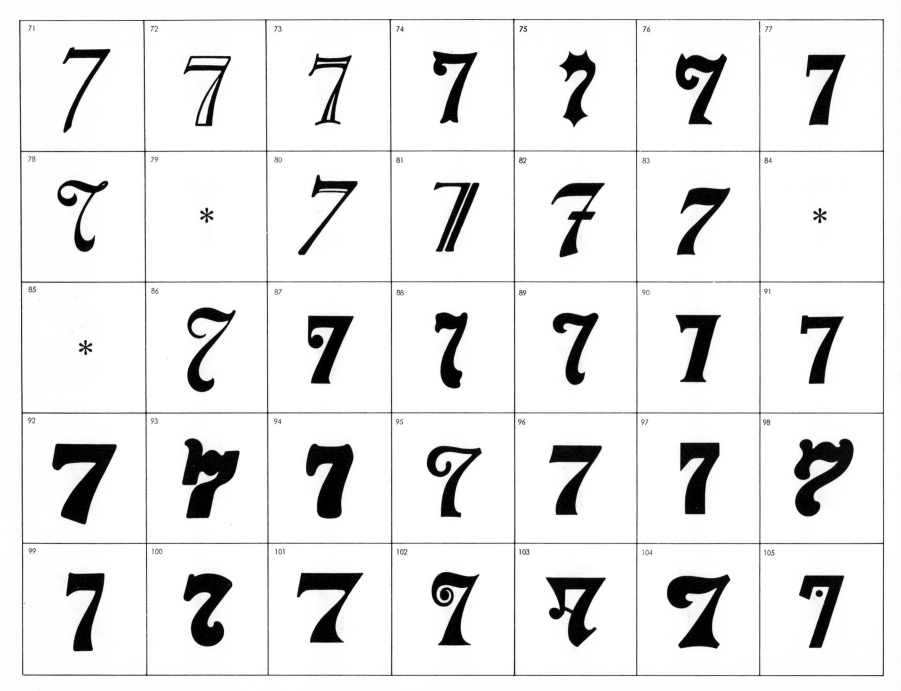

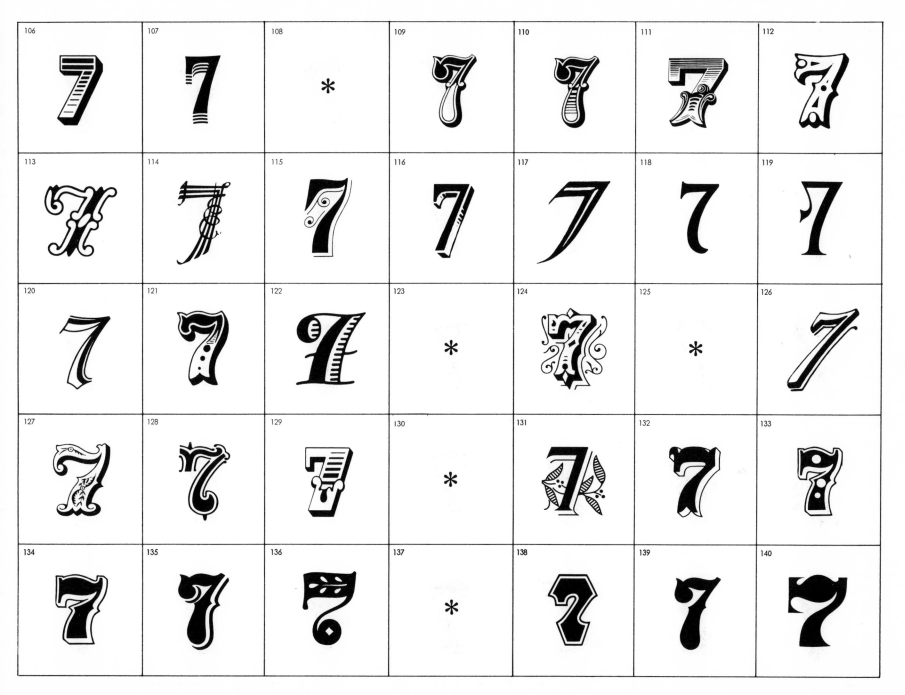

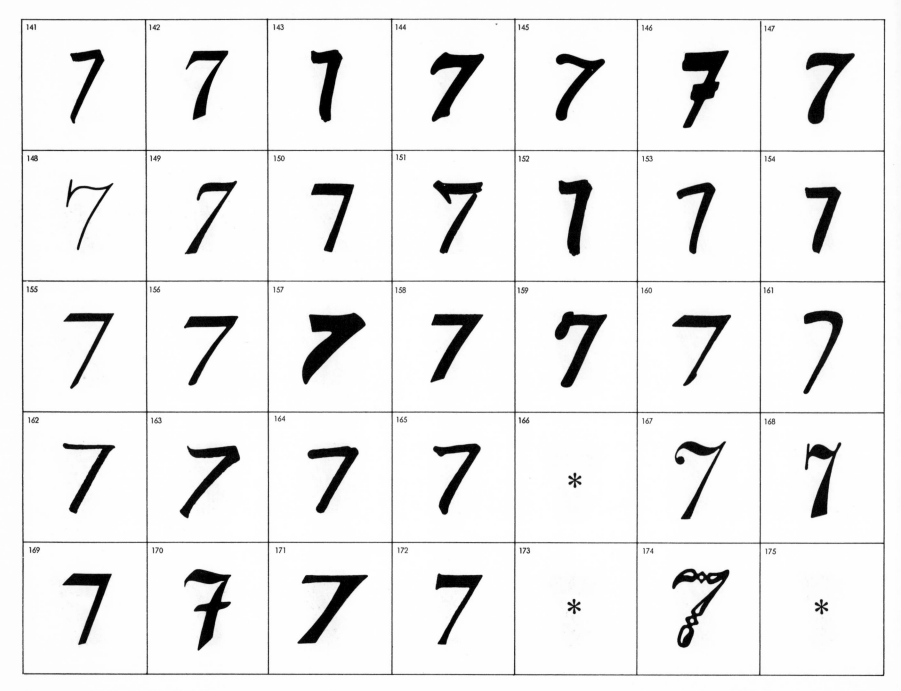

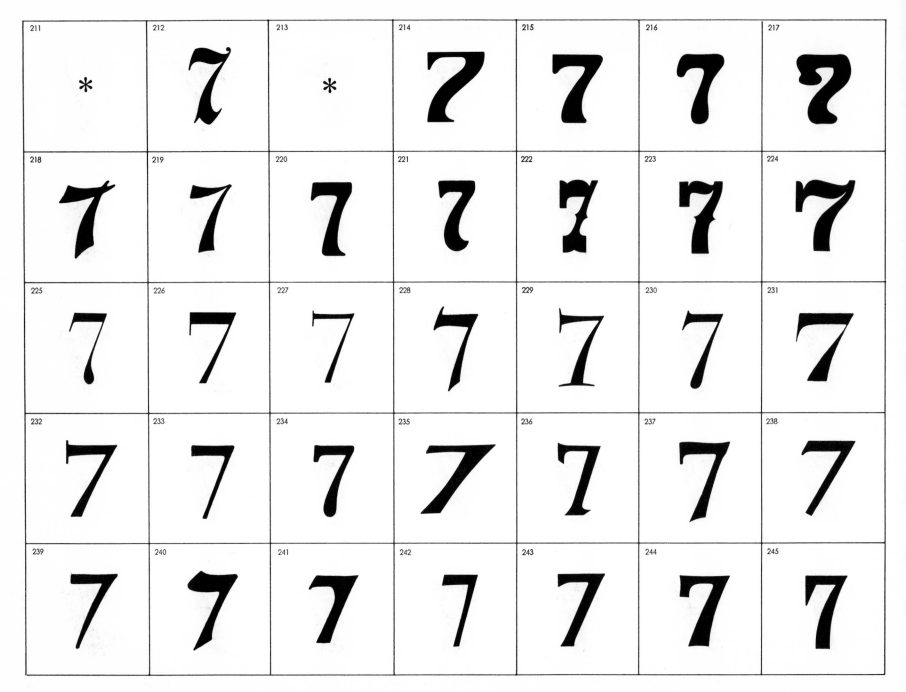

246	247	248	249	250	251	252
7	7	7	7	7	7	7

253	254	255	256	257	258	259
7	7	7	7	7	7	7

260	261	262	263	264	265	266
7	7	7	7	7	7	7

267	268	269	270	271	272	273
7	7	7	7	7	7	*

274	275	276	277	278	279	280
7	7	7	7	7	7	7

366

367

368

369

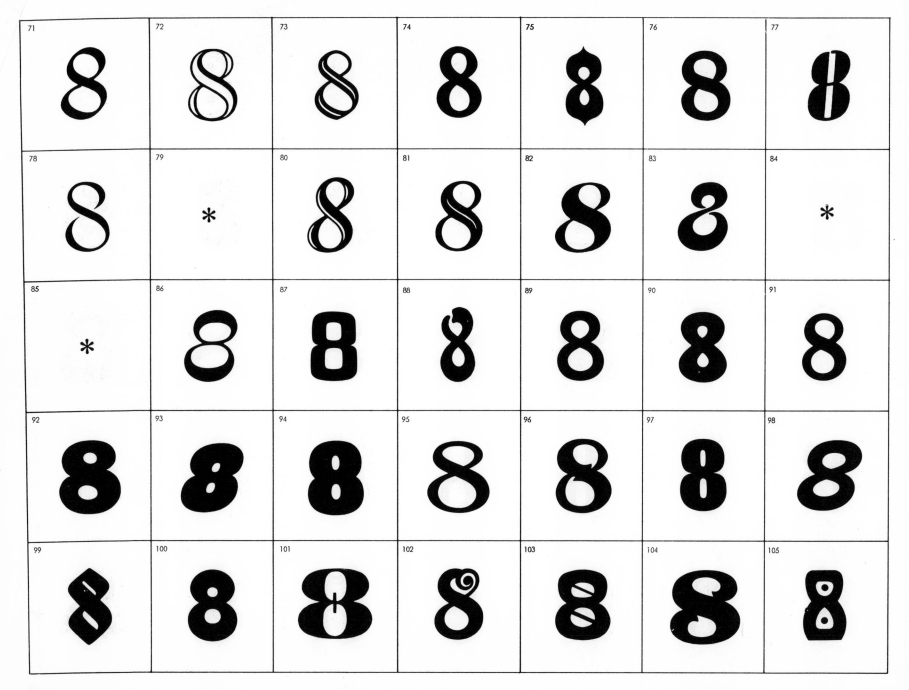

36	37	38	39	40	41	42
*	8	8	*	8	8	*

43	44	45	46	47	48	49
*	*	8	*	8	8	8

50	51	52	53	54	55	56
8	8	8	8	8	8	8

57	58	59	60	61	62	63
8	8	8	8	8	*	8

64	65	66	67	68	69	70
8	8	8	8	8	8	8

*Denotes that no numerals have been designed.

106	107	108	109	110	111	112
		*				
113	114	115	116	117	118	119
120	121	122	123	124	125	126
			*		*	
127	128	129	130	131	132	133
			*			
134	135	136	137	138	139	140
			*			

141	142	143	144	145	146	147
8	8	8	8	8	8	8

148	149	150	151	152	153	154
8	8	8	8	8	8	8

155	156	157	158	159	160	161
8	8	8	8	8	8	8

162	163	164	165	166	167	168
8	8	8	8	*	8	8

169	170	171	172	173	174	175
8	8	8	8	*	8	*

176 177 178 179 180 181 182
183 184 185 186 187 188 189
190 191 192 193 194 195 * 196
197 198 199 200 201 202 203
204 205 206 207 208 209 210

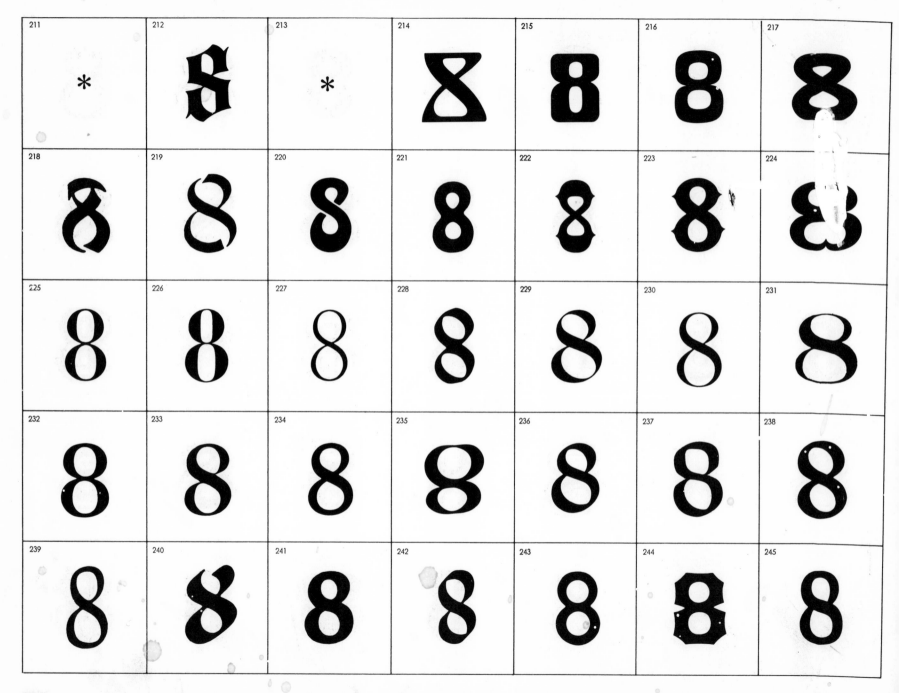

382

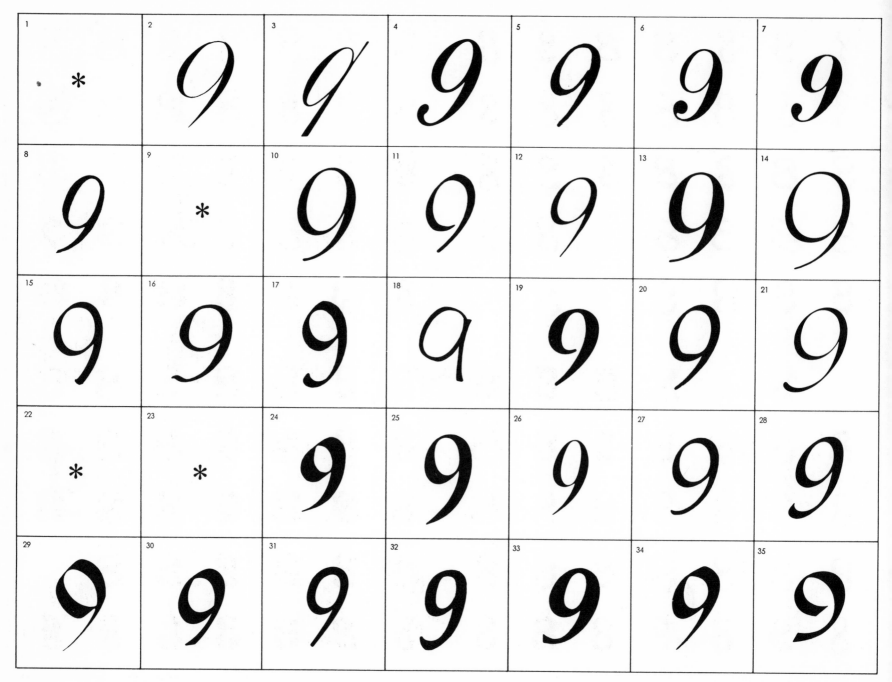

386

36 *	37	38	39 *	40	41	42 *
43 *	44 *	45	46 *	47	48	49
50	51	52	53	54	55	56
57	58	59	60	61	62 *	63
64	65	66	67	68	69	70

*Denotes that no numerals have been designed.

387

71	72	73	74	75	76	77
9	9	9	9	9	9	9

78	79	80	81	82	83	84
9	*	9	9	9	9	*

85	86	87	88	89	90	91
*	9	9	9	9	9	9

92	93	94	95	96	97	98
9	9	9	9	9	9	9

99	100	101	102	103	104	105
9	9	9	9	9	9	9

106	107	108 *	109	110	111	112
113	114	115	116	117	118	119
120	121	122	123 *	124	125 *	126
127	128	129	130 *	131	132	133
134	135	136	137 *	138	139	140

389

141	142	143	144	145	146	147
9	9	9	9	9	9	9

148	149	150	151	152	153	154
9	9	9	9	9	9	9

155	156	157	158	159	160	161
9	9	9	9	9	9	9

162	163	164	165	166	167	168
9	9	9	9	*	9	9

169	170	171	172	173	174	175
9	9	9	9	*	9	*

176 177 178 179 180 181 182
183 184 185 186 187 188 189
190 191 192 193 194 195 * 196
197 198 199 200 201 202 203
204 205 206 207 208 209 210

211	212	213	214	215	216	217
*	𝔤	*	9	9	9	9

218	219	220	221	222	223	224
9	9	9	9	9	9	9

225	226	227	228	229	230	231
9	9	9	9	9	9	9

232	233	234	235	236	237	238
9	9	9	9	9	9	9

239	240	241	242	243	244	245
9	9	9	9	9	9	9

246	247	248	249	250	251	252
253	254	255	256	257	258	259
260	261	262	263	264	265	266
267	268	269	270	271	272	273 *
274	275	276	277	278	279	280

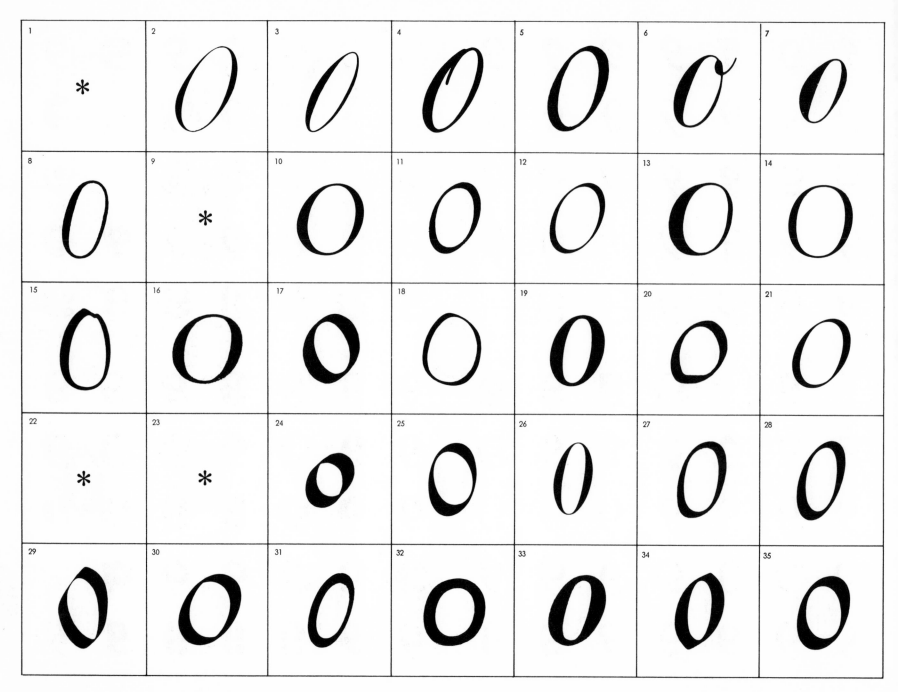

396

36 ✳	37	38	39 ✳	40	41	42 ✳
43 ✳	44 ✳	45	46 ✳	47	48	49
50	51	52	53	54	55	56
57	58	59	60	61	62 ✳	63
64	65	66	67	68	69	70

✳ *Denotes that no numerals have been designed.*

397

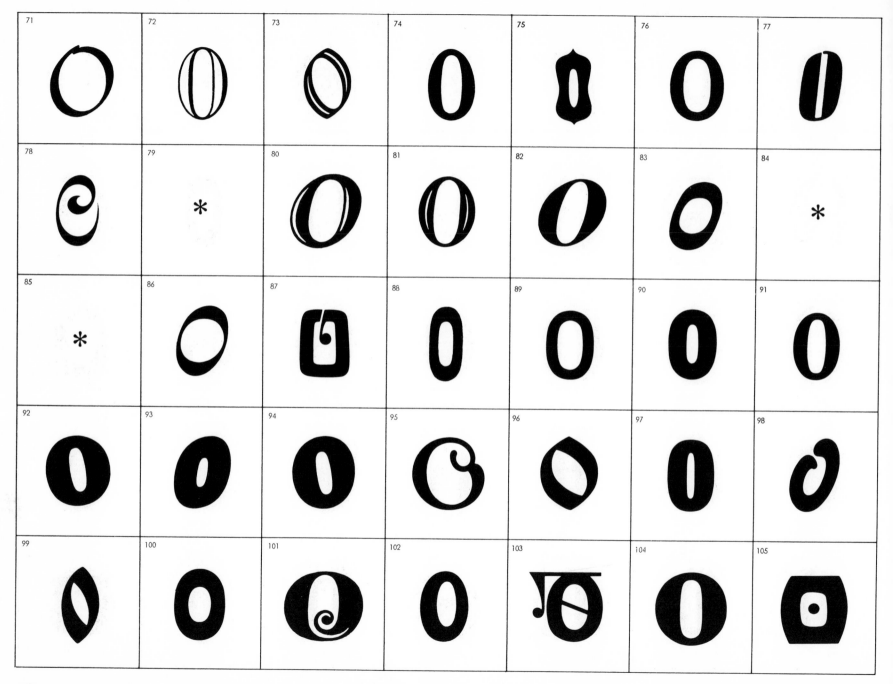

398

106	107	108 *	109	110	111	112
113	114	115	116	117	118	119
120	121	122	123 *	124	125 *	126
127	128	129	130 *	131	132	133
134	135	136	137 *	138	139	140

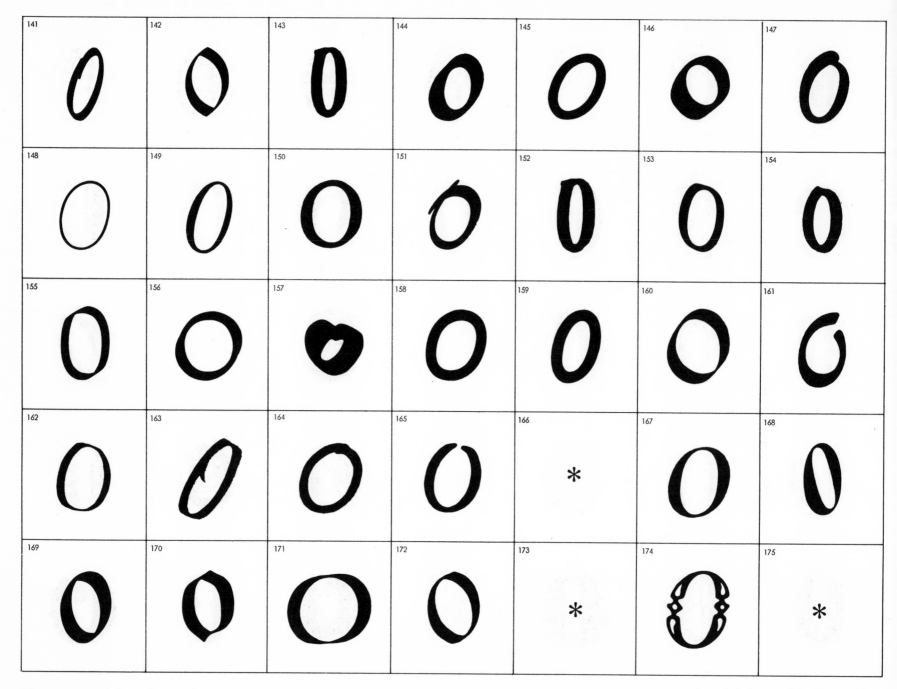

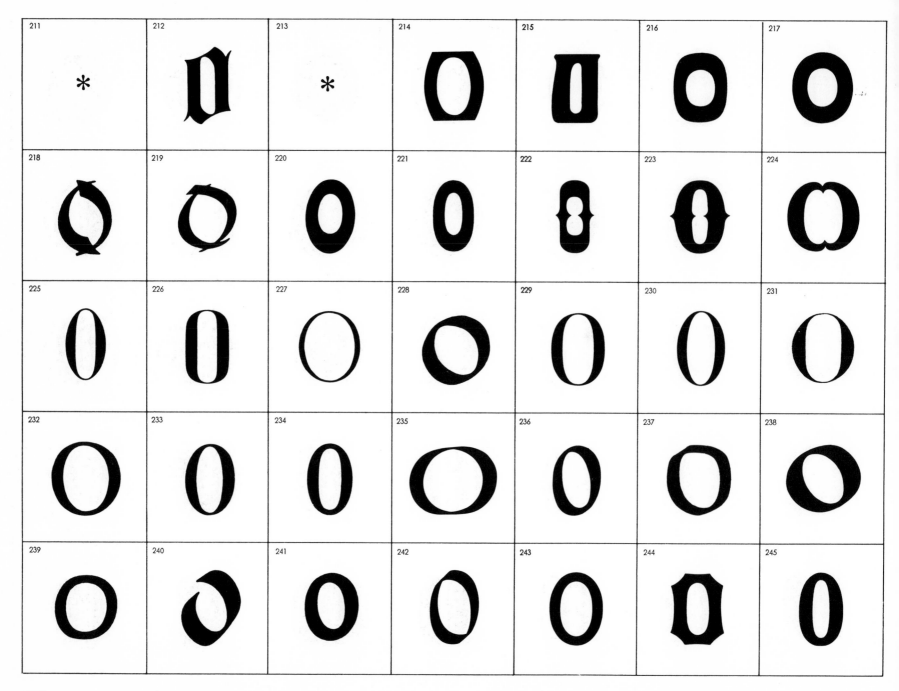

246	247	248	249	250	251	252
253	254	255	256	257	258	259
260	261	262	263	264	265	266
267	268	269	270	271	272	273 *
274	275	276	277	278	279	280

403

396

397

398

399

1 **BALLE INITIALS** Bauer Alphabets Inc.	**2** **BENGUIAT, ED. CONGRESSIONAL SCRIPT 5376n** Photo-Lettering Inc.	**3** **BONAGURA, TONY SPENCERIAN 2201n** Photo-Lettering Inc.	**4** **THOMPSON, TOMMY PENNSCRIPT 0779n** Photo-Lettering Inc.	**5** **STATIONERS SEMI-SCRIPT** American Type Founders Inc.	**6** **VIRTUOSO BOLD** Bauer Alphabets Inc.	**7** **COMMERCIAL SCRIPT** American Type Founders Inc.
8 **STRADIVARIUS** Bauer Alphabets Inc.	**9** **BERNHARD TANGO INITIALS** American Type Founders Inc.	**10** **LIBERTY** American Type Founders Inc.	**11** **GAVOTTE** Bauer Alphabets Inc.	**12** **TRAFTON SCRIPT** Bauer Alphabets Inc.	**13** **BERNHARD CURSIVE BOLD** Bauer Alphabets Inc.	**14** **BERNHARD TANGO** American Type Founders Inc.
15 **MURRAY-HILL BOLD** American Type Founders Inc.	**16** **RALEIGH CURSIVE** American Type Founders Inc.	**17** **CIVILITE** American Type Founders Inc.	**18** **GELBERG, DAN INFORMAL UPRIGHT 2070 2n** Photo-Lettering Inc.	**19** **CORONET BOLD** Monotype Corp. Ltd.	**20** **PARK AVENUE** American Type Founders Inc.	**21** **RICHELIEU CURSIVE 3781n** Photo-Lettering Inc.
22 **RHAPSODIE SWASH** Ludwig and Mayer	**23** **MILLSTEIN, WM. MARLBORO 1948n** Photo-Lettering Inc.	**24** **ROSA, GUIDO CALLIGRAPHIC ITALIC 2492n** Photo-Lettering Inc.	**25** **LEGEND** Bauer Alphabets Inc.	**26** **CASLON ITALIC 540 SWASH 3729n** Photo-Lettering Inc.	**27** **PALATINO ITALIC** Bauer Alphabets Inc.	**28** **HOLLAND, HOLLIS BELEZA 0887e** Photo-Lettering Inc.
29 **SHAAR, EDWIN DIANE 0691n** Photo-Lettering Inc.	**30** **LYDIAN CURSIVE** American Type Founders Inc.	**31** **GRAYDA** American Type Founders Inc.	**32** **EL GRECO** Bauer Alphabets Inc.	**33** **STYLESCRIPT** Monotype Corp. Ltd.	**34** **DERBY** Bauer Alphabets Inc.	**35** **RONDO BOLD** Bauer Alphabets Inc.

Above style names correspond by grid number and location to each specimen.

36 **VOGUE INITIALS** **4002n** Photo-Lettering Inc.	**37** **GOVERNALE, SANDI WROUGHT IRON A** **5349e** Photo-Lettering Inc.	**38** **DU BARRY XENOTYPE** **3818e** Photo-Lettering Inc.	**39** **GOUDY ORNATE** **1137 2n** Photo-Lettering Inc.	**40** **BASKERVILLE SWIRL** **4757n** Photo-Lettering Inc.	**41** **KISMET XENOTYPE** **3545n** Photo-Lettering Inc.	**42** **CURFEW INITIALS** **0387 3n** Photo-Lettering Inc.
43 **LOUIS XIV XENOTYPE** **3805e** Photo-Lettering Inc.	**44** **NYMPHIC XENOTYPE** **3799 4n** Photo-Lettering Inc.	**45** **FLIRT XENOTYPE** **3546n** Photo-Lettering Inc.	**46** **NYMPHIC XENOTYPE** **3799 2n** Photo-Lettering Inc.	**47** **FLORADORA** **0496 2n** Photo-Lettering Inc.	**48** **CAVANAUGH, F.H.K. EIGHTEEN NINETY** **0509 3n** Photo-Lettering Inc.	**49** **CLOCK XENOTYPE** **3842n** Photo-Lettering Inc.
50 **CICERO** Los Angeles Type Founders Inc.	**51** **BELLE XENOTYPE** **3840e** Photo-Lettering Inc.	**52** **HENRION, F.H.K. FLOWER E** **3749 2n** Photo-Lettering Inc.	**53** **EIGHTEEN EIGHTY** **3829n** Photo-Lettering Inc.	**54** **BAROQUE ORNAMENTAL** **4438n** Photo-Lettering Inc.	**55** **DAVISON, DAVE BAROQUE** **5406 1n** Photo-Lettering Inc.	**56** **BUCKLIN XENOTYPE A** **3478n** Photo-Lettering Inc.
57 **WYCLIFFE** **3086n** Photo-Lettering Inc.	**58** **EMERSON CALLIGRAPHIC HEAVY** **3087n** Photo-Lettering Inc.	**59** **HANOVER BOLD** **4258 2c** Photo-Lettering Inc.	**60** **PISCITELLE, GEO. STRATFORD** **1525 2n** Photo-Lettering Inc.	**61** **COPELAND, L.H. BACCALAUREATE** **1509c** Photo-Lettering Inc.	**62** **MEDALLION** **0452 3n** Photo-Lettering Inc.	**63** **WALLENBERG, R. DOCUMENTARY** **2357 3c** Photo-Lettering Inc.
64 **SEIDELBURG HEAVY** **1977c** Photo-Lettering Inc.	**65** **AMERICAN TEXT** American Type Founders Inc.	**66** **GOUDY TEXT** Monotype Corp. Ltd.	**67** **ALCOCK, DAISY ROMAN** **2345n** Photo-Lettering Inc.	**68** **ENGRAVERS OLD ENGLISH** American Type Founders inc.	**69** **CLOISTER BLACK** American Type Founders inc.	**70** **KERR, MAX CHRISTMAS** **424 3c** Photo-Lettering Inc.

408

71 **THOMPSON QUILLSCRIPT** American Type Founders inc.	**72** **CASLON SHADED** American Type Founders inc.	**73** **ERBAR** Bauer Alphabets Inc.	**74** **WELLS FARGO** **1470 2n** Photo-Lettering Inc.	**75** **CLOWN KING XENOTYPE** **4364n** Photo-Lettering Inc.	**76** **OLYMPIAN XENOTYPE** **3447c** Photo-Lettering Inc.	**77** **ALLEGRO** Bauer Alphabets Inc.
78 **HATRACK XENOTYPE** **4423e** Photo-Lettering Inc.	**79** **PHOTO BOOKMAN SWASHES** **3922 2c** Photo-Lettering Inc.	**80** **CLOISTER CURSIVE HANDTOOLED** American Type Founders inc.	**81** **ROYAL** Bauer Alphabets Inc.	**82** **GLORIA** Bauer Alphabets Inc.	**83** **KALLIGRAPHIA XENOTYPE** **3477n** Photo-Lettering Inc.	**84** **STAUDEL XENOTYPE B** **3497e** Photo-Lettering Inc.
85 **KOSTER** Mackellar, Smith & Jordan	**86** **CRAYONET XENOTYPE** **3953n** Photo-Lettering Inc.	**87** **DAVIDA BOLD** **4754n** Photo-Lettering Inc.	**88** **RECLAME XENOTYPE** **3788e** Photo-Lettering Inc.	**89** **GLORIA GURSCH XENOTYPE** **3803n** Photo-Lettering Inc.	**90** **THALIA XENOTYPE** **0528e** Photo-Lettering Inc.	**91** **BOOKMAN SWASH HEAVY** **4448n** Photo-Lettering Inc.
92 **GOUDY HEAVYFACE SWASH** **4489n** Photo-Lettering Inc.	**93** **WEST, DAVE BEHEMOTH CLARENDON ITALIC SWASH** **5546c** Photo-Lettering Inc.	**94** **COOPER CONTEMPO SWASH** **4481c** Photo-Lettering Inc.	**95** **MUSEE XENOTYPE** **4403n** Photo-Lettering Inc.	**96** **BALTIMORE XENOTYPE** **3808n** Photo-Lettering Inc.	**97** **PACELLA, VINCE LATINA SWASH** **5538c** Photo-Lettering Inc.	**98** **WEST, DAVE COOPER NOUVEAU SWASH** **5558n** Photo-Lettering Inc.
99 **BRADLEY** Monotype Corp. Ltd.	**100** **NEPTUN XENOTYPE** **3471n** Photo-Lettering Inc.	**101** **MESSICK, M.A. EXOTIC BOLD** **5437n** Photo-Lettering Inc.	**102** **CARUSO, VIC ROXY** **5017n** Photo-Lettering Inc.	**103** **TELEPHONE XENOTYPE** **4351n** Photo-Lettering Inc.	**104** **PRETORIAN XENOTYPE** **3466n** Photo-Lettering Inc.	**105** **HOGARTH** **4359 4n** Photo-Lettering Inc.

106 **JIM CROW 1108 3n** Photo-Lettering Inc.	107 **GRANDMOTHER ORNAMENTAL 4405n** Photo-Lettering Inc.	108 **ANGELFACE 4257 2n** Photo-Lettering Inc.	109 **DAVISON, DAVE CAROUSEL E 1533e** Photo-Lettering Inc.	110 **DAVISON, DAVE CAROUSEL G 1535e** Photo-Lettering Inc.	111 **BRACELET 4806n** Photo-Lettering Inc.	112 **TROCADERO** Los Angeles Type Founders Inc.
113 **FONTANESI** Bauer Alphabets Inc.	114 **RAFFIA INITIALS** Bauer Alphabets Inc.	115 **PHYDIAN XENOTYPE 3835e** Photo-Lettering Inc.	116 **BURLESQUE 4181 4e** Photo-Lettering Inc.	117 **ALCOCK, DAISY INLINE 2257c** Photo-Lettering Inc.	118 **CAMPANILE XENOTYPE 3734e** Photo-Lettering Inc.	119 **RENAISSANCE BOLD 3746e** Photo-Lettering Inc.
120 **WESTMINISTER SHADED 0345n** Photo-Lettering Inc.	121 **ROMANTIQUE NO. 2** Los Angeles Type Founders Inc.	122 **LILITH** Bauer Alphabets Inc.	123 **CLOISTER INITIALS** American Type Founders inc.	124 **TANGIER 4847n** Photo-Lettering Inc.	125 **DUTCH INITIALS** American Type Founders inc.	126 **OLD LACE XENOTYPE 0388e** Photo-Lettering Inc.
127 **HENRION, F.H.K. FLOWER A 3760 3n** Photo-Lettering Inc.	128 **ST. CLAIRE 4841e** Photo-Lettering Inc.	129 **CAVANAUGH, J.A. CHANDELIER 0521c** Photo-Lettering Inc.	130 **OMBRE INITIALS** Deberny et Peignot, Foundries	131 **ARBORET 4799n** Photo-Lettering Inc.	132 **EIGHTEEN NINETY 3828n** Photo-Lettering Inc.	133 **PUNCH & JUDY 3687n** Photo-Lettering Inc.
134 **PHILADELPHIAN 0488n** Photo-Lettering Inc.	135 **DAVISON, DAVE CAROUSEL C 1537e** Photo-Lettering Inc.	136 **SAPHIRE** Bauer Alphabets Inc.	137 **CAVANAUGH, F.H.K. DAHLIA 2394 1n** Photo-Lettering Inc.	138 **MANSARD XENOTYPE 3794c** Photo-Lettering Inc.	139 **DAVISON, DAVE CAROUSEL B 1530e** Photo-Lettering Inc.	140 **WEST, DAVE ROMA 5982n** Photo-Lettering Inc.

141 **REPRO SCRIPT** American Type Founders Inc.	**142** **FREEHAND** American Type Founders Inc.	**143** **BRUSH** American Type Founders Inc.	**144** **PALETTE** Bauer Alphabets Inc.	**145** **CIRCLE 1223 2n** Photo-Lettering Inc.	**146** **FOX** Bauer Alphabets Inc.	**147** **CHARME BOLD** Bauer Alphabets Inc.
148 **STEINWEISS, ALEX SCRAWL MEDIUM 2335n** Photo-Lettering Inc.	**149** **AMAZONE** Bauer Alphabets Inc.	**150** **CARTOON LIGHT** Bauer Alphabets Inc.	**151** **SLOGAN** Bauer Alphabets Inc.	**152** **BRODY** American Type Founders Inc.	**153** **MEGEE, GARNET MIAMI 2380c** Photo-Lettering Inc.	**154** **DOM CASUAL** American Type Founders Inc.
155 **STUDIO BOLD** Bauer Alphabets Inc.	**156** **FONTANA SCRIPT MEDIUM 9057n** Photo-Lettering Inc.	**157** **MAXIME** Bauer Alphabets Inc.	**158** **GILLIES GOTHIC BOLD** Bauer Alphabets Inc.	**159** **KAUFMAN BOLD** American Type Founders Inc.	**160** **CYPRESS, A.C. SYLVAN 2907n** Photo-Lettering Inc.	**161** **KEYNOTE** American Type Founders Inc.
162 **CYPRESS, A.C. CARILLON 2833e** Photo-Lettering Inc.	**163** **GELBERG, DAN SEQUIN 3053n** Photo-Lettering Inc.	**164** **SOROKA, AL FLAIR MEDIUM 0181n** Photo-Lettering Inc.	**165** **CAPRICE 0375n** Photo-Lettering Inc.	**166** **CHRISTMAS SCRIPT HEAVY 0518 1n** Photo-Lettering Inc.	**167** **MAYFAIR CURSIVE** Ludlow Typograph Co.	**168** **TYPO UPRIGHT BOLD** American Type Founders Inc.
169 **EDRIDGE, D.A. MODERN UNCIAL 2373n** Photo-Lettering Inc.	**170** **RHAPSODIE** Ludwig and Mayer	**171** **AMERICAN UNCIAL** Bauer Alphabets Inc.	**172** **LIBRA** Bauer Alphabets Inc.	**173** **SYLVAN** Stephenson, Blake and Co. Ltd.	**174** **FOURNIER** Monotype Corp. Ltd.	**175** **FRY'S ORNAMENTED** Stephenson, Blake and Co. Ltd.

176 **CHELTENHAM BOLD OUTLINE** Baltimore Type and Composition Co.	177 **COLUMNA** Bauer Alphabets Inc.	178 **AUGUSTEA SHADED** Bauer Alphabets Inc.	179 **DELPHIAN** Bauer Alphabets Inc.	180 **FUTURA INLINE** Bauer Alphabets Inc.	181 **CHELTENHAM INLINE EXTENDED** American Type Founders Inc.	182 **GOUDY HANDTOOLED** American Type Founders Inc.
183 **JOHN ALLEN STRING 2851n** Photo-Lettering Inc.	184 **PRISMA** Baltimore Type and Composition Co.	185 **ATRAX 0497 4c** Photo-Lettering Inc.	186 **ADASTRA** Bauer Alphabets Inc.	187 **HOMEWOOD** Baltimore Type and Composition Co.	188 **GALLIA** Monotype Corp. Ltd.	189 **BROADWAY ENGRAVED** Monotype Corp. Ltd.
190 **NEULAND INLINE** American Type Founders Inc.	191 **ORPLID** Bauer Alphabets Inc.	192 **SHADOW** American Type Founders Inc.	193 **UMBRA** Detroit Type Foundry	194 **BAS RELIEF B 4880 1n** Photo-Lettering Inc.	195 **HENRION, F.H.K. RELIEF 2997 2n** Photo-Lettering Inc.	196 **STYMIE OPEN** Baltimore Type and Composition Co.
197 **TALBOT, R. BEVEL GOTHIC 2975 3n** Photo-Lettering Inc.	198 **CHISEL** Stephenson, Blake and Co. Ltd.	199 **SHADOWLINE 4254 1n** Photo-Lettering Inc.	200 **TRUMP GRAVURE** C. E. Weber	201 **BOSTONIAN 1715 2e** Photo-Lettering Inc.	202 **COOPER HILITE** American Type Founders Inc.	203 **FRENCH ANTIQUE INLINE 4245 3n** Photo-Lettering Inc.
204 **RENAISSANCE DROPSHADOW XENOTYPE 1488e** Photo-Lettering Inc.	205 **THORNE SHADED** Stephenson, Blake and Co. Ltd.	206 **DAVISON, DAVE VARIETY E 1546e** Photo-Lettering Inc.	207 **FORUM 2** Bauer Alphabets Inc.	208 **BENGUIAT, ED. EPHRAM DROPSHADOW 5216e** Photo-Lettering Inc.	209 **GOLDRUSH 4154 3c** Photo-Lettering Inc.	210 **SPHINX INLINE** Deberny et Peignot, Foundries

211 **STAUDEL XENOTYPE D** **3489e** Photo-Lettering Inc.	**212** **WINDSOR** **1151c** Photo-Lettering Inc.	**213** **MISSAL INITIALS** American Type Founders Inc.	**214** **STAUDEL XENOTYPE P** **3482n** Photo-Lettering Inc.	**215** **STAUDEL XENOTYPE J** **3481n** Photo-Lettering Inc.	**216** **BENGUIAT, ED. BRAVADO** **5450 2n** Photo-Lettering Inc.	**217** **BENGUIAT, ED. DISCOTHEQUE** **5470n** Photo-Lettering Inc.
218 **MANDARIN** Los Angeles Type Founders Inc.	**219** **SHANGHAI** **2700 2n** Photo-Lettering Inc.	**220** **STAUDEL XENOTYPE** **4465e** Photo-Lettering Inc.	**221** **HOBO** American Type Founders Inc.	**222** **NEW ORLEANS** **2657 3e** Photo-Lettering Inc.	**223** **CLARENDON ORNAMENTAL A** **3811e** Photo-Lettering Inc.	**224** **EDWARDIAN ORNAMENTAL BOLD WIDE** **3681c** Photo-Lettering Inc.
225 **BODONI** American Type Founders Inc.	**226** **CORVINUS MEDIUM** Bauer Alphabets Inc.	**227** **WEISS INITIALS SERIES 1** Bauer Alphabets Inc.	**228** **EVE HEAVY** Stempel	**229** **BERNHARD MODERN BOLD** American Type Founders Inc.	**230** **CASLON 540** American Type Founders Inc.	**231** **ENGRAVERS ROMAN** Monotype Corp. Ltd.
232 **WEISS INITIALS SERIES 3** Bauer Alphabets Inc.	**233** **GARAMOND** American Type Founders Inc.	**234** **CHELTENHAM MEDIUM** Monotype Corp. Ltd.	**235** **AMERICAN UNCIAL** **3778n** Photo-Lettering Inc.	**236** **EDRIDGE, D.A. CALLIGRAPHIC ROMAN** **1653n** Photo-Lettering Inc.	**237** **SOLEMNIS** Bauer Alphabets Inc.	**238** **JUBILEE** **1234n** Photo-Lettering Inc.
239 **CODEX** C. E. Weber	**240** **ONDINE** Deberny et Peignot, Foundries	**241** **CANDIDA** **3317c** Photo-Lettering Inc.	**242** **LYDIAN** American Type Founders Inc.	**243** **ALBERTUS** Mouldtype Foundries, Ltd.	**244** **GRANDMOTHER** **2875 3n** Photo-Lettering Inc.	**245** **LATIN BOLD CONDENSED** Stephenson, Blake and Co. Ltd.

246 **P.T. BARNUM** American Type Founders Inc.	**247** **CITY MEDIUM** Bauer Alphabets Inc.	**248** **STYMIE MEDIUM** American Type Founders Inc.	**249** **BOLD ANTIQUE** American Type Founders Inc.	**250** **GRAY, WM. BULBA 5146 3c** Photo-Lettering Inc.	**251** **CRAW CLARENDON** American Type Founders Inc.	**252** **FOLIO MEDIUM EXTENDED** Bauer Alphabets Inc.
253 **OPTIMA SEMI-BOLD** Bauer Alphabets Inc.	**254** **RADIANT HEAVY** Baltimore Type and Composition Co.	**255** **BROADWAY** Monotype Corp. Ltd.	**256** **NEULAND** Bauer Alphabets Inc.	**257** **REPUBLIC 0128n** Photo-Lettering Inc.	**258** **COPPERPLATE GOTHIC BOLD** Monotype Corp. Ltd.	**259** **SAMSON** Ludlow Typograph Co.
260 **TAMBOURINE HEAVY 4268n** Photo-Lettering Inc.	**261** **COOPER BLACK** Monotype Corp. Ltd.	**262** **KOMPAKT** Bauer Alphabets Inc.	**263** **BENGUIAT, ED. ZENEDIPITY 5314 3c** Photo-Lettering Inc.	**264** **DOMINO** Ludwig and Mayer	**265** **METROPOLIS BOLD** Bauer Alphabets Inc.	**266** **ULTRA BODONI** Monotype Corp. Ltd.
267 **SPHINX** Deberny et Peignot, Foundries	**268** **MESSICK, M.A. ASTRONAUT 5128n** Photo-Lettering Inc.	**269** **JAVELIN 2561 2n** Photo-Lettering Inc.	**270** **CROOTOF, HAROLD MARK 1987e** Photo-Lettering Inc.	**271** **CRENSHAW, HENRY TAMBOURINE BOLD 1784n** Photo-Lettering Inc.	**272** **GELBERG, DAN FLURRY 1942n** Photo-Lettering Inc.	**273** **PETE DOM DARKY 0861 2n** Photo-Lettering Inc.
274 **DYNAMIC** Deberny et Peignot, Foundries	**275** **ALIGNER 9098n** Photo-Lettering Inc.	**276** **WESTVACO STENCIL 4308 2c** Photo-Lettering Inc.	**277** **STENCIL** American Type Founders Inc.	**278** **FUTURA BLACK** Bauer Alphabets Inc.	**279** **FUTURA DISPLAY** Bauer Alphabets Inc.	**280** **BANCO** Bauer Alphabets Inc.

A Adastra **186**
Albertus **243**
Alcock Inline (2257c)* **117**
Alcock Roman (2345n)* **67**
Aligner (9098n)* **275**
Allegro **77**
Amazone **149**
American Text **65**
American Uncial **171**
American Uncial (3778n)* **235**
Angelface (4257 2n)* **108**
Arboret (4799n)* **131**
Atrax (0497 4c)* **185**
Augustea Shaded **178**

B Balle Initials **1**
Baltimore Xenotype (3808n)* **96**
Banco **280**
Baroque Ornamental (4438n)* **54**
Baskerville Swirl (4757n)* **40**
Bas Relief B (4880 1n)* **194**
Belle Xenotype (3840e)* **51**
Bernhard Cursive Bold **13**
Benguiat Bravado (5450 2n)* **216**
Benguiat Congressional Script (5376n)* **2**
Benguiat Discotheque (5470n)* **217**
Benguiat Ephram Dropshadow (5216e)* **208**
Benguiat Zenedipity (5314 3c)* **263**
Bernhard Modern Bold **229**
Bernhard Tango **14**
Bernhard Tango Initials **9**
Bodoni **225**
Bold Antique **249**
Bonagura Spencerian (2201n)* **3**
Bookman Swash Heavy (4448n)* **91**
Bostonian (1715 2e)* **201**
Bracelet (4806n)* **111**
Bradley **99**
Broadway **255**
Broadway Engraved **189**
Brody **152**
Brush **143**
Bucklin Xenotype A (3478n)* **56**
Burlesque (4181 4e)* **116**

C Caslon Shaded **72**
Campanile Xenotype (3734e)* **118**
Candida (3317c)* **241**
Caprice (0375n)* **165**

Cartoon Light **150**
Caruso Roxy (5017n)* **102**
Caslon 540 **230**
Caslon Italic 540 Swash (3729n)* **26**
Cavanaugh Chandelier (0521c)* **129**
Cavanaugh Dahlia (2394 1n)* **137**
Cavanaugh Eighteen Ninety (0509 3n)* **48**
Charme Bold **147**
Cheltenham Bold Outline **176**
Cheltenham Inline Extended **181**
Cheltenham Medium **234**
Chisel **198**
Christmas Script Heavy (0518 1n)* **166**
Cicero **50**
Circle (1223 2n)* **145**
City Medium **247**
Civilite **17**
Clarendon Ornamental A (3811e)* **223**
Clock Xenotype (3842n)* **49**
Cloister Black **69**
Cloister Cursive Handtooled **80**
Cloister Initials **123**
Clown King Xenotype (4364n)* **75**
Codex **239**
Columna **177**
Cooper Black **261**
Cooper Contempo Swash (4481c)* **94**
Cooper Hilite **202**
Commercial Script **7**
Copeland Baccalaureate (1509c)* **61**
Copperplate Gothic Bold **258**
Coronet Bold **19**
Corvinus Medium **226**
Craw Clarendon **251**
Crayonet Xenotype (3953n)* **86**
Crenshaw Tambourine Bold (1784n)* **271**
Crootof Mark (1987e)* **270**
Curfew Initials (0387 3n)* **42**
Cypress Carillon (2833e)* **162**
Cypress Sylvan (2907n)* **160**

D Davida Bold (4754n)* **87**
Davison Baroque (5406 1n)* **55**
Davison Carousel B (1530e)* **139**
Davison Carousel C (1537e)* **135**
Davison Carousel E (1533e)* **109**
Davison Carousel G (1535e)* **110**
Davison Variety E (1546e)* **206**

Delphian **179**
Derby **34**
Dom Casual **154**
Domino **264**
Du Barry Xenotype (3818e)* **38**
Dutch Initials **125**
Dynamic **274**

E Edridge Calligraphic Roman (1653n)* **236**
Edridge Modern Uncial (2373n)* **169**
Edwardian Ornamental Bold Wide (3681c)* **224**
Eighteen Eighty (3829n)* **53**
Eighteen Ninety (3828n)* **132**
El Greco **32**
Emerson Calligraphic Heavy (3087n)* **58**
Engravers Old English **68**
Engravers Roman **231**
Erbar **73**
Eve Heavy **228**

F Flirt Xenotype (3546n)* **45**
Floradora (0496 2n)* **47**
Folio Medium Extended **252**
Fontana Script Medium (9057n)* **156**
Fontanesi **113**
Forum 2 **207**
Fournier **174**
Fox **146**
Freehand **142**
French Antique Inline (4245 3n)* **203**
Fry's Ornamented **175**
Futura Black **278**
Futura Display **279**
Futura Inline **180**

G Gallia **188**
Garamond **233**
Gavotte **11**
Gelberg Flurry (1942n)* **272**
Gelberg Informal Upright (2070 2n)* **18**
Gelberg Sequin (3053n)* **163**
Gillies Gothic Bold **158**
Gloria **82**
Gloria Gursch Xenotype (3803n)* **89**
Goldrush (4154 3c)* **209**
Goudy Ornate (1137 2n)* **39**
Goudy Handtooled **182**
Goudy Heavyface Swash (4489n)* **92**
Goudy Text **66**

Bold face type refers to grid box number.

*Photo-Lettering Inc.,
216 East 45 Street, New York, N.Y.

ALPHABETICAL INDEX

Governale Wrought Iron A (5349e)* **37**
Grandmother (2875 3n)* **244**
Grandmother Ornamental (4405n)* **107**
Gray Bulba (5146 3c)* **250**
Grayda **31**

H Hanover Bold (4258 2c)* **59**
Hatrack Xenotype (4423e)* **78**
Henrion Flower A (3760 3n)* **127**
Henrion Flower E (3749 2n)* **52**
Henrion Relief (2997 2n)* **195**
Hobo **221**
Hogarth (4359 4n)* **105**
Holland Beleza (0887e)* **28**
Homewood **187**

J Javelin (2561 2n)* **269**
Jim Crow (1108 3n)* **106**
John Allen String (2851n)* **183**
Jubilee (1234n)* **238**
Kalligraphia Xenotype (3477n)* **83**

K Kaufman Bold **159**
Kerr Christmas (4243c)* **70**
Keynote **161**
Kismet Xenotype (3545n)* **41**
Kompakt **262**
Koster **85**

L Latin Bold Condensed **245**
Legend **25**
Liberty **10**
Libra **172**
Lilith **122**
Louis XIV Xenotype (3805e)* **43**
Lydian **242**
Lydian Cursive **30**

M Mandarin **218**
Mansard Xenotype (3794c)* **138**
Maxime **157**
Mayfair Cursive **167**
Medallion (0452 3n)* **62**
Megee Miami (2380c)* **153**
Messick Astronaut (5128n)* **268**
Messick Exotic Bold (5437n)* **101**
Metropolis Bold **265**
Millstein Marlboro (1948n)* **23**
Missal Initials **213**
Murray-Hill Bold **15**
Musee Xenotype (4403n)* **95**

N Neptun Xenotype (3471n)* **100**

Neuland **256**
Neuland Inline **190**
New Orleans (2657 3e)* **222**
Nymphic Xenotype (3799 2n)* **46**
Nymphic Xenotype (3799 4n)* **44**

O Old Lace Xenotype (0388e)* **126**
Olympian Xenotype (3447c)* **76**
Ombre Initials **130**
Ondine **240**
Optima Semi-Bold **253**
Orplid **191**

P Pacella Latina Swash (5538c)* **97**
Palatino Italic **27**
Palette **144**
Park Avenue **20**
Pete Dom Darky (0861 2n)* **273**
Philadelphian (0488n)* **134**
Photo Bookman Swashes (3922 2c)* **79**
Phydian Xenotype (3835e)* **115**
Piscitelle Stratford (1525 2n)* **60**
Pretorian Xenotype (3466n)* **104**
Prisma **184**
P. T. Barnum **246**
Punch & Judy (3687n)* **133**

R Radiant Heavy **254**
Raffia Initials **114**
Raleigh Cursive **16**
Reclame Xenotype (3788e)* **88**
Renaissance Bold (3746e)* **119**
Renaissance Dropshadow Xenotype (1488e)* **204**
Repro Script **141**
Republic (0128n)* **257**
Rhapsodie **170**
Rhapsodie Swash **22**
Richelieu Cursive (3781n)* **21**
Romantique No. 2 **121**
Rondo Bold **35**
Rosa Calligraphic Italic (2492n)* **24**
Royal **81**

S St. Claire (4841e)* **128**
Samson **259**
Saphire **136**
Seidelburg Heavy (1977c)* **64**
Shaar Diana (0691n)* **29**
Shadow **192**
Shadowline (4254 1n)* **199**
Shanghai (2700 2n)* **219**

Slogan **151**
Solemnis **237**
Soroka Flair Medium (0181n)* **164**
Sphinx **267**
Sphinx Inline **210**
Stationers Semi-Script **5**
Staudel Xenotype (4465e)* **220**
Staudel Xenotype B (3497e)* **84**
Staudel Xenotype D (3489e)* **211**
Staudel Xenotype J (3481e)* **215**
Staudel Xenotype P (3482n)* **214**
Steinweiss Scrawl Medium (2335n)* **148**
Stencil **277**
Stradivarius **8**
Studio Bold **155**
Stylescript **33**
Stymie Medium **248**
Stymie Open **196**
Sylvan **173**

T Talbot Bevel Gothic (2975 3n)* **197**
Tambourine Heavy (4268n)* **260**
Tangier (4847n)* **124**
Telephone Xenotype (4351n)* **103**
Thalia Xenotype (0528e)* **90**
Thompson Pennscript (0779n)* **4**
Thompson Quillscript **71**
Thorne Shaded **205**
Trafton Script **12**
Trocadero **112**
Trump Gravure **200**
Typo Upright Bold **168**

U Ultra Bodoni **266**
Umbra **193**

V Virtuoso Bold **6**
Vogue Initials (4002n)* **36**

W Wallenberg Documentary (2357 3c)* **63**
Weiss Initials Series 1 **227**
Weiss Initials Series 3 **232**
Wells Fargo (1470 2n)* **74**
West Behemoth Clarendon Italic Swash (5546c)* **93**
West Cooper Nouveau Swash (5558n)* **98**
West Roma (5982n)* **140**
Westminister Shaded (0345n)* **120**
Westvaco Stencil (4308 2c)* **276**
Windsor (1151c)* **212**
Wycliffe (3086n)* **57**

Bold face type refers to grid box number.

*Photo-Lettering Inc.,
216 East 45 Street, New York, N.Y.